Portrait of the Artist

JORGE LEWINSKI

Portrait of the Artist

Twenty five years of British Art

CARCANET

First published in 1987 by
Carcanet Press Limited
208-212 Corn Exchange Buildings
Manchester M4 3BQ
and
198 Sixth Avenue
New York, NY 10013

British Library Cataloguing in Publication Data

Lewinski, Jorge
 Portrait of the artist : 25 years of
 British art.
 1. Photography — Great Britain —
 Portraits 2. Artists — Great Britain
 — Portraits
 I. Title
 779'.2 TR681.A7

 ISBN 0-85635-722-7

The Publisher acknowledges the financial assistance of
the Arts Council of Great Britain

Book designed by Stephen Raw

Typeset in 10pt Ehrhardt by Bryan Williamson, Manchester
Printed in England by Jolly & Barber Limited, Rugby

I started to visit artists in their studios in 1962 when I was still an amateur photographer. I don't know why I later became wholeheartedly involved with modern artists. Obviously I was interested in modern art in general, but probably the most important reason was my belief that artists would provide me with a fascinating subject matter for creating interpretative portraits. From the beginning I did not intend merely to record artists' faces, but to achieve a deeper kind of portrait – portraits which not only described a person but gave the viewer an insight into the imaginative world of each sitter. I knew that my portraits were bound to be at least partly subjective, but this was unavoidable.

A few years later I made photography my main occupation. I continued to photograph artists regularly, encouraged by the fact that three Sunday papers started to publish my portraits on the occasion of artists' one-man shows. I also started to collect drawings, paintings and sculpture in exchange for photographic work performed for artists. This of course more than made up for the fact that photographing artists, for a professional photographer, was not remunerative.

Recently I made a list of all the artists I have photographed since 1962. Over four hundred names appeared. About eighty of them were foreign artists (and not considered for this book), still my collection of British artists was well over three-hundred strong. Of these I had to select a mere seventy-seven – less than one in three.

It is a great pleasure for a photographer to see his favourite images presented in a book (I hold the view that a book, not exhibition space, is the right showcase for photography), but the task of whittling down the list by two thirds was a painful process. In the end, important artists I had photographed were omitted, many of them good friends, which makes it worse. Nevertheless I believe that this book represents a valuable cross-section of British art of the last quarter of century. It is not, in any way, definitive: it remains my personal selection of artists I admired and, in the majority of cases, liked. I would wish to thank them for their kindness in giving me so much of their time and for their general friendliness and welcome.

A note on technique

The majority of portraits in this book were taken in natural light. If the light was inadequate I invariably used one fairly large tungsten-halogen reflected light lamp: I never use flash. Early portraits – till about 1970 – were taken with 6cm x 6cm Mamiyaflex camera; later I switched to a 6 x 7 Pentax, but a few of the portraits were also taken with a Nikon camera. I have a distinct preference for wide-angle lenses and only occasionally use a long-focus lens. Over twenty-five years I have used a variety of black and white films, but for the last few years a medium speed 100 ASA film (Kodak or Ilford) exposed to 300 ASA and processed in Promicrol developer.

As to the conduct of a portrait session, I never deliberately pose my 'sitters' and let them select the pose, although I occasionally suggest the part of the studio in which I would like to work. I prepare myself for each session quite thoroughly, finding out all I can about my subject, looking at his or her paintings or sculptures if possible. If I am able to show my interest and knowledge about their work it both flatters and relaxes them immeasurably: a successful portrait session is very much a sum total of the efforts of both photographer and sitter.

10 Eileen AGAR b. Buenos Aires, 1904
Studied at the Slade and in Paris.
First individual show at Redfern Gallery, 1942.
A number of exhibitions since, including a retrospective at
the Commonwealth Art Gallery, 1971.

12 Kenneth ARMITAGE b. Yorkshire, 1916
Studied at Leeds College of Art and at the Slade.
Exhibitions in New York 1958, 1962; Venice 1958; Tokyo
Biennale 1963. Retrospective in the Whitechapel Gallery,
1959.

14 Frank AUERBACH b. Berlin, 1931; came to live in
England 1939. Studied at St Martin's School of Art and at
the Royal College.
First exhibition at Beaux Arts Gallery, 1956.
Exhibited in Sydney, Melbourne, Milan, Dublin, Zurich.
Retrospective at the Hayward Gallery, 1978.

16 Gillian AYRES b. London, 1930
Studied at the Camberwell School of Art.
First exhibition at Gallery One, 1956.
Retrospective at the Serpentine Gallery, 1985; major
exhibition at the Knoedler Gallery, New York, 1986.

18 Michael AYRTON b. London, 1921, d. 1975
Educated in England, France and Austria.
First exhibition 1939; started to sculpt in 1953. Annual
visits to Italy and Greece.
Retrospective at the Whitechapel Gallery, 1955.

19 Francis BACON b. Dublin, 1909
After a period of designing furniture and rugs, started to
paint in 1929. First exhibition 1934.
Exhibited round the world, including retrospectives in New
York, Chicago, the Tate Gallery, Hamburg, the Grand
Palais (Paris).

22 Edward BAWDEN b. Essex, 1903
Studied at Cambridge University and the Royal College.
Mostly celebrated for his murals (for P & O and B.P. among
others) and his graphic work, especially for British industry.

24 Peter BLAKE b. Kent, 1932
Studied at Gravesend Technical College and School of Art,
and at the Royal College.
First one-man exhibition at the Portal Gallery, 1962.
Numerous exhibitions in Britain and abroad, including a
retrospective at the Tate Gallery, 1985.

28 Derek BOSHIER b. Portsmouth, 1937
Studied at Yeovil School of Art and at the Royal College.
First one-man exhibition at the Grabowski Gallery, 1962.
Numerous exhibitions in Britain and abroad.

30 Fionnuala BOYD & Leslie EVANS Boyd b. Welwyn
Garden City, 1944; Evans b. St Albans, 1945. Both
educated in Leeds.
Numerous exhibitions around the world, including Tokyo,
Delhi, Washington and Canada.
Regular shows at the Angela Flowers Gallery, London.

32 The BOYLE Family Mark Boyle, b. 1934, Joan Hills,
Sebastian and Georgia Boyle
Mark Boyle studied at Glasgow University, Joan Hills at
the Edinburgh School of Architecture.
First joint exhibition at Indica Gallery, 1966.
A number of exhibitions and light shows, including the
Venice Biennale 1978, and at the Hayward Gallery, 1987.

33 Antonas BRAZDYS b. Lithuania, 1939
Studied at the Art Institute of Chicago, and the Royal
College.
First one-man show at the Hamilton Galleries, 1965.
A number of individual and mixed exhibitions; several
major commissions.

34 Stuart BRISLEY b. Haslemere, 1933
Studied at Guildford School of Art, the Royal College,
Florida State University and in Munich.
Numerous one-man exhibitions and performances in
Britain and abroad, most recently at the Serpentine Gallery,
1987.

36 Reg BUTLER b. Buntingford, 1913, d. 1981
Studied architecture.
First sculpture exhibition at the Hanover Gallery, 1954.
Major exhibitions include the Venice Biennale,
Documenta in Kessel, Paris, New York, Brussels.

38 Anthony CARO b. London, 1924
Studied at the Regent Street Polytechnic and the Royal
Academy Schools.
Worked as part-time assistant to Henry Moore. Taught at
St Martin's School of Art, 1952-79.
Exhibitions include Venice and Paris Biennales,
Washington, Amsterdam, São Paulo.

41 Patrick CAULFIELD b. London, 1936
Studied at the Chelsea School of Art and the Royal College.
First one-man show at the Robert Frazer Gallery, 1965.
Numerous individual exhibitions, including Paris and São
Paulo Biennale, 1967.
Retrospective at the Tate Gallery, 1981.

44 Lynn CHADWICK b. London, 1914
Trained as an architect, started to sculpt late in life.
Numerous exhibitions, including Paris, New York,
Brussels, Rome and Geneva. Exhibited at the Venice
Biennale 1952, 1956; São Paulo Biennale 1957, 1962.

46 Prunella CLOUGH b. London, 1919
Studied at the Chelsea School of Art.
First individual exhibition at the Leger Gallery, 1947.
A number of exhibitions, mainly in Britain.
Retrospectives at the Whitechapel Art Gallery, 1960; at
Graves Art Gallery, Sheffield, 1972; at the Serpentine
Gallery, 1976.

48 Bernard COHEN b. London, 1933
Studied at St Martin's School of Art and the Slade.
First one-man exhibition at Gimpel Fils Gallery, 1953.
Numerous exhibitions in Britain and abroad, including the
Venice Biennale, 1966.
Retrospective exhibition at the Hayward Gallery, 1972.

50 Sir William COLDSTREAM b. Northumberland, 1908,
d. 1987 Studied at the Slade.
Member of the London Group and founding member of
the Euston Road School of Painting. Official War Artist.
Slade Professor of Fine Art at University College, London
1949-75.

52 Cecil COLLINS b. Plymouth, 1908
Studied at Plymouth School of Art and the Royal College.
First one-man exhibition at Bloomsbury Gallery, 1935.
A number of exhibitions, mainly in Britain. Retrospectives
at the Ashmolean Museum, Oxford, 1953; Whitechapel
Gallery, 1959; planned for the Tate Gallery, 1988.

53 **Alan DAVIE** b. Scotland, 1920
Studied at the Royal College.
First one-man show at Gimpel Fils, 1950.
Numerous exhibitions all round the world, including
retrospective shows in Amsterdam, New York, Toronto,
and the Royal Scottish Academy.

56 **Richard DEACON** b. Wales, 1949
Studied at St Martin's School of Art and the Royal College.
First one-man show at Brixton, followed by a larger show
at the Lisson Gallery, 1983.

58 **Paul FEILER** b. Frankfurt-on-Main, 1918;
came to live in England 1933. Studied at the Slade.
Head of Painting at Bristol Polytechnic since 1963.
Many one-man exhibitions; travelling retrospective in
1985, shown at the Warwick Trust Galleries in London.

60 **Barry FLANAGAN** b. Prestatyn, 1941
Studied at St Martin's School of Art.
First one-man exhibition at the Rowan Gallery, 1966.
Numerous exhibitions, including Paris and Tokyo
Biennales; represented Britain in the Venice Biennale,
1984.

62 **Dame Elisabeth FRINK** b. Suffolk, 1930
Studied at Guildford and Chelsea Schools of Art.
First one-woman exhibition at St George's Gallery, 1955.
Numerous official commissions; exhibitions worldwide.
Retrospective at the Royal Academy, 1986.

66 **Terry FROST** b. Leamington Spa, 1915
Mainly self-taught; brief periods at St Ives School of
Painting and Camberwell School of Art.
First one-man exhibition at the Leicester Gallery, 1952.
Exhibitions in Britain, New York, Paris, Norway.
Travelling Arts Council retrospective exhibition, 1976/77.

68 **GILBERT and GEORGE** b. Gilbert Proesch, 1943 and
George Passmore, 1942
Studied at St Martin's School of Art.
A number of exhibitions in Britain and abroad; awarded
the Turner Prize, 1986.
Retrospective at the Whitechapel Gallery, 1986.

70 **Katherine GILI** b. Oxford, 1948
Studied at Bath Academy of Art and St Martin's School of
Art. First exhibition with five other sculptors at the Chelsea
Gallery, 1971.
Regular exhibitions since, including the Hayward Gallery,
1979, and with her group at the Tate Gallery, 1985.

72 **Anthony GREEN** b. London, 1939
Studied at the Slade.
First one-man exhibition at the Rowan Gallery, 1962.
Many exhibitions abroad, including New York, Rotterdam,
Stuttgart, Tokyo and Brussels.

74 **Richard HAMILTON** b. London, 1922
Studied at the Westminster Technical College, the Royal
Academy Schools and the Slade.
First one-man exhibition at the Hanover Gallery, 1955.
Numerous exhibitions including retrospectives at the Tate
Gallery (1970), New York, Cincinatti, Munich and Berlin.

77 **Dame Barbara HEPWORTH** b. Yorkshire, 1903, d. 1975
Educated at Leeds School of Art and the Royal College.
Numerous exhibitions worldwide, including retrospectives
in New York, Stockholm and the Tate Gallery.

82 **Josef HERMAN** b. Warsaw, 1911; came to live in England,
1940
Studied at the School of Art and Decoration, Warsaw.
First one-man exhibition at the Lefevre Gallery, 1943.
Numerous exhibitions around the world; retrospectives at
the Whitechapel Gallery, 1956; Glasgow and Cardiff, 1975.

84 **Patrick HERON** b. Leeds, 1920
Studied part-time at the Slade.
First one-man exhibition at the Redfern Gallery, 1947.
Numerous exhibitions around the world including New
York, Zurich, São Paulo.
Retrospectives in Edinburgh, Oxford, Oslo, Austin and at
the Barbican, London 1985.

86 **Roger HILTON** b. Northwood, Middlesex, 1911, d. 1975
Studied at the Slade and at the Académie Ranson, Paris.
First one-man exhibition at the Bloomsbury Gallery, 1936.
A number of exhibitions including Venice Biennale, 1964
(awarded UNESCO Prize).
Retrospective at the Serpentine Gallery, 1974.

88 **Ivon HITCHENS** b. London, 1893, d. 1979
Studied at St John's School of Art and the Royal Academy
Schools.
First one-man exhibition at the Mayor Gallery, 1925.
Numerous exhibitions including retrospectives at the
Venice Biennale, 1956; Paris and Amsterdam, 1957; the
Tate Gallery, 1963.

90 **David HOCKNEY** b. Bradford, 1937
Studied at Bradford College of Art and the Royal College.
First one-man exhibition Kasmin Gallery, 1963.
Numerous exhibitions in New York, Amsterdam, Paris,
Venice Biennale.
Retrospective at the Whitechapel Gallery, 1970.

94 **Howard HODGKIN** b. London, 1932
Studied at the Camberwell School of Art and the Bath
Academy.
First one-man exhibition at the Tooths Gallery, 1962.
Numerous exhibitions around the world including Venice
Biennale, where he represented Britain in 1984. Awarded
the Turner Prize, 1985.

96 **John HOYLAND** b. Sheffield, 1934
Studied at Sheffield College of Art and the Royal Academy
Schools.
First one-man exhibition at Marlborough New London
Gallery, 1964.
Numerous exhibitions in Britain and abroad, including
major shows at the Whitechapel Gallery, 1979, and the
Serpentine Gallery, 1979.

97 **Patrick HUGHES** b. Birmingham, 1939
Studied at James Graham Teachers' Training College,
Leeds.
First one-man show at the Portal Gallery, 1961. Several
exhibitions; regular shows at the Angela Flowers Gallery.

100 **Albert IRVIN** b. London, 1922
Studied at Northampton School of Art and Goldsmiths'
College.
First one-man show at the 57 Gallery, Edinburgh, 1960.
Several exhibitions in Britain and Germany; large touring
exhibition in Glasgow, Aberdeen and Birmingham, 1983.

101 Allen JONES b. Southampton, 1937
Studied at Hornsey College of Art and the Royal College.
First one-man show at Tooths Gallery, 1963.
Exhibited around the world including Tokyo Biennale
1964, 1966; São Paulo Biennale, 1967.

104 Tom KEATING b. London, 1917, d. 1984
Mostly self-educated, studied at Goldsmiths' College.
A collection of 135 of his paintings sold for a large sum at
Christie's in 1983.

105 Phillip KING b. Tunisia, 1934
Studied at Cambridge University and St Martin's School
of Art. First one-man show at the Rowan Gallery, 1964.
Exhibited widely, including Venice Biennale 1968.
Retrospective at the Hayward Gallery, 1981.

107 R.B. KITAJ b. Ohio, 1932
Studied in New York, Vienna, Ruskin School of Drawing,
Oxford, and the Royal College. First one-man show at
Marlborough Fine Arts Gallery, 1963.
A number of exhibitions around the world, including New
York, Rotterdam, Berlin, Los Angeles.
Retrospectives in Washington and Cleveland, 1981;
Düsseldorf, 1982.

109 Stefan KNAPP b. Poland, 1921
Studied at the Slade.
First one-man show at the London Gallery, 1947.
Numerous shows around the world including France,
Germany, USA, Brasil.
Retrospective at Warsaw Gallery of Zacheta, 1974.

111 Leon KOSSOFF b. London, 1926
Studied at St Martin's School of Art and the Royal College.
First one-man show at the Beaux Arts Gallery, 1957.
A number of exhibitions since, including a major show at
the Whitechapel Gallery, 1972.

112 Peter LANYON b. St Ives, 1918, d. 1964
Studied at the Penzance School of Art and at the Euston
Road School.
Exhibited regularly at Gimpel Fils Gallery, held several
exhibitions in New York; São Paulo Biennale, 1961.
Retrospective at the Tate Gallery, 1978.

113 Liliane LIJN b. New York, 1939; settled in England 1966
Studied archaeology and art history in Paris.
First one-woman show at La Librarie Anglaise, Paris, 1963.
Exhibited widely throughout Europe; major show at the
Serpentine Gallery, 1976.

115 Kim LIM b. Singapore, 1936
Studied at St Martin's School of Art and the Slade.
First one-woman show at the Axiom Gallery, 1962.
A number of exhibitions in Britain and abroad, including
an inaugural at the National Museum of Art, Singapore,
1976; prints at the Tate Gallery, 1977; Round House
Gallery, 1979.

116 L.S. LOWRY b. Manchester, 1887, d. 1976
Studied at Manchester Municipal Art College and Salford
School of Art.
First one-man show at the Lefevre Gallery, 1939.
Numerous exhibitions and retrospectives, mainly in Britain,
including a retrospective at the Tate Gallery, 1966-7.

118 Denis MITCHELL b. Middlesex, 1912
Largely self-taught; evening classes at Swansea College of
Art. Worked for Dame Barbara Hepworth, 1949-59.
Several one-man shows; commission for University of
Bogota.

119 Henry MOORE b. Castleford, Yorkshire, 1898, d. 1986
Studied at Leeds College of Art and Royal College.
First one-man exhibition at the Leicester Gallery, 1930.
Countless exhibitions around the world.
Retrospectives at the Tate Gallery, 1951, 1968; Hamburg,
1960; Philadelphia, 1966; Florence, 1972, among others.

124 Graham OVENDEN b. Hampshire, 1943
Studied at the Royal College.
A number of one-man exhibitions, mainly in Britain.
Co-founder of the Brotherhood of Ruralists, 1975.

125 Eduardo PAOLOZZI b. Scotland, 1924
Studied at Edinburgh College of Art and at the Slade.
First one-man show at the Mayor Gallery, 1947.
Numerous exhibitions around the world, including
Biennales in São Paulo, 1957, 1963; New York, 1960;
Tokyo, 1962, 1964.
Retrospectives at the Tate Gallery, 1971, in Berlin, 1975.

128 Victor PASMORE b. Surrey, 1908
Largely self-educated; attended evening classes LCC
Central School of Arts and Crafts.
First one-man show at the Redfern Gallery, 1940.
Co-founder of the Euston Road School of Painting, 1938.
Numerous exhibitions in Britain and abroad.
Retrospective shows in Paris and Amsterdam, 1961; Berne,
1963; the Tate Gallery, 1965; the Royal Academy, 1980,
among others.

130 Tom PHILLIPS b. London, 1937
Studied at the Camberwell School of Art.
First one-man show at the AIA Galleries, 1965.
A number of exhibitions abroad, including the Venice
Biennale, 1971; published *A Humament*, 1980, illustrations
to Dante's *Inferno*, 1982.
Retrospectives in The Hague and Basel, 1975; at the
Serpentine Gallery, 1975.

133 John PIPER b. Epsom, 1903
Studied law and then attended the Royal College.
First one-man show at the Leicester Gallery, 1940.
Numerous exhibitions and commissions in Britain and
abroad.
Retrospective travelling exhibition 1967/8, and at the Tate
Gallery, 1983/4.

136 Patrick PROCKTOR b. Dublin, 1936
Studied at the Slade.
First one-man exhibition at the Redfern Gallery, 1963.
Exhibitions in Britain and abroad, also book illustration,
scenery and costume designs for ballet and opera.

138 William PYE b. London, 1938
Studied at Wimbledon School of Art and at the Royal
College.
First one-man exhibition at the Redfern Gallery, 1966.
A number of exhibitions in Britain and abroad, including
major show at the Yorkshire Sculpture Park, 1978.

140 **William REDGRAVE** b. Essex, 1903, d. 1986
Studied art in evening classes.
First one-man show in Cornwall, c. 1940.
Several exhibitions in British galleries.

141 **Alan REYNOLDS** b. Suffolk, 1926
Studied at Woolwich Polytechnic School of Art and at the
Royal College.
First one-man exhibition at the Redfern Gallery, 1952.
Exhibitions in Britain and Pittsburgh, Paris, Brussels.

143 **Ceri RICHARDS** b. Wales, 1903, d. 1971
Studied at Swansea School of Art and at the Royal College.
First one-man exhibition at the Leger Gallery, 1942.
Numerous exhibitions in Britain and abroad, including
retrospectives at the Whitechapel Gallery, 1960; Venice
Biennale, 1962; the Tate Gallery, 1981.

144 **Bridget RILEY** b. London, 1931
Studied at Goldsmiths' College and the Royal College.
First one-woman exhibition at Gallery One, 1962.
Numerous exhibitions around the world, including New
York, Turin, Düsseldorf, Tokyo.
Retrospectives at the Hayward Gallery, 1971; touring USA,
Australia and Japan 1978-80.

147 **William SCOTT** b. Scotland, 1913
Studied at Belfast School of Art, Royal Academy Schools.
First one-man show at the Leger Gallery, 1946.
A number of exhibitions around the world, including Venice
Biennale, 1958; São Paulo Biennale, 1953, 1961; New
York, Japan.
Retrospectives at Gimpel Fils, 1985; National Galleries of
Scotland, 1986.

150 **Jack SMITH** b. Sheffield, 1928
Studied at Sheffield College of Art, St Martin's School of
Art, Royal College.
First one-man show at Beaux Arts Gallery, 1952.
A number of exhibitions in Britain and abroad, including
the Whitechapel Gallery, 1970, 1971; Pittsburgh
International, 1957, 1964.
Retrospectives at the Sunderland Arts Centre, 1977 and
the Serpentine Gallery, 1978.

152 **Ruskin SPEAR** b. London, 1911
Studied at Hammersmith School of Art, Royal College.
First one-man exhibition at the Leicester Gallery, 1951.
Exhibited in Britain and abroad, including Paris, USA,
Belgium, Australia. Portraits in many galleries including
National Portrait Gallery.

153 **Graham SUTHERLAND** b. London, 1903, d. 1980
Studied at Goldsmiths' College.
Numerous exhibitions around the world, including Venice
Biennale, 1952; Tate Gallery, 1953; Museum of Modern
Art, Turin, 1965.

154 **Wendy TAYLOR** b. Lincolnshire, 1945
Studied at St Martin's School of Art.
First one-woman show at the Axiom Gallery, 1970.
Exhibitions and commissions mainly in Britain.

156 **Joe TILSON** b. London, 1928
Studied at St Martin's School of Art, Royal College, British
School at Rome.
First one-man exhibition at Marlborough Fine Art, 1962.
A number of exhibitions, including Venice Biennale 1964,
1971, 1976; Tokyo Biennale 1963, 1964.
Retrospectives at Rotterdam, 1973; Vancouver, 1979.

158 **Felix TOPOLSKI** b. Poland, 1907; settled in England
1935. Studied at the Academy of Art, Warsaw.
Numerous exhibitions around the world, and publications.
Working on permanent exhibition 'Memoir of the Century'
at the South Bank Arts Centre, London.

160 **William TURNBULL** b. Dundee, 1922
Studied at the Slade School.
First one-man exhibition at the Hanover Gallery, 1950.
Various exhibitions, including the Venice Biennale, 1952;
Hayward Gallery, 1968.
Retrospective at the Tate Gallery, 1973.

162 **Euan UGLOW** b. London, 1932
Studied at the Camberwell School of Art, and the Slade
School.
First one-man exhibition at the Beaux Arts Gallery, 1961.
Member of the London Group from 1960. A number of
exhibitions, mainly in Britain; major show at the
Whitechapel Gallery, 1974.

163 **Keith VAUGHAN** b. Sussex, 1912, d. 1977
Largely self-taught.
First one-man exhibition at the Lefevre Gallery, 1944.
Numerous shows in Britain and abroad, including a
travelling Arts Council retrospective 1957/8, and a
retrospective at the Whitechapel Gallery, 1962.

165 **John WELLS** b. London, 1907
Studied medicine at Epsom College and University College,
London; self-taught as an artist.
First one-man show at Waddington Gallery, 1960.
A number of shows mainly in England; at present not
showing with art galleries.

166 **Richard WILSON** b. London, 1953
Studied at the London College of Printing, Hornsey
College of Art and Reading University.
First one-man show at the Coracle Press Gallery, London,
1978.
Various exhibitions and constructions, mainly in England.

167 **Bill WOODROW** b. Henley-on-Thames, 1948
Studied at Winchester School of Art, St Martin's School
of Art and Chelsea School of Art.
First one-man exhibition at the Whitechapel Gallery, 1972.
A number of individual shows in Britain and abroad,
including Venice and Paris Biennales, and Sydney Biennale
1982.

KENSINGTON. A huge Victorian red-brick house, on the pillar a number 1, slightly flaked. No. 1 Melrose Avenue, surely, even though I find it (London logic) between numbers 11 and 7, with all the others missing.

Eileen Agar lives alone on the second floor of this monster of a house, with her studio on the third and, of course, no lift. Her large studio window overlooks other red-brick houses and a tiny church squeezed in between them. 'T.S. Eliot was married in that church, when he lived nearby,' Ms Agar explains. Her paintings surround me, hanging on the walls, propped against them, on chairs – simply everywhere. Semi-abstract, colourful compositions with a strong dash of surrealism. Eileen Agar was a prominent member of the pre-war British surrealist group and took an active part in the 1936 exhibition of surrealist painting in London over which Dali himself presided. A large framed photograph on the wall recalls the occasion. She is in the front row between Lee Miller and Nusch Eluard, with an anonymous lady friend of Dali (Eileen did not remember her name) at the side. Roland Penrose, Paul Eluard, André Breton and a resplendent Dali stand at the back.

In the corridor outside the studio, I spot more photographs, mainly of Picasso, with the substantial forms of the beautiful Dora Maar and Man Ray. I learn that Ms Agar was also an accomplished photographer. She took these on a visit to the master's house in Mougins in 1937.

All this was a long time ago, alas. Now Eileen Agar is moving to a first-floor flat with a lift. For an eighty-three year old, however sprightly, climbing to the third floor is no longer a pleasure.

Eileen Agar –

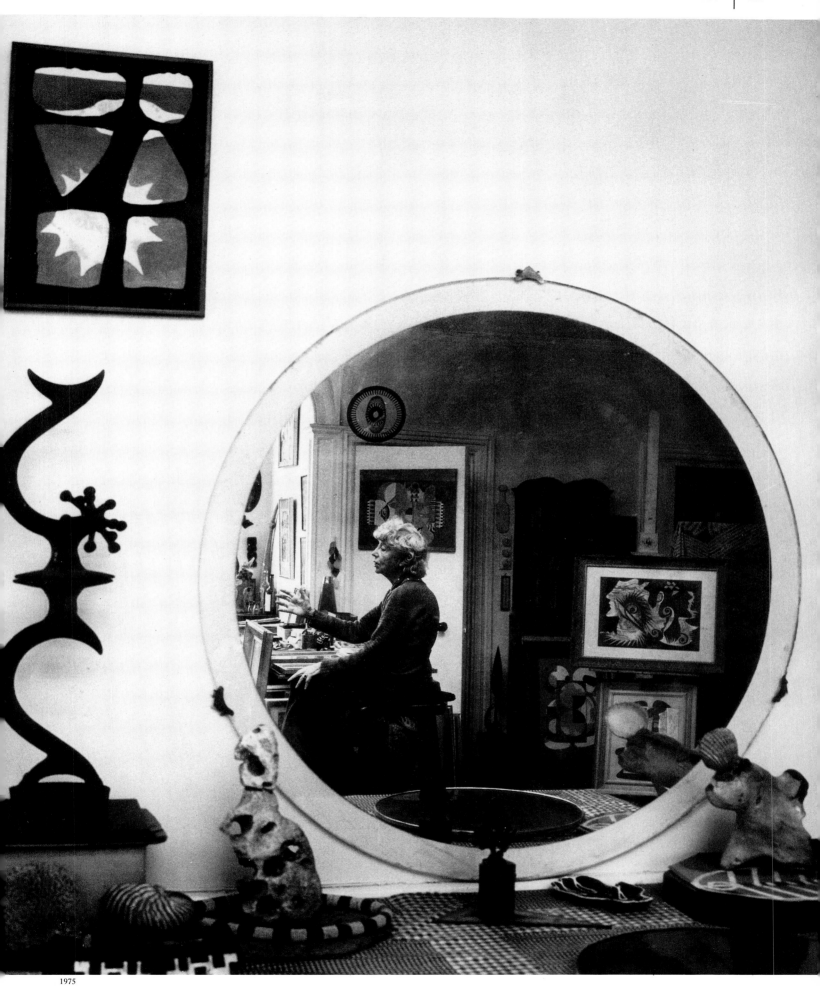

1975

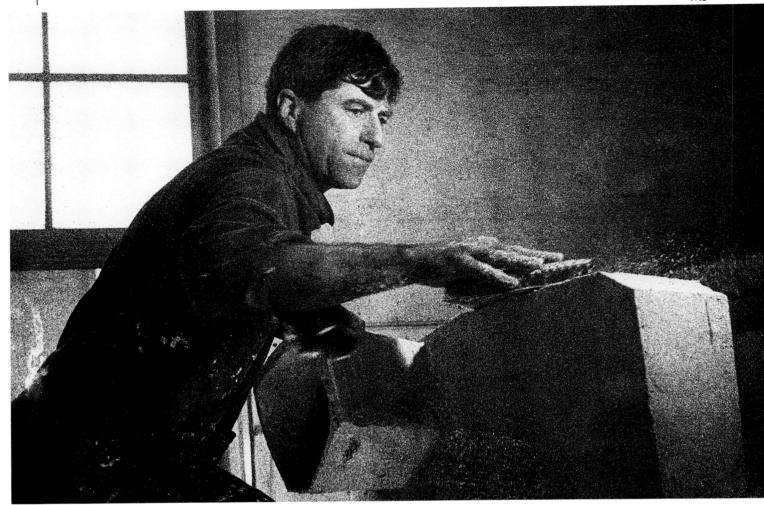

IF, AS HERBERT READ asserted, most modern sculptors constantly search for a personal '"icon" – a plastic symbol of the artist's inner sense of ... mystery', then the ancient Yugoslavian legend of Skadar was Kenneth Armitage's 'icon'. To ward off the evil spirits, a chief's wife was walled in alive, but with her breasts exposed so she could feed her newly born child. For Armitage the legend embodied his abhorrence of oppression and injustice – a despairing cry for freedom.

His studio, a stone's throw from the halls of Olympia, was full of models, large and small, mainly in plaster, of rough 'walls' with arms and breasts protruding, symbols of the immured human spirit. Another theme was the treacherous Pandarus. Wide openings in the textured walls of his bronzes seem to shout in outrage. These mysterious and threatening shapes, both finished and in progress, co-existed with cranes, chains and various sculptor's instruments. The sculptor himself, tall, dark, full of contained energy, was always on the move – either working on one of the sculptures, or expounding his ideas with words and gestures.

When I first photographed Kenneth (in 1962) he was in the vanguard of a group of remarkable young British 'expressionistic' sculptors (Reg Butler, Lynn Chadwick and Hubert Dalwood among them). The subsequent rise in popularity of abstraction and minimalist sculpture temporarily eclipsed this group of largely figurative sculptors, but fortunately not for long.

Kenneth Armitage

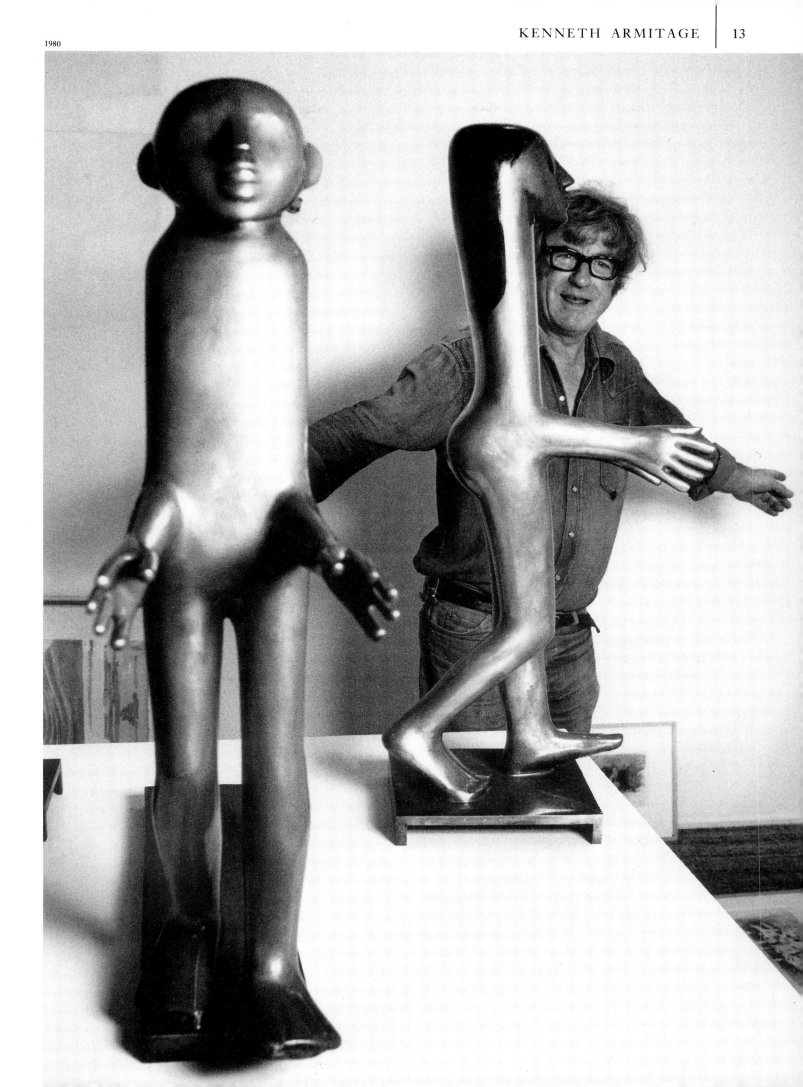

OF ALL THE ARTISTS I have met, Auerbach comes nearest to the romantic image of the poor artist, suffering for his art in a windy garret. Even though his studio is in a basement, one gets this impression, at least at first.

A narrow, dark alleyway with an unmarked, slightly peeling door. No bell to be found. I knock, and after a while (I can sense the reluctance) the artist opens it. Not too wide, mind you, just enough to let me squeeze through with my cameras. A short, unlit passage leads into as individual a studio-cum-living-room as I have ever seen. The room is huge – some thirty by forty feet – lit only by two small, rather dirty windows. Far on the right I noticed a bed, wardrobes, a chair or two and a curtain partly concealing a sink, a cooker and a few shelves with cups and dishes.

The rest of the room is all painting – and this is precisely what I mean: one continuous, vast painting. Benches, easels, walls, the artist himself in his paint-spattered overalls and heavy boots, are part of this painting, which naturally includes the floor as well. One must step carefully so as not to trip over the large and small mounds of partly dried multi-coloured oil paint. The floor has become a repository, thickening over the years, of all his unsuccessful paintings ruthlessly scraped down. The whole room/canvas is in dark colours, brown predominating, but with patches of black, olive green and deep purple, a kind of sombre uneven mosaic of drips and splashes.

Into this environment Auerbach's paintings, finished and unfinished, on easels and benches and drying on top of the wardrobes, fit perfectly. Brooding building sites. Ungainly, powerful portrait heads. Some figure studies. All in deep slashes of oil paint, in places an inch thick. Some seem at first sight entirely abstract until you change perspective and they spring to life as a head, a woman's body or a city-scape.

Yet the first impressions of a lonely, struggling artist are misleading. Auerbach is no longer a garret creature. The Marlborough Gallery has a list of clients patiently waiting for his paintings, and the artist himself is far from reclusive or boorish. He is gentle, courteous, easy to talk to, apparently at peace with himself. He is part of a group of close friends which includes Francis Bacon. Presumably he also leads a second, separate life in a rather different environment.

When working, Auerbach becomes the totally single-minded and dedicated painter. And it is because of this absorption in his art that he chooses to live at one with his art, assimilated to it. His paintings become inseparable from him, and he almost a figure in them.

Frank Auerbach

1963

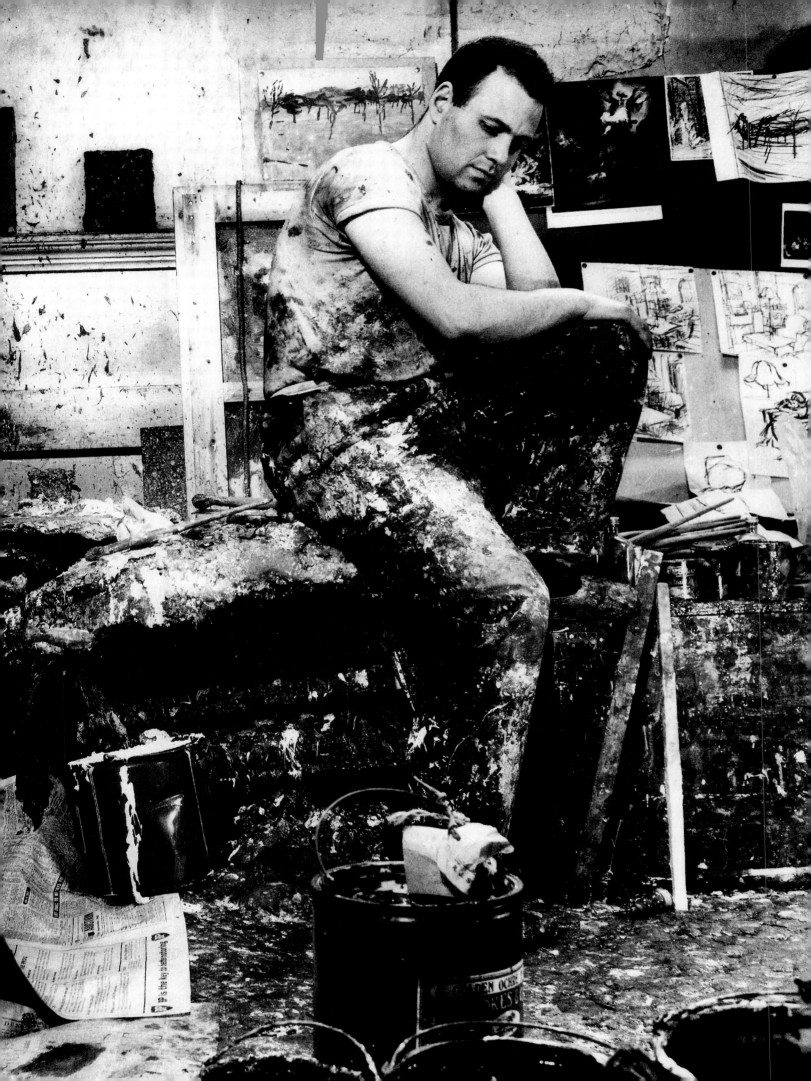

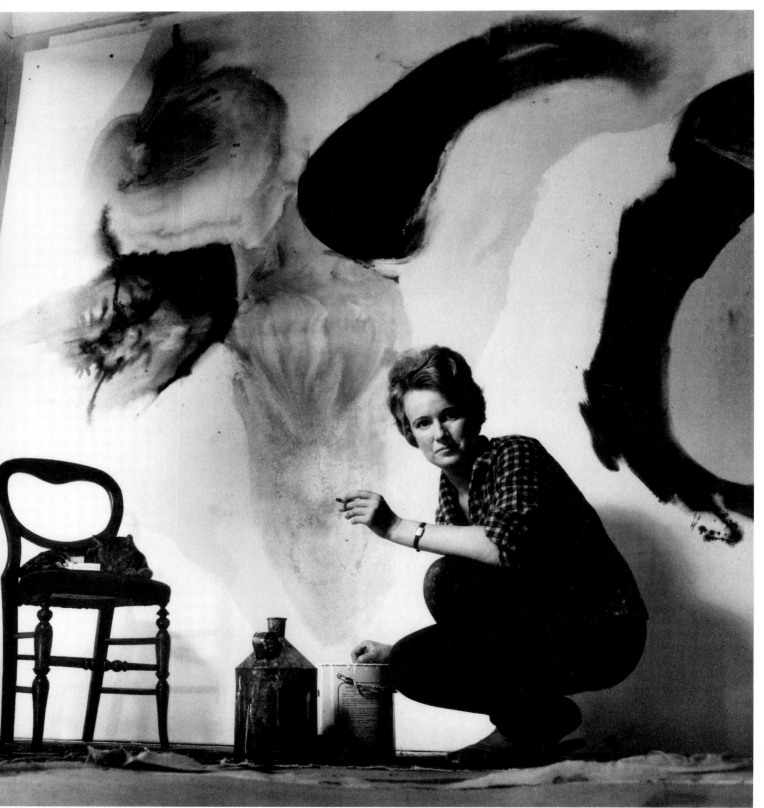

1963

Gillian Ayres [signature]

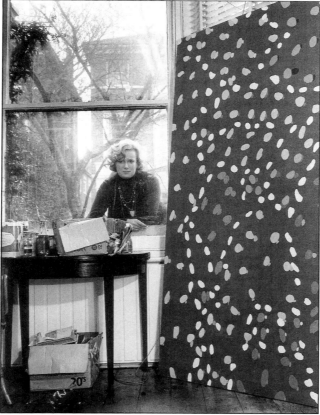

1968

GILLIAN AYRES is now considered by many critics to be among the best British abstract painters. Her rise to prominence has been gradual, a journey not without reversals. Although faithful to her abstract idiom from the start of her career as one of the brilliant discoveries of Victor Musgrave at Gallery One, she has varied her technique and her abstract configuration quite considerably.

I photographed Gillian for the first time in her suburban house in Barnes in 1962. The first-floor room overflowed with a chaos of canvases and pots of paint. Her patches of delicate, almost pastel, colours were defined and distinct, like multi-coloured clouds fleeing across a sky. Then the shapes shrank to tiny, regular blobs, dancing on the surface of a single deep tone. But soon afterwards she returned to her earlier freedom of generous unrestrained strokes and now, in her latest phase, she has changed from acrylic paint to oils with the subsequent considerable thickening of the paint, acquiring an almost three-dimensional texture. The patches of strong colours overlap and flow into each other, with dazzling reds and blues predominating. As she once wrote, 'Through colour can be created a vision of human scale and a sense of experience of space – an art which is finally unrestrained'.

Gillian now lives and works in a tiny village deep in a remote Welsh peninsula. A large, wild garden climbs steeply behind her cottage and a flock of chickens scratches the ground in front of it. Her house is like her work and like herself, warm, friendly, hospitable, slightly dishevelled and unrestrained.

MICHAEL AYRTON was a Renaissance artist, who almost certainly regarded himself as the logical successor to Michelangelo. Superb draughtsman, sought-after theatre and opera designer, accomplished painter, sculptor extraordinary, and also an exceptionally gifted writer, it is not surprising that Ayrton chose for his art large themes to challenge his genius. Many of his sculptures depicted giants of Greek mythology: Icarus, Minotaur, Pythias, Nautilus and giant Mazemaker were his familiars. His huge studio in Bradfields, Essex, was inhabited by their superhuman forms, mostly in plaster, their muscles bulging and their heads aggressively thrust forward. Michael's small sculptures, before being cast in bronze, were often made from wax heated on a small stove. It was fascinating to watch his skill in fashioning hot, flowing wax into beautiful, extra-terrestial beings.

Unfortunately Ayrton's most creative period in the 1960s and 1970s coincided with the Western obsession with abstraction. Critics ignored his exhibitions or dismissed them contemptuously. I not only photographed Ayrton on several occasions, but also most of his work. I used to meet him quite often. He was not a happy man in spite of his prodigious gifts. The neglect of the critics and of the majority of the intellectual public troubled him, but he believed in his destiny, and so did a sizeable group of rich collectors (mainly American). Perhaps the collectors were right and in time Ayrton will be recognized as the Michelangelo of the late twentieth century. I would not be surprised if this were so.

1964

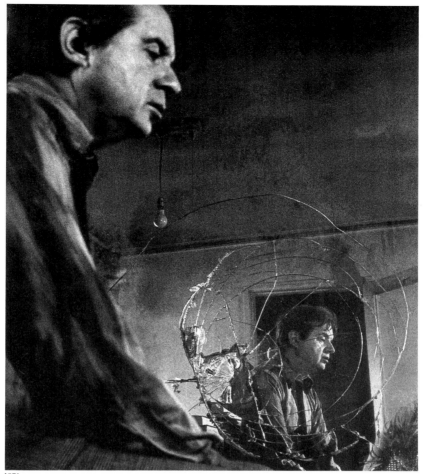

1971

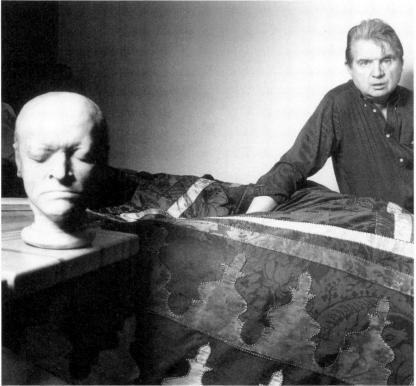

1980

THE PLAIN GREEN DOOR of a small mews house in South Kensington. It opens directly on to an extremely narrow, steep wooden staircase to the first floor. Two thick ropes serve as makeshift – and very necessary – bannisters. A clear electric bulb hanging from a wire above the stairs lights

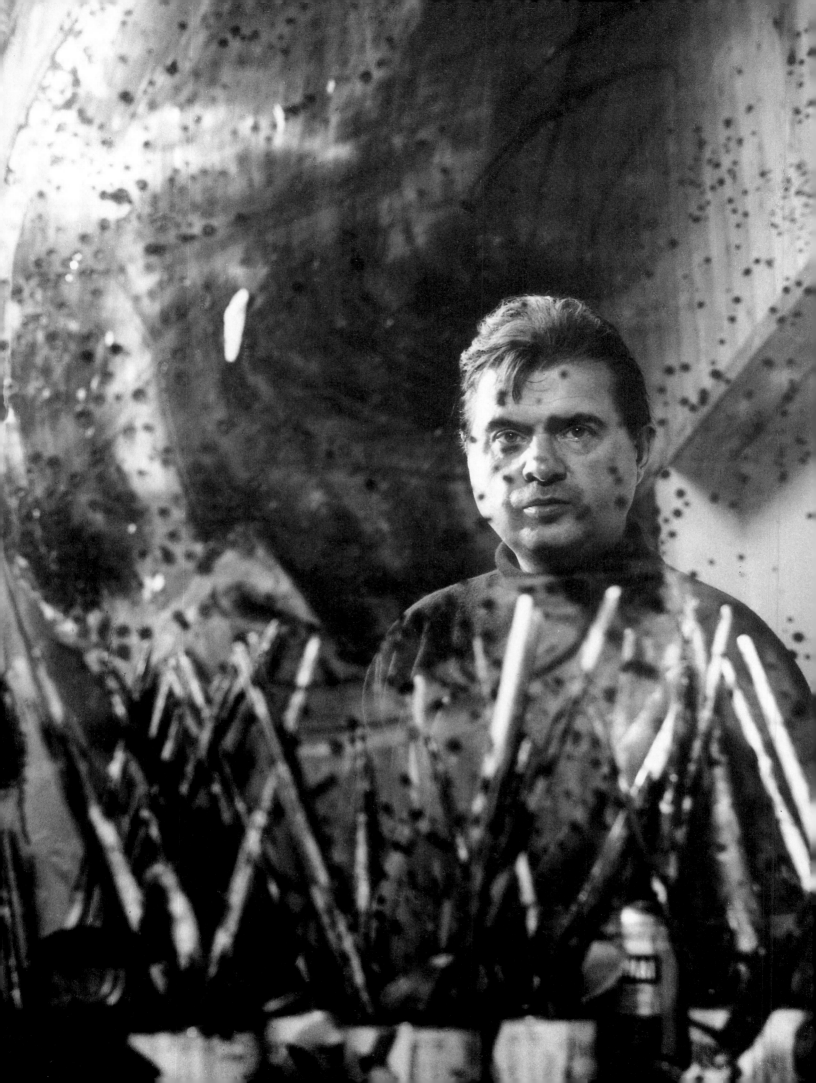

a small hall with a little kitchen almost opposite. On the left is a medium-sized sitting-room-cum-bedroom. A large cracked mirror ('Someone threw an ashtray at me and missed,' Bacon says), a pine table and at the far end a vast unmade bed, with a white bust of William Blake beside it. The only other room opens on the right of the precarious staircase. It is the studio of the finest contemporary British painter.

A few cut-outs from art books – Muybridge's 'Animal Locomotion' figures, Velasquez' *Pope Pius X* – adorn the walls, with random trial brush strokes in various colours. A circular mirror pock-marked with dots of dampness, a narrow table full of tins and brushes, two empty easels and several paintings propped against the wall, but all turned towards it, complete the inventory. With no paintings on view, the most arresting part of the studio is the floor. At least half of it is covered to a depth of several inches in books, photographs, magazines and prints. Some torn, some left open

and obviously trodden upon. Bacon is said to be fascinated and inspired by images from various media – many of his famous paintings bear a direct relationship to such images.

Each time I photographed Bacon I found him civil and helpful, a charming and fascinating conversationalist. But on one point he was always insistent. He would never be photographed with his paintings or at work. Painting is a solitary and all-absorbing activity; any outside interference would destroy his concentration. Also, like a number of dedicated artists, he tends to be unpredictable – dates, appointments, time in general mean little to him. After my first session in 1964, his picture was published in the *Observer*. A few days later I phoned him and asked whether he would like a print or two. 'Oh, that's thoughtful of you,' he replied, 'I would like a copy. Come at five, I shall be here.' But he was not. I found out later that on an impulse he had decided to take a midday train to the Côte d'Azure and Monte Carlo.

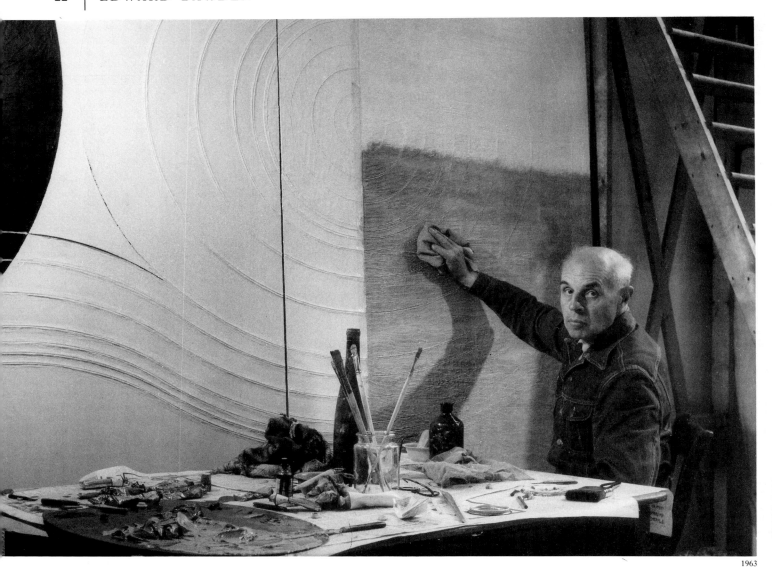

1963

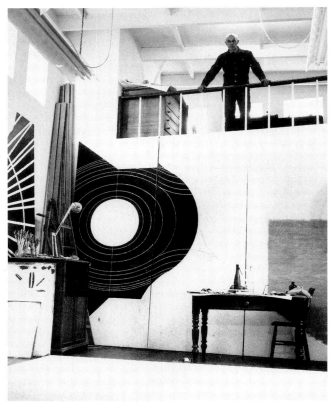

1963

I PHOTOGRAPHED Edward Bawden twice. First we met in his London studio in 1963. Fifteen years later his dealers, the Fine Art Society, commissioned a portrait to mark Bawden's seventy-fifth birthday exhibition. The contrast between the two occasions was striking. Bawden at sixty was at the height of his powers, working at the time on one of his huge murals, and his spacious, high studio was almost completely filled with it. The setting for the second session was, instead of a modern London studio, a charming cottage in Saffron Walden. His studio here, much reduced in size, was still filled with light but instead of a mural, the area in front of the window was filled with a multitude of potted plants, mainly chunky cactuses. But though he chose the Essex village as his retirement home, away from the noise of London, he was as far from retirement as on my first visit to him in London. Only the scale of his work was reduced. In 1978 he was concentrating on watercolours but still producing a number of his superb prints, and in the library adjoining the studio pride of place was reserved for a splendid antique printing press.

Edward Bawden.

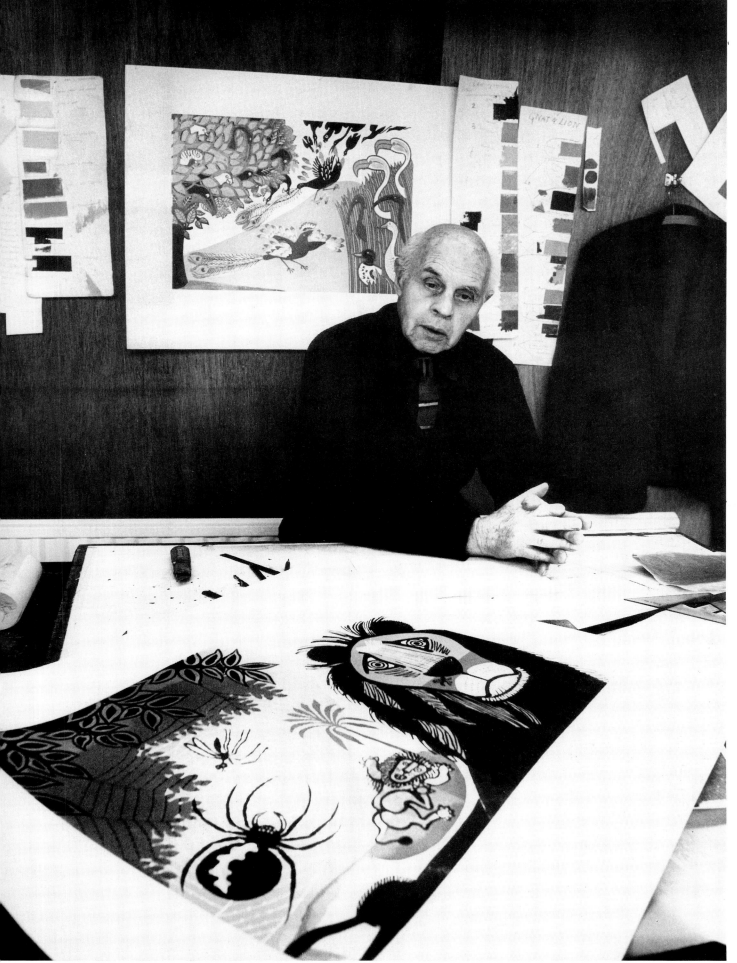

1978

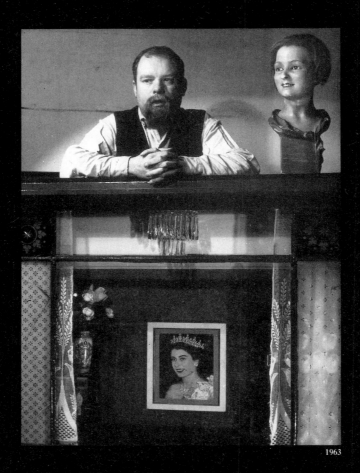

1963

Peter Blake

RICHARD HAMILTON may be the intellectual leader of British 'pop', but in my view Peter Blake is the spiritual heart of the movement, its most accomplished and acclaimed exponent.

Blake is stocky, bearded, a serious and even severe-looking man. His work, by contrast, displays an inner warmth and humour. His favourite subject-matter has always been circus and music-hall performers, children's toys, seaside souvenirs, royalty knick-knacks and other trifles which were invariably in evidence on shelves and window-sills, in the corners of all the studios in which I have visited him over the years.

First, it was an untidy low-ceilinged house in West London with 'Cherry Blossom' and B.P. hoardings to the rear. Later he moved with his then wife, American sculptress Jann Haworth, to a disused railway station near Bath. They converted it with extravagant taste and panache. A nearby chapel became his studio, with Chinese lamps, stairs leading nowhere and a multitude of Victorian statues, hairdresser's model heads and busts. After his marriage was dissolved, Blake moved back to London where he now lives and works in a charming house in Chiswick with narrow staircases and pink interiors. His newly converted studio, with huge windows overlooking the roofs of the nearby houses, still contains the knick-knacks and figurines, and the familiar statue of an Arab sheikh in the corner. The man himself has changed little, though the neat beard is now whiter. His work has possibly lost some of the exuberance and humour of his youthful years, but he remains an artist of brilliant skill and inventiveness.

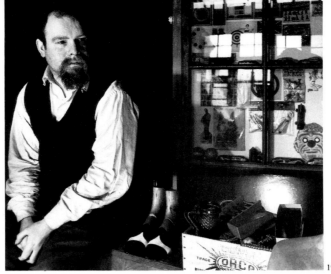

1962

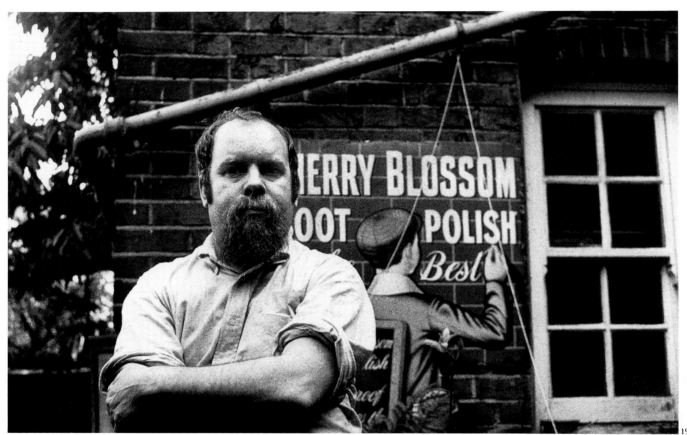

1969

1987

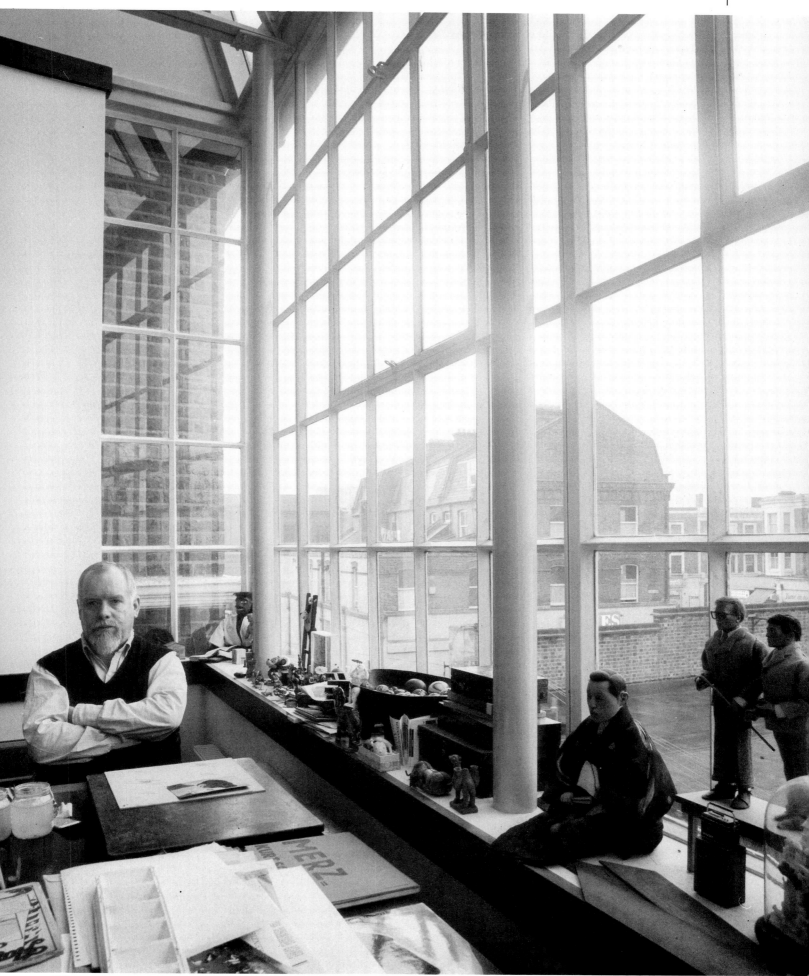

1987

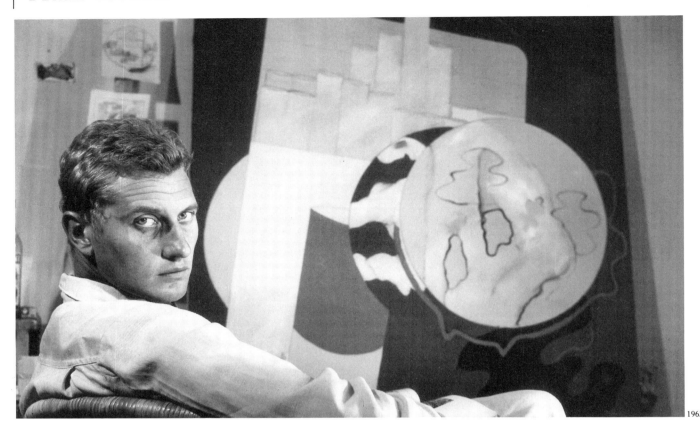

1963

1968

JACK-OF-ALL-TRADES? An unkind way to describe Derek, who is a fine and imaginative artist and a master of the various media which he has tackled. But I have photographed him six times in the space of sixteen years and on each occasion I have been shown a different kind of art.

First, in 1963, I went to a flat near Holland Park. A set of 'pop' paintings awaited me, mostly on the theme of cigarette packets. Their creator had recently starred as the Pre-

Raphaelite painter John Millais in two Ken Russell films, *Pop goes the easel* and *Dante's Inferno*.

In 1968, in a different studio, he was using with equal confidence sheets of coloured transparent plastic, creating three-dimensional structures and experimenting with the representation of space. Then, in 1970, it was the Hayward Gallery for a change: he was showing several huge, striking sculptures made of black, shining plastic. A few years on

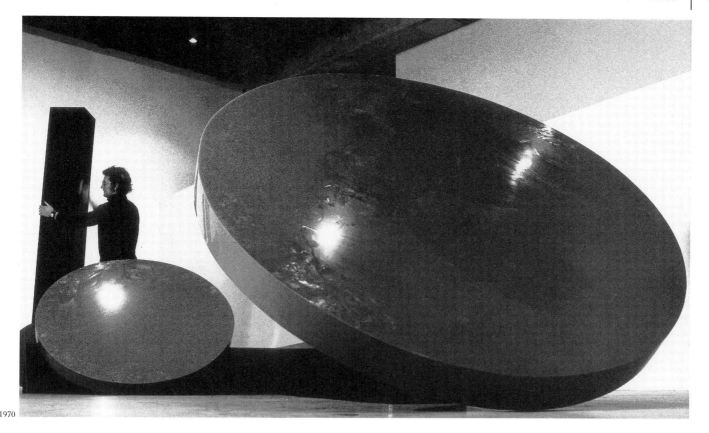

1970

1973

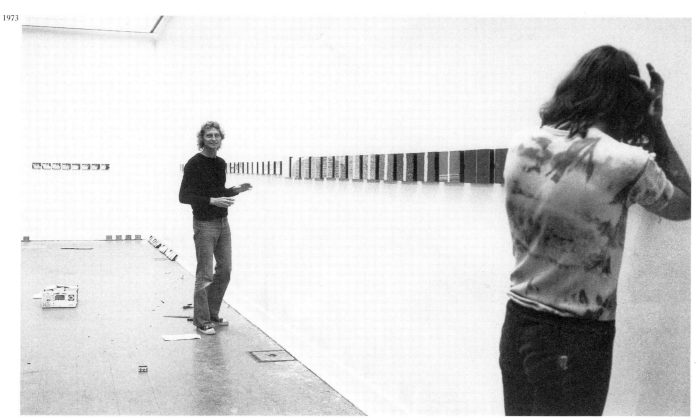

and I was surprised to be confronted at the Whitechapel Gallery with long rows of black and white photographs, neatly framed close-up sequences of objects and motion. A few years later, at Angela Flowers Gallery, he was back to 'pop' ideas and idioms, with small collages/constructions incorporating photographs, cut-outs, drawings and real objects. Then, in 1979, in another gallery, I found him with small collages but this time with a pronounced tendency towards conceptualism, with messages and words incorporated into the compositions.

I hear that (like Hockney) Derek has been unable to resist the call of America. And in the meantime he has been painting 'pop' portraits of wealthy American ladies. What's next?

Derek Boshier

ARTISTIC ACTIVITY is characteristically a solitary, introspective occupation. Some artists resent the presence of another person in their studio. Among the 300 or so artists that I have been privileged to photograph, I found only three joint artistic enterprises, the Boyle family, Gilbert and George and Fionnuala Boyd and Leslie Evans, who extended the husband and wife team a step further. From 1968 on they have painted and signed their paintings together. Even if they do happen to work on a painting separately, they never divulge who did what. Since they work from their own photographs (and at times exhibit fine cibachrome prints) and mainly use spray-guns, there are no brushstrokes to give the game away.

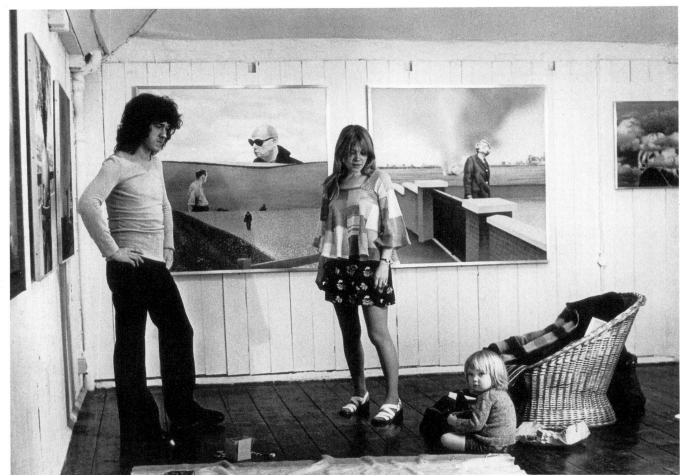

1972 (opposite: 1977)

I photographed them first at the Angela Flowers Gallery in 1972. Their first baby accompanied them in a smart carry-cot to the opening. Later I went to their house in the small Leicestershire village of Plungar. The first room I entered was a modern-looking design studio with a dark-room adjoining it. But it was the sitting-room-cum-studio which caught my eye. A large window, almost as wide as the room, opened on a green landscape with some trees. Its top half was covered with one of their large photographic paintings: I experienced a momentary sense of disorientation, the painting merging with the natural world outside.

They could not keep their cottage, which in any case was too far from London. Now they live and work in Milton Keynes.

Boyd & Evans

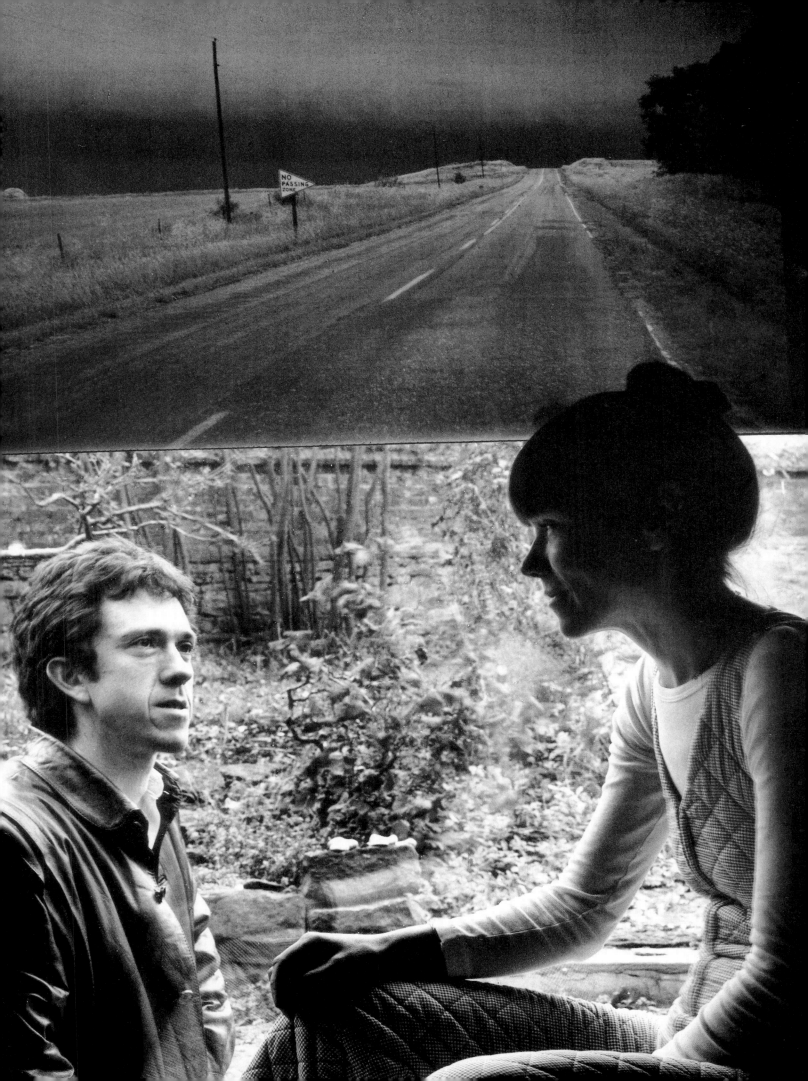

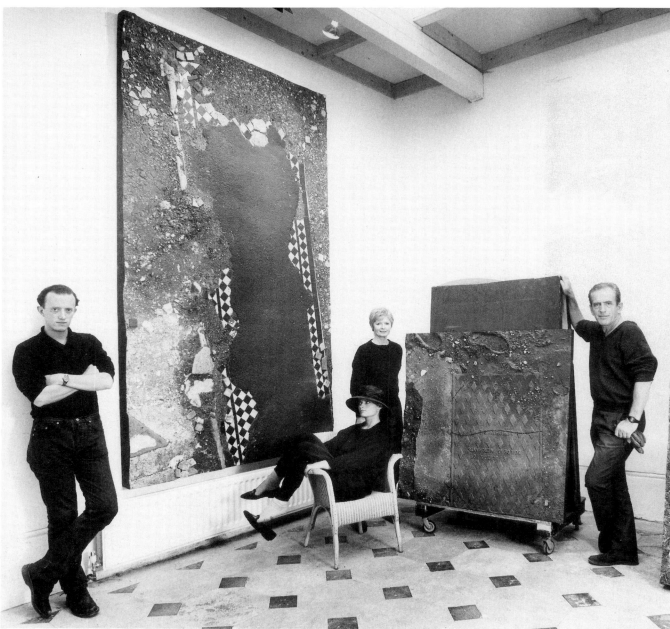

1987

THE BOYLE FAMILY works together as a unit: Mark, his wife Joan Hills, and their two children, now grown up – Sebastian and Georgia. They say they've always worked together, even when the children were quite small, but galleries disliked the idea of a family as an artist. Now they are sufficiently established to do as they please, so the collaborative origin of their pieces is acknowledged.

In the past Mark and Joan were chiefly engaged in experiments and presentations of light-environments. Now their main preoccupation is creating replicas of reality, often merely a piece of ground, a geographical site, usually two metres by two metres or larger. They invariably present the viewer with a microscopic copy of a sizeable chunk of the surface of the earth, down to the smallest detail: grains of sand, tiny pebbles or a piece of human debris, like a Coca Cola can or a button. The Boyles work with various light plastic materials and their method is a family secret. No outsider has photographed them at work. In the last few years they have acquired a huge house on the slope of a hill in Greenwich and at last can work and display their works without hindrance.

One of their major projects was a 'Journey to the Surface of the Earth'. Some of their friends at a party were blindfolded, then asked to throw darts at a large map of the world. Subsequently the Boyles journeyed to the spots where the darts landed – in India, South America, Australia and Great Britain. Later they recreated, as only they know how, a fragment of the area from each of these randomly selected sites. It is necessary to see their creations at close range to appreciate the incredible accuracy of representation.

Sebastian Boyle

Joan Hills

Mark Boyle

Georgia Boyle

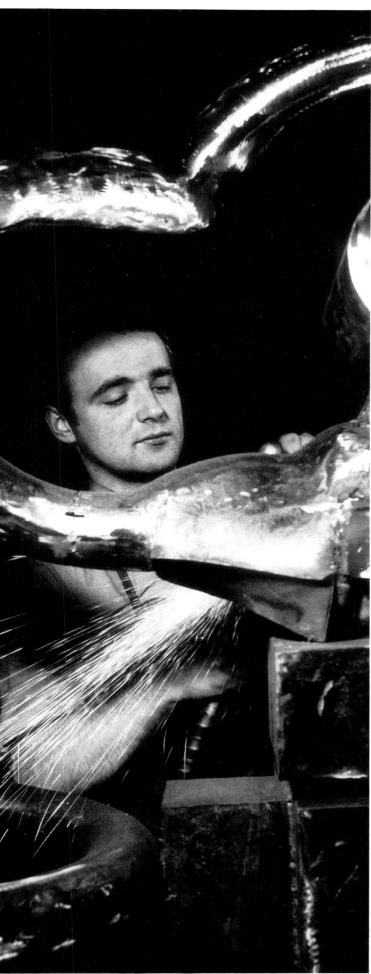

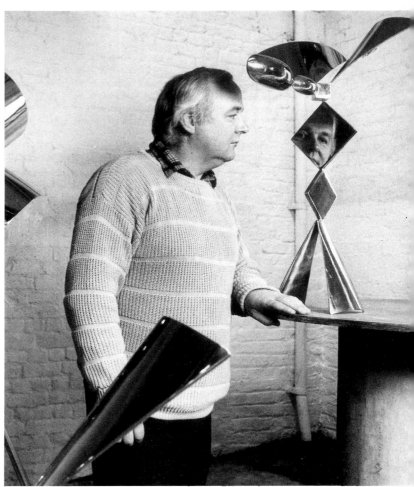

I PHOTOGRAPHED Tony Brazdys for the first time at the Royal College of Art, School of Sculpture, in 1963. He was then a second-year student though he had studied for several years in the United States. He was in his early twenties, still slim, enthusiastic and eager to make his mark as soon as possible. He had already selected his favourite material for sculpture, adopted his basic abstract idiom and preferred finish. His work was, and still is, mainly abstract and his constructions are made from tubular stainless steel polished to a high reflective finish. Bill Pye (also a student at the R.C.A.) used similar material and finish for a long time, and it is a matter of dispute between them who did what first.

Brazdys' chosen medium had a disadvantage: it was expensive and extremely time-consuming. He had problems with funds, sponsors and galleries. Thus he tried to work for specific commissions rather than exhibit his sculptures in galleries, though he held several individual shows, and the commissions were not always numerous. As a result he used to teach a great deal.

He somehow survived and recently acquired his own fairly large studio, devoting more than a year to rebuilding it in order to have an adequate working space and, above his working floor, an independent exhibition area. In the last few years he has completed several large commissions including his thirty-feet-high *Solo Flight* for Harlow New Town.

1963 1987

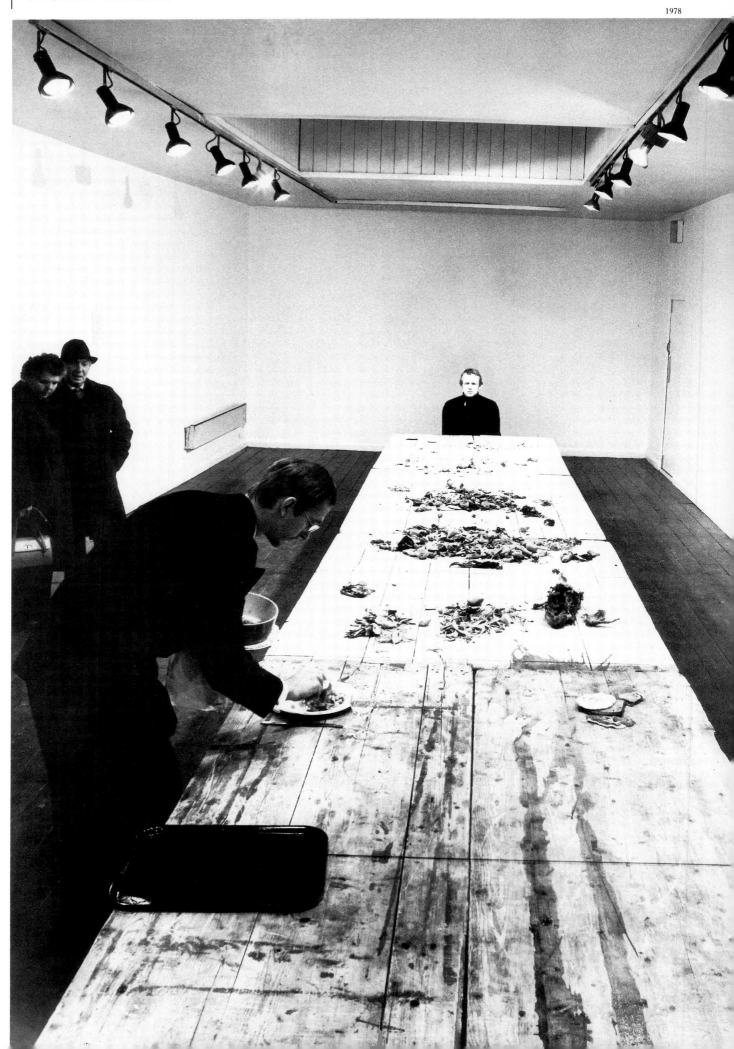

Stuart Brisley .

UNTIL QUITE RECENTLY Stuart Brisley's work was uncollectable – existing only during the act of performance, with the artist the medium. This in itself is unremarkable: there is any number of so-called 'performance artists'. But Brisley not only 'performed', he suffered for his art. Most of his 'performances' required great physical endurance; his act invariably involved pain, discomfort and hunger.

I met and photographed Stuart Brisley for the first time in 1978, when he was in residence for '10 Days' at the Acme Gallery, during the Christmas holidays. Every day he sat at a table in the middle of the gallery in total silence; three times a day a waiter served him a sumptuous three-course meal which he refused (but it was then offered to any visitor and Brisley watched impassively while it was consumed). The remains of each meal were left on the table to rot during the remaining days of the fast. This was Brisley illustrating the waste of food and resources in our society. Another more exacting and painful performance, also on the theme of wasted resources, was called 'Survival in Alien Circumstances'. It was staged a year earlier at the Kassel Documenta 6 show. Brisley dug a large hole in the ground and lived in it for a fortnight.

In later years Brisley has devised a number of different performances, but now that he is over fifty, he has decided to call it a day and has stopped punishing his body. He still maintains his polemic through the construction of politically motivated exhibits and sculptures. His *1 = 66,666*, for example, illustrates the evil of unemployment and redundancy – 'a record of failure without parallel, without reason'. This was one of a number of constructions in his exhibition at the Serpentine Gallery, 1987.

1980

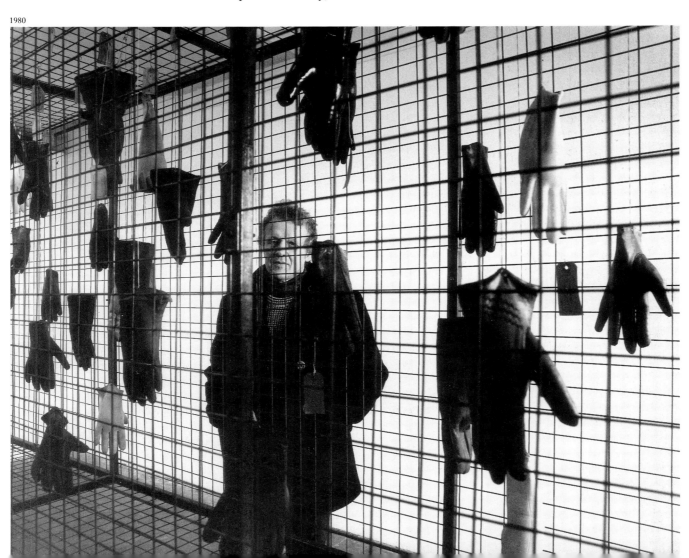

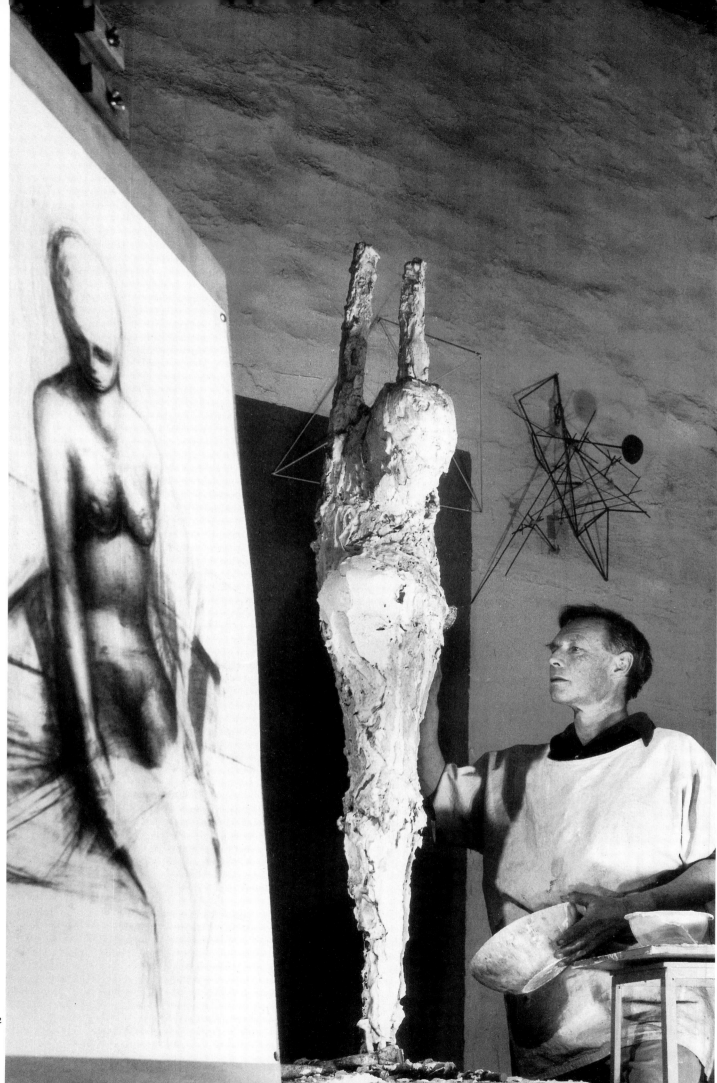

1962

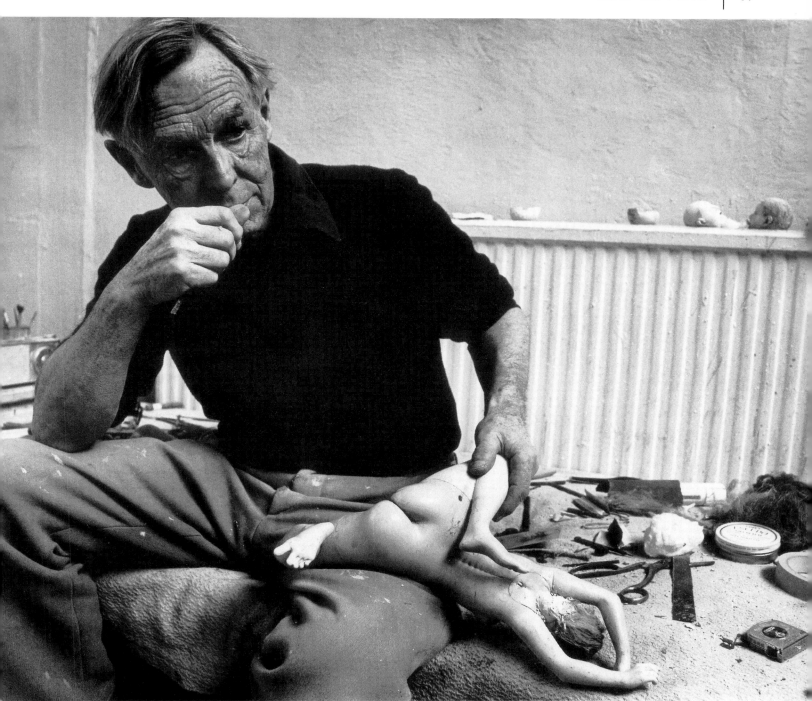

1977

REG BUTLER'S career as a sculptor falls into two major periods. I was fortunate enough to photograph him in both.

Butler took up sculpture rather late – at thirty-six (after a spell as an architect) – and almost immediately won an international competition for a Monument to an Unknown Soldier in 1951. (An irate Hungarian damaged the maquette exhibited at the Tate Gallery, which made Butler almost a household name.) Thus began the first and, in my view, the more interesting creative phase in his career, running parallel with the development of other exciting young British sculptors, also 'welders' of iron, like Chadwick and Robert Adams. The group was greeted as a new school of British expressionistic sculpture.

Butler's second phase began late in the 1960s. He abandoned the rough texture and semi-abstraction of welded iron and turned instead to realistic and erotically posed figures of nude women, with a smooth finish, real hair and life-like glass eyes. These pieces soon found favour with collectors, especially in America, but they were largely ignored or derided by the critics.

Reg Butler lived and worked in a large modernized house in Berkhamsted, for many years commuting to the Slade School of Art, where he was Professor of Sculpture. On my first visit to Berkhamsted in 1962, he presented me to two charming ladies, introducing both of them as his wives.

Butler was an exceptionally erudite and urbane man, hospitable and helpful, and his studio a model of order and purpose. On my second visit, in 1977, I found the man and his studio subtly altered. Butler had withdrawn from the public art scene and seldom exhibited. His studio was now full of machines, pulleys, cameras and gadgets. His early exuberance and creative urge seemed somehow to have been replaced by intellectualized representations, catalysed by machines rather than by an intuitive hand. He seemed older, more subdued. He died four years later.

Butler '79.

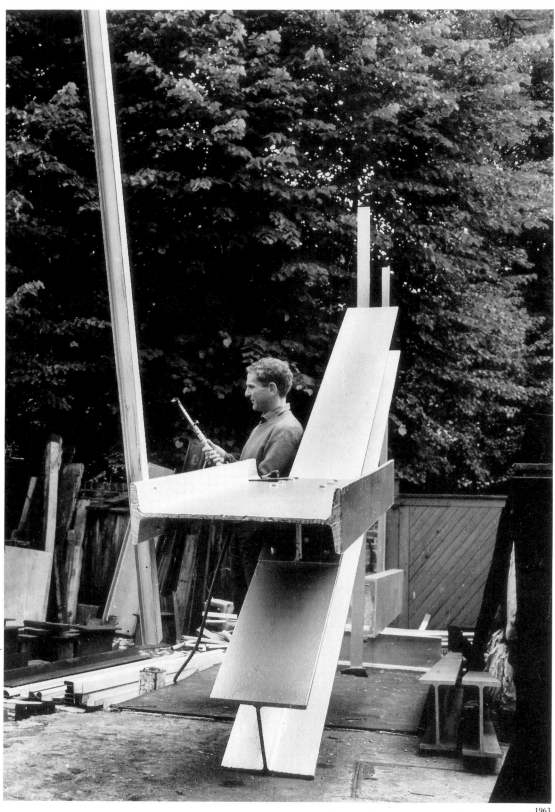

1963

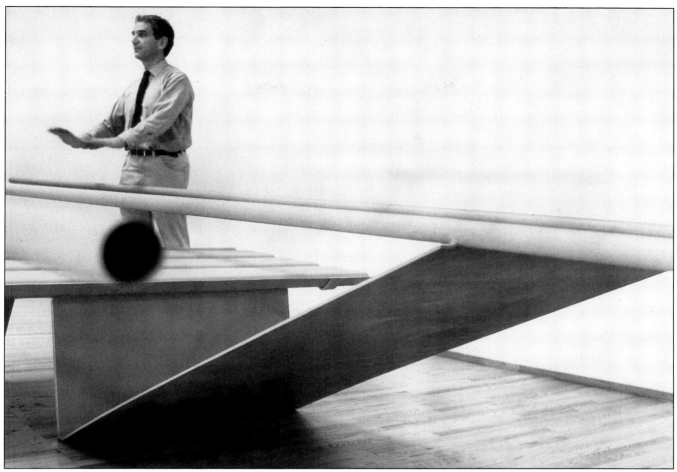

1967

1972

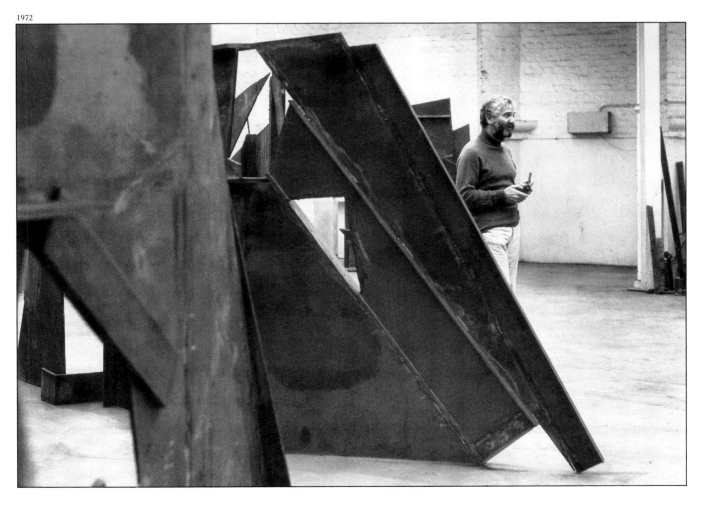

1983 *(opposite: 1965)*

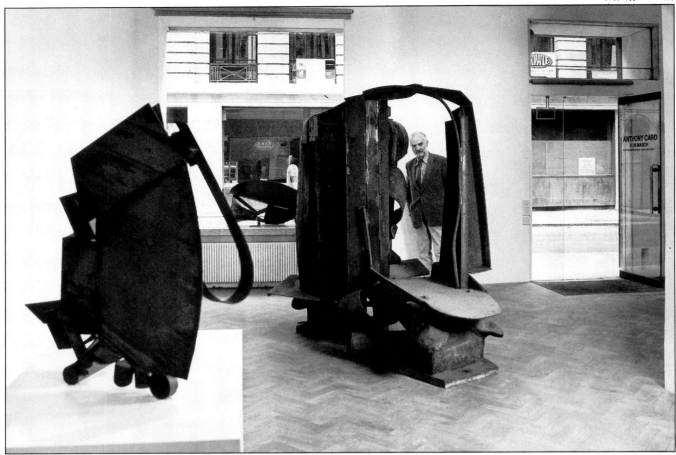

WHEN I FIRST MET and photographed Anthony Caro his decisive break with figurative sculpture, which he had pursued in the 1950s, had already taken place. It was also after his first visit to the United States in 1959, a visit which transformed his work. In 1963 when I went to his Hampstead studio, the rough lumps of distorted human figures were gone, the floor and the garden in front of the studio were littered instead with straight steel girders which Caro would weld together to create his sprawling, spider-like, mainly floor-bound structures. In this period the pieces were painted in flat bright colours, influenced by the American sculptor David Smith, and also by the American hard-edge painters. He had already been teaching at St Martin's School of Art for some years, where he led almost single-handed a revolution in modern British sculpture.

Despite the impersonality of Caro's work, he is himself a sensitive, sophisticated and gentle man. He works with classical music in the background – Mozart especially – and insists that his sculpture has a close affinity with music: 'the expression of feeling in terms of the material'.

On later visits, from the early 1970s onwards, I found Caro beginning to abandon painted sculpture. Now he works mainly with pre-rusted steel and his sculptures no longer depend on straight lines and sharp angles. Having learned from modern American art, he in turn influences a generation of American artists, teaching summer seminars and short courses in New England.

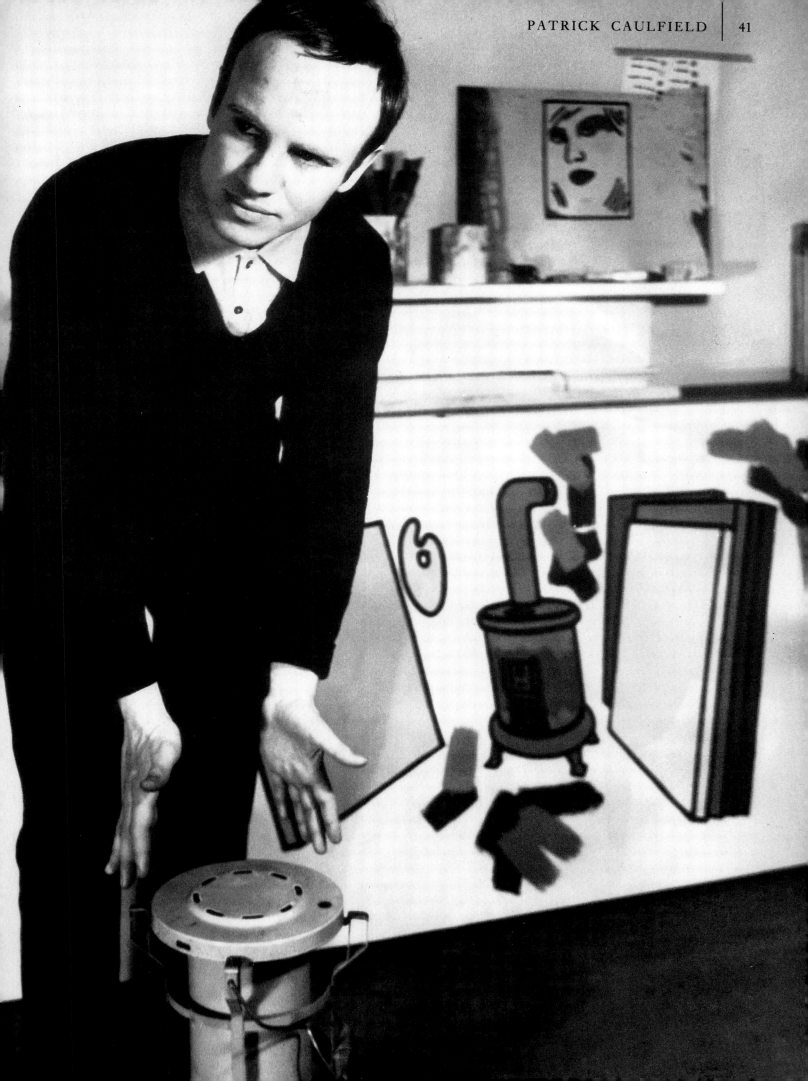

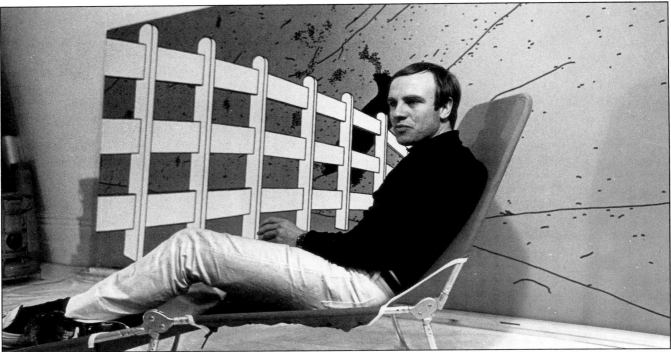

1968

PATRICK CAULFIELD enjoys working in seclusion, totally undisturbed. Each time I have photographed Patrick, we have met in a rented studio away from his home and family. This studio retreat or hiding-place he always transforms into a lived-in space full of personal objects and bric-à-brac. One studio, near Shepherd's Bush, was rather like a white temple with rows of soldiers in precise ranks prepared for a 'war game' – a favourite hobby of his. All the objects were neatly arranged. The floor was painted in brilliant white. I had brought a couple of my students along for the session and we had to take off our shoes, to the distress of the one with a large hole in his sock.

Patrick's present studio is even more removed, in the centre of Soho beside a Casino, on the fourth floor (with no lift). You climb to it by way of a metal staircase outside.

No telephone, of course. A large window frames a pattern of London roofs and chimneys, which reminded Patrick of the San Francisco skyline described by Dashiell Hammett, so he promptly decorated it with Sam Spade's name in reverse. There are other personal touches in odd corners of his little retreat: 'My Braque corner' – a couple of Cubist collages of a guitar, a sign of his favourite restaurant and some personal snapshots in front of a mirror.

Despite these personal touches and symbols, the over-riding feeling is of detachment, as if Patrick Caulfield the artist stood at a slight remove. This is in keeping with his work: cool, straightforward description of everyday objects or scenes painted in flat house-paint without nuances or details, observed with a touch of irony and dry humour – mocking, not condemning.

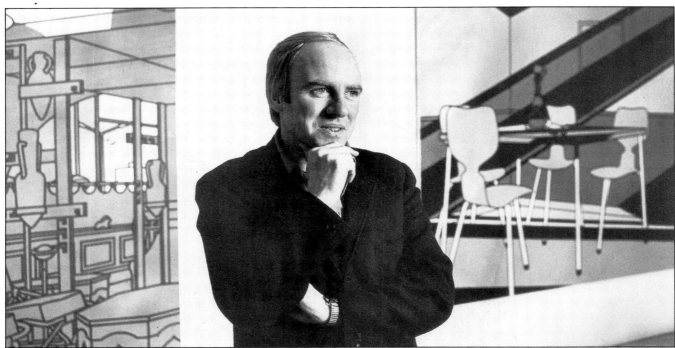

1975 (opposite: 1987)

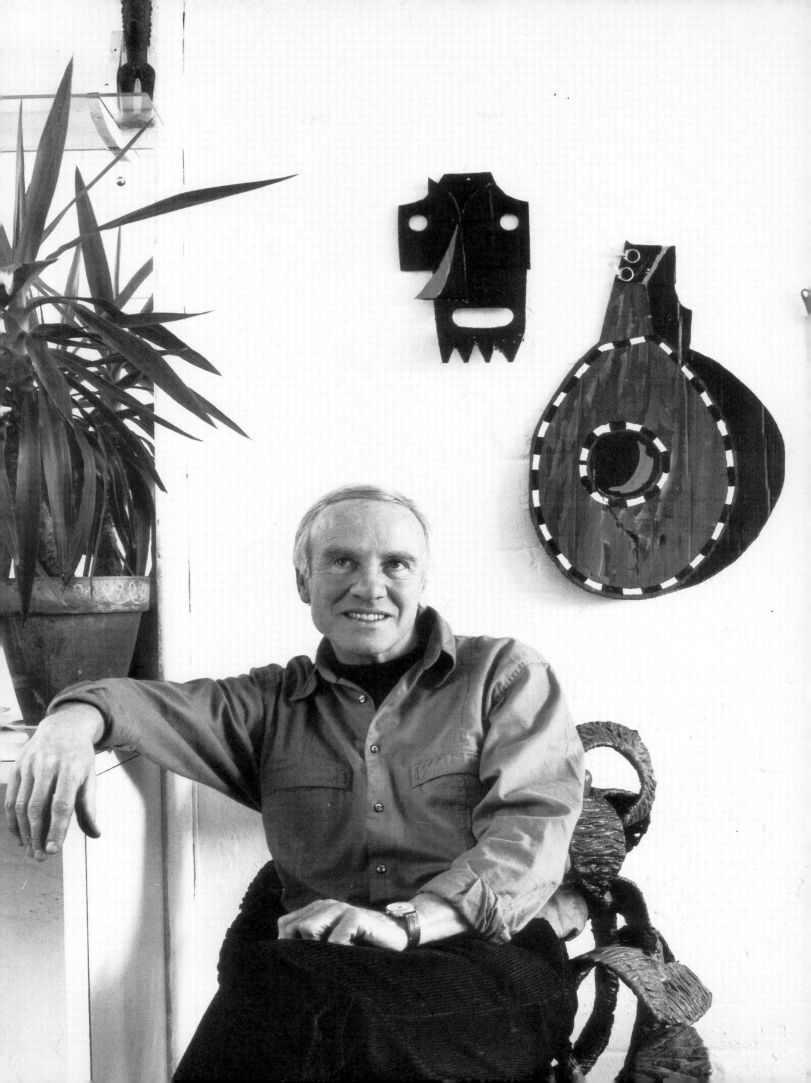

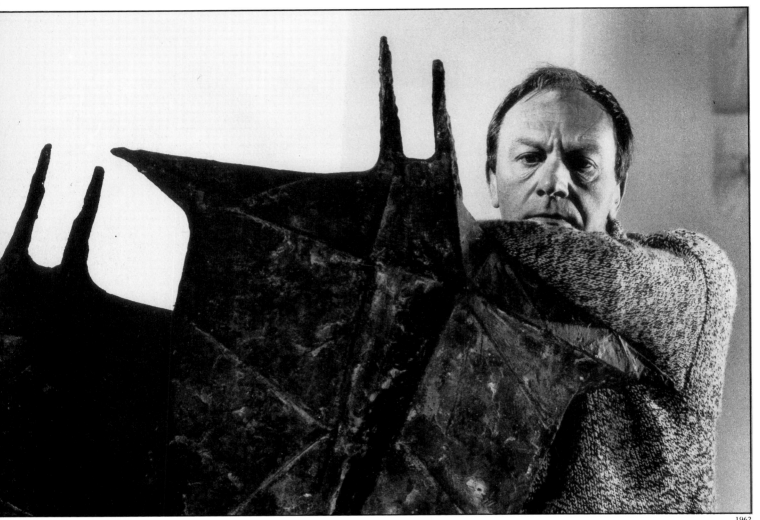

1962

THOUGH PATRICK HERON'S house, Eagle's Nest, commands the most spectacular setting of any British artist's home, none rivals the splendour of the interiors of Lynn Chadwick's neo-Gothic castle. It is set a few miles from Stroud in a beautiful valley in the Cotswolds. Chadwick spent a small fortune on restoring and decorating it. The high interiors, painted gleaming white with jet black fireplaces, beams and window-frames are magnificent, but it is the bathroom which is most often admired: a huge room with a bath the size of a small swimming-pool set into the floor, with marble interior and superb fittings.

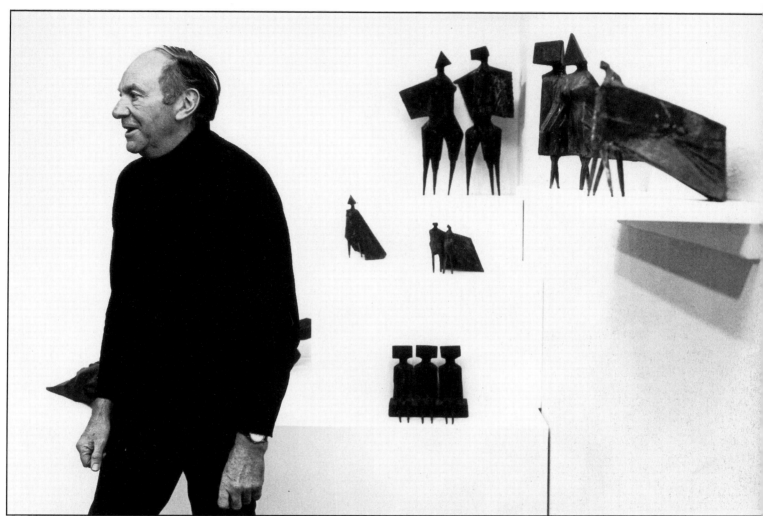

1978

When I visited Chadwick for the first time in 1963, he was considered the leader of a group of British sculptors (with Butler and Armitage among others) working mostly in welded iron and metal armature. Chadwick's aggressive black animals, birds of prey and strange insects stood out against the white, high walls of his castle.

Some serious personal problems interrupted his progress. He did not exhibit in Britain for a number of years. His more recent (1978) exhibition shows a return to old ideas and preoccupations and a loss of some of the vitality and exuberance which marked his early work.

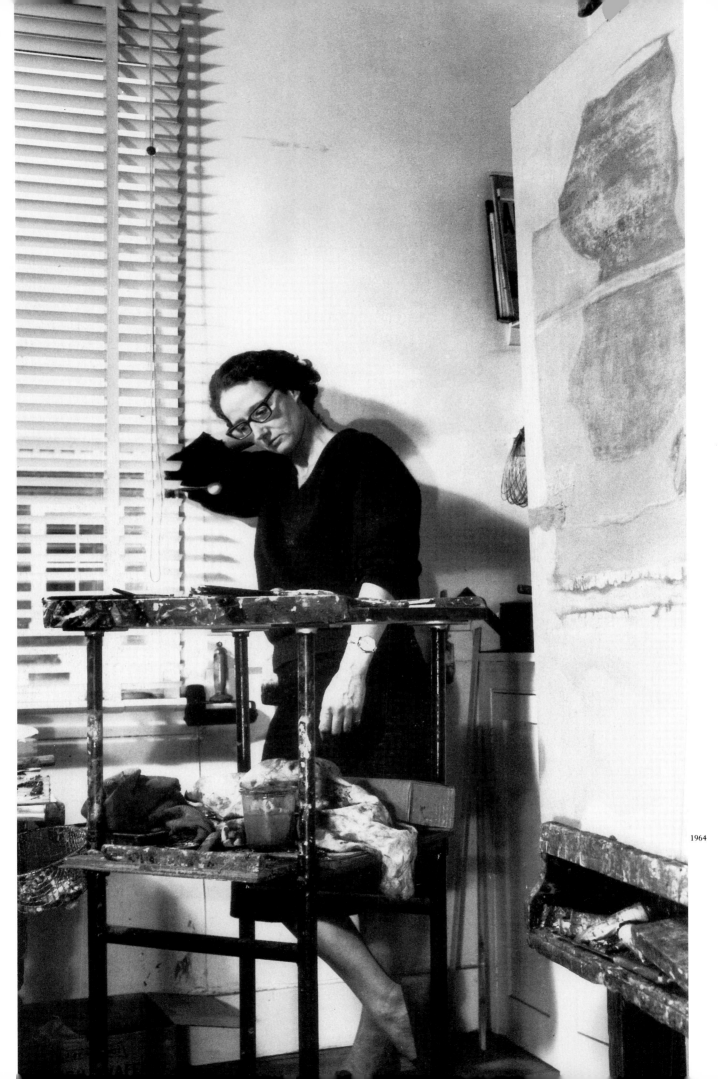

1964

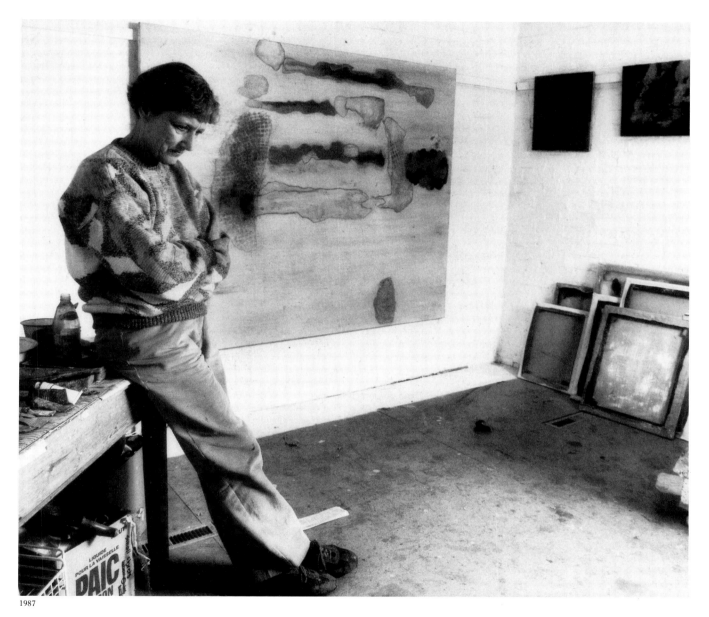

1987

PRUNELLA CLOUGH is a painters' painter. Most of the artists I have contacted recently asked whether I was including Prunella in my book. They all thought her one of the finest British abstract painters, though an artist one rarely hears about.

Prunella is a very private person. She does not try to catch the attention of the public art world. Even if she did, they would not make the slightest effort to promote her kind of painting. It lacks the requisite bold, brand-new and slightly uncouth quality that makes news. The nuances and subtle harmonies of Prunella's abstracts are not for them.

She has also been out of circulation because of problems with her eyes, which stopped her working for the best part of two years. Fortunately this problem is solved. So too is the bother of having to use a studio away from her home. I met her first at her flat in Fulham where she also had a studio. But it was small and unsuitable for reasonably large canvases, so she had to rent a larger space on the outskirts of London. Recently she has been able to buy a house with a kind of a barn (possibly originally a stable for the public house next door) which she has converted into a spacious studio.

BERNARD COHEN is among the leading British artists who have grown disillusioned with the way art is treated in this country by the general public and – especially – by the art establishment. He has withdrawn almost entirely from the public arena and has not exhibited for a long time. His reluctance to show his work in this country has nothing to do with the progress of his own paintings – on my recent visit to his studio I found a series of new and very beautiful works – but with the state of art patronage and the quality of art criticism. He plans to show his recent work in New York where public, galleries and museums are, he feels, more visually aware and advanced.

Bernard leads a peaceful life in a small house near Kew Gardens and teaches full time at the Wimbledon College of Art. He is cheerful, good-humoured and easy-going, always a pleasure to visit. I have photographed him many times, but first at the Kasmin Gallery in 1963.

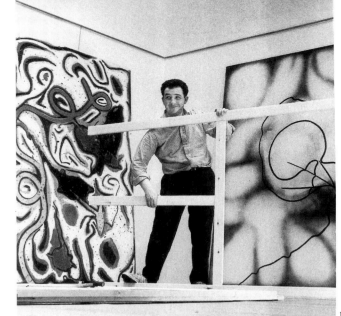

1963

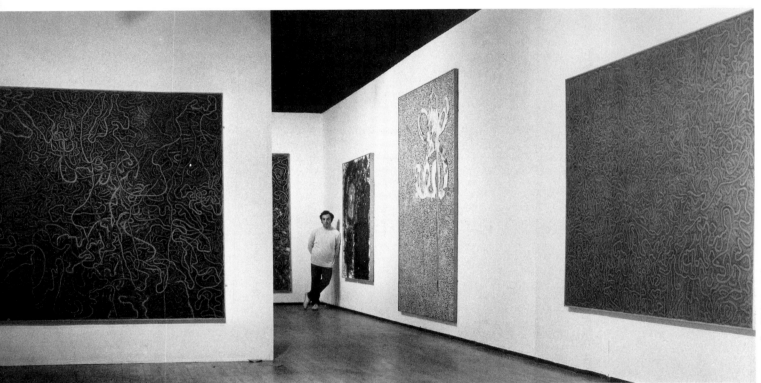

1972

1974

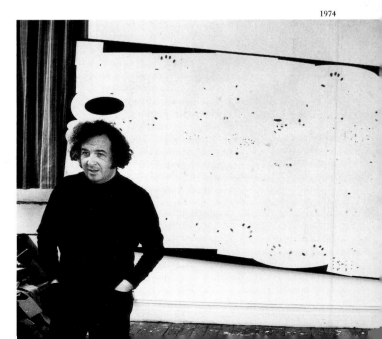

At a glance you get the impression that Bernard's style of abstract painting has changed considerably over the years. The early sinuous narrow bands of colour changed to wider overlapping stripes of paint, and then, for a time, became almost pure white with traces of subdued hues. Then strong vivid colours came back into his paintings: clearly defined and intricate patches within patches, suggesting joyful, riotous Eastern European national costumes. Within these variations, Bernard has pursued a strict and consistent exploration of the capacity of colours to integrate and interact.

1987

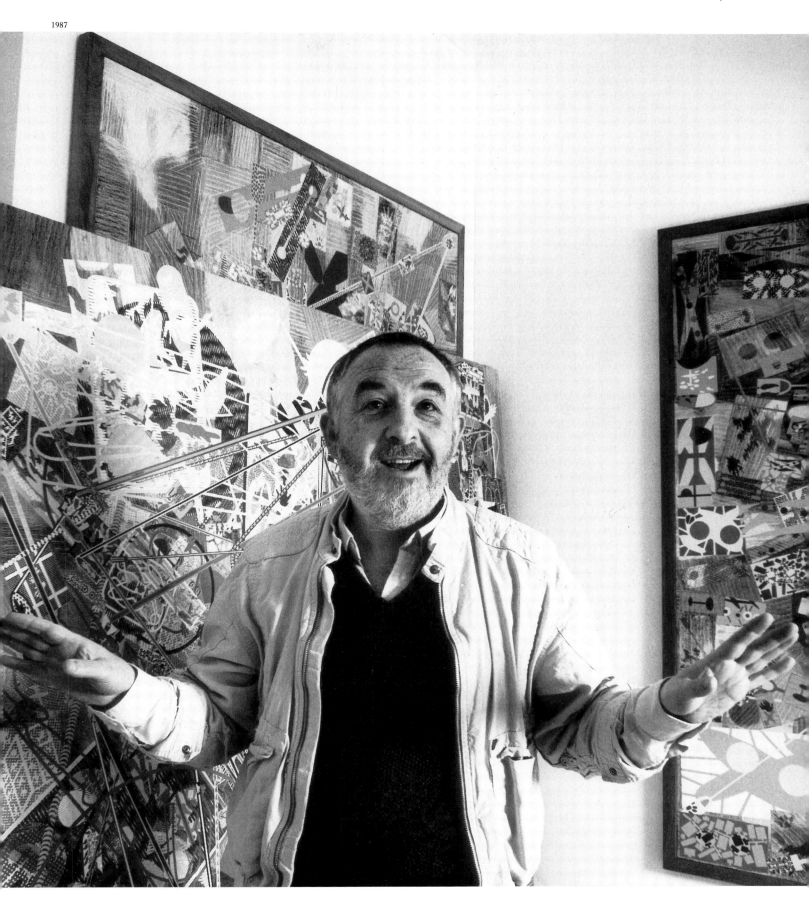

SIR WILLIAM COLDSTREAM, erect, severe looking, was waiting for me in the hall of the Slade School in Gower Street. He insisted on helping me with my equipment. The Slade Professor of Fine Art at the Royal College led me through a maze of corridors to the tiny painting studio he used at the college. Chairman of many British art organisations, a trustee, at the time, of both the Tate and the National Gallery, the most powerful and influential figure in the British art establishment, he appeared satisfied with this 10' x 12' cubicle. One unclean window, one chair near it and an armchair for his sitter, placed before a black cloth fixed to the wall with pins, a small storage area for paintings above the door and an easel with a portrait in progress completed the inventory. Sir William was a perfect example of a distinguished English professor of art: polite, detached, reserved, in this sparse setting a symbol of English understatement, his body almost deliberately shielding his painting throughout the sitting. His manner announced: 'I am a mere teacher here – my own painting is not at all important'. Of course he well knew that it had been important for the best part of half a century.

Later he led me to a door, just across from his studio. It opened on to a little balcony overlooking a huge teaching hall. A few students were drawing a particularly unprepossessing nude model. This was part of Sir William's kingdom.

Sir William retired from direct control of the Slade some years ago but remained active in the art world till the end, always available to friends and past students and enjoying their love and respect.

W. Coldstream.

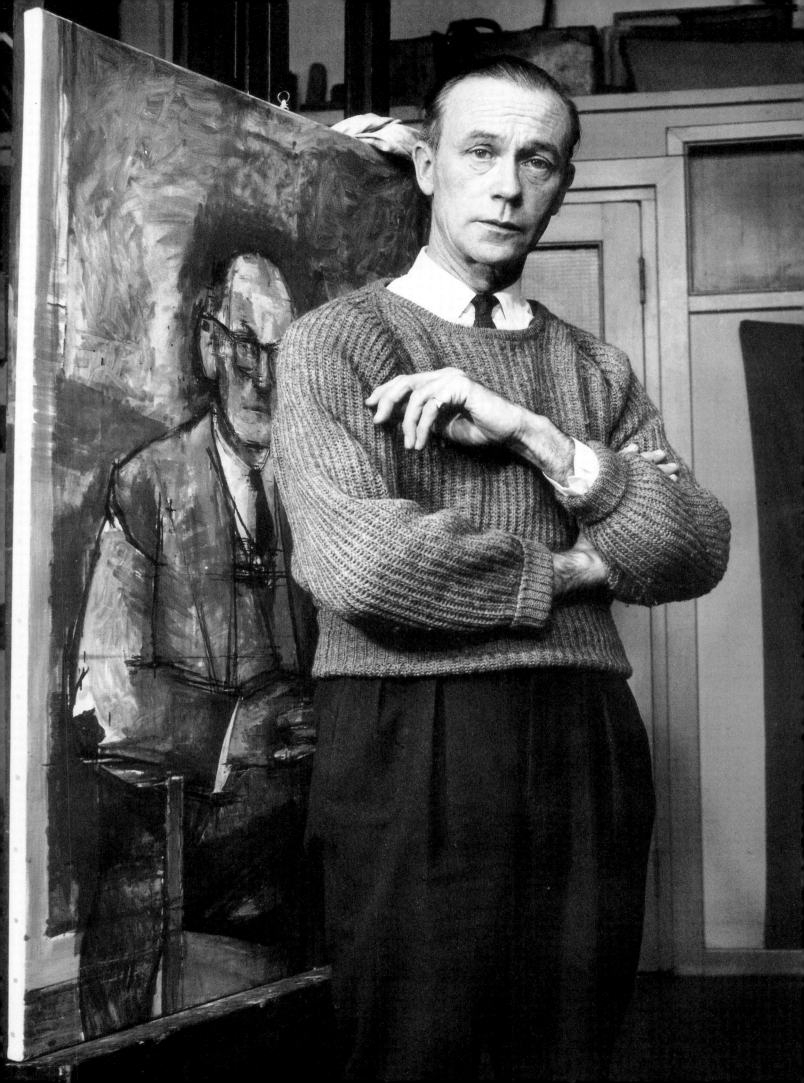

A QUIET SQUARE off the King's Road in Chelsea, London. The narrowest staircase I have ever climbed. A series of reproductions of William Blake's pictures on the landing of the first floor. Then Cecil Collins's small paintings and drawings of clowns, mountebanks, dancers, some from his book *The Vision of the Fool*. Another narrow landing, and finally the artist awaiting me on the top floor. A tiny, frail, stooping figure, with a small bird-like face. Collins has reached four-score years, near enough; his posture and face show his age. His voice and his words – alert and penetrating – do not.

For the last fifteen years, since coming to London from Cambridge, Cecil Collins has lived and worked in this one medium-sized room with adjacent bathroom. I have never seen more stuff packed into one room in my life. On the right were wide shelves for the storage of paintings, but there was not enough room; paintings, framed and unframed, spilled out on to the floor in untidy rows. The rest of the room was occupied by what seemed one large table (in fact there may have been more than one). The surface was covered by papers, books, prints, notebooks etc. to a depth of some two feet or, in places, four feet. The window on the right was invisible behind the mountain, the one on the left relatively free with a narrow passage towards it. The mantelpiece (with an old-fashioned electric fire below) was covered with tins of coffee and tea and a bottle of milk. A kettle just peeped out from behind the fire. An armchair on the left, presumably for the occasional visitor, blocked the way to the untidy camp-bed, with a shelf full of paperbacks behind it. Beside it sat the artist. Fitting in my lamp and a tripod with my camera was no mean acrobatic feat.

Cecil Collins's career as marginally a surrealist, but chiefly a romantic visionary artist concerned with metaphysical experiences and inner contemplation, will be crowned by a large retrospective at the Tate Gallery in 1988. He is still working hard. 'For large paintings,' he explains, 'I have to do a little tidying up and rearranging in this room. But it is possible.' Frankly, I do not see how.

1987

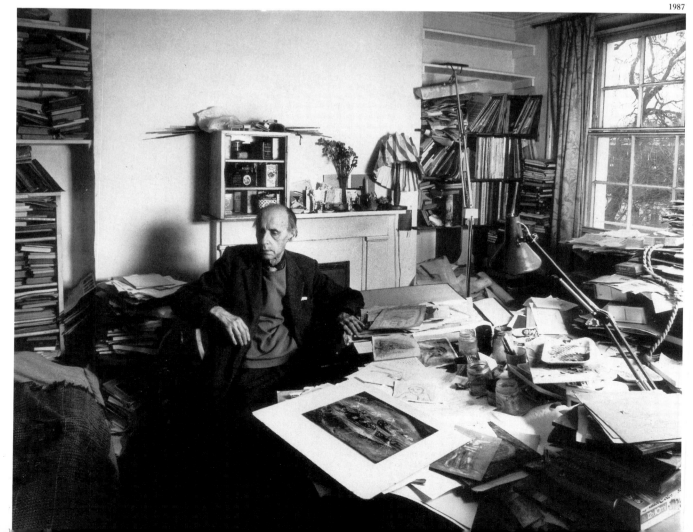

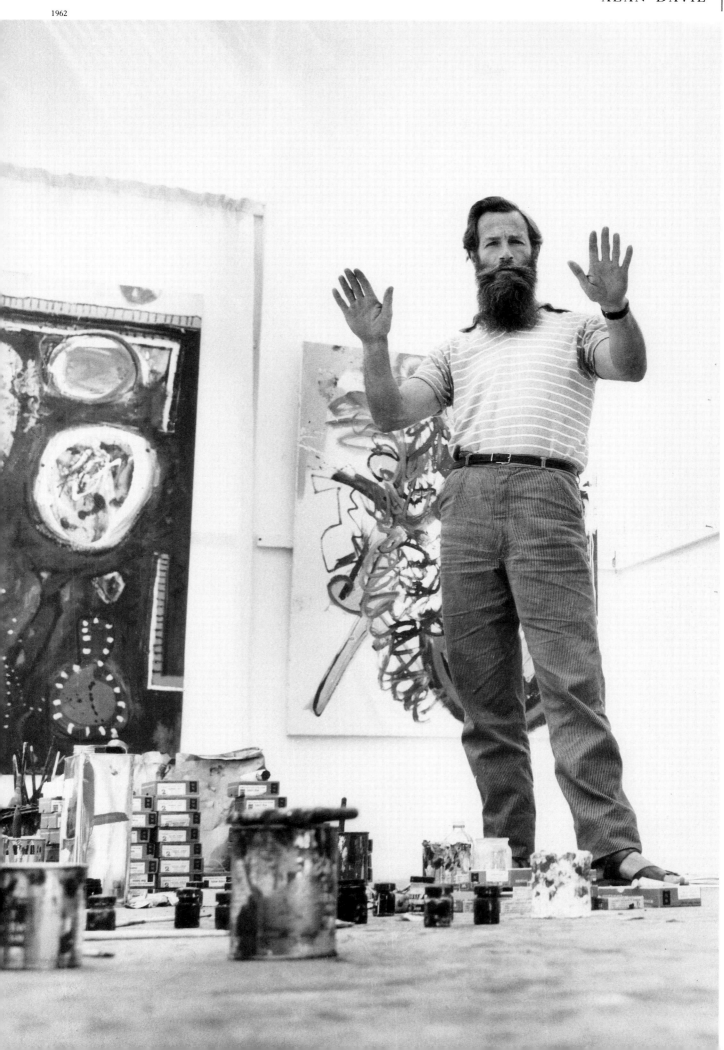

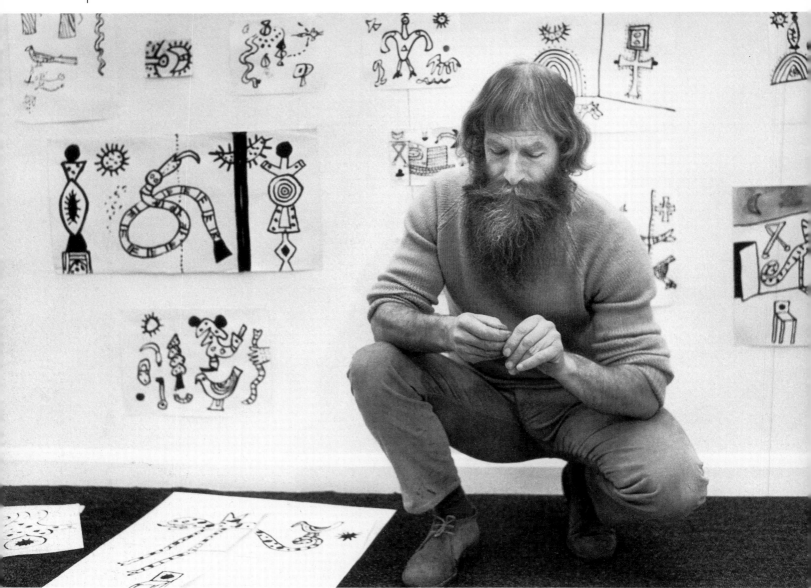

1972 (*opposite:* 1977)

TALL, POWERFULLY BUILT with a blond (now visibly greying) patriarchal beard, slow and deliberate in movement (except when painting), Alan Davie strikes one as self-confident, with a settled belief in himself and his genius. Those near him, including his family, share his view. No visitor would dare to disagree. Success as a painter, which he achieved fairly early in his life (despite the fact that soon after the war he worked for a time as a professional jazz musician), now allows him to maintain three residences: a cottage in Cornwall, a converted and beautifully modernized stone barn near Hertford and, in the last few years, a house on the island of St Lucia in the West Indies. I have photographed him in the first two, alas not in the third.

Alan Davie is a superb subject for a photographer, unselfconscious, relaxed and, when painting, totally absorbed in his work. Occasionally one finds jazz instruments interspersed among his paintings. He requires little prompting to improvise on a clarinet or saxophone.

When I photographed him first, in 1962, he was just entering a more controlled phase in his painting, after the initial free, instinctive abstract-expressionist period. Magical symbols of birds, totems and fishes abounded and his colour achieved a new resonance and sonority. Whichever way the camera turned, it encountered intoxicating images.

Alan Davie

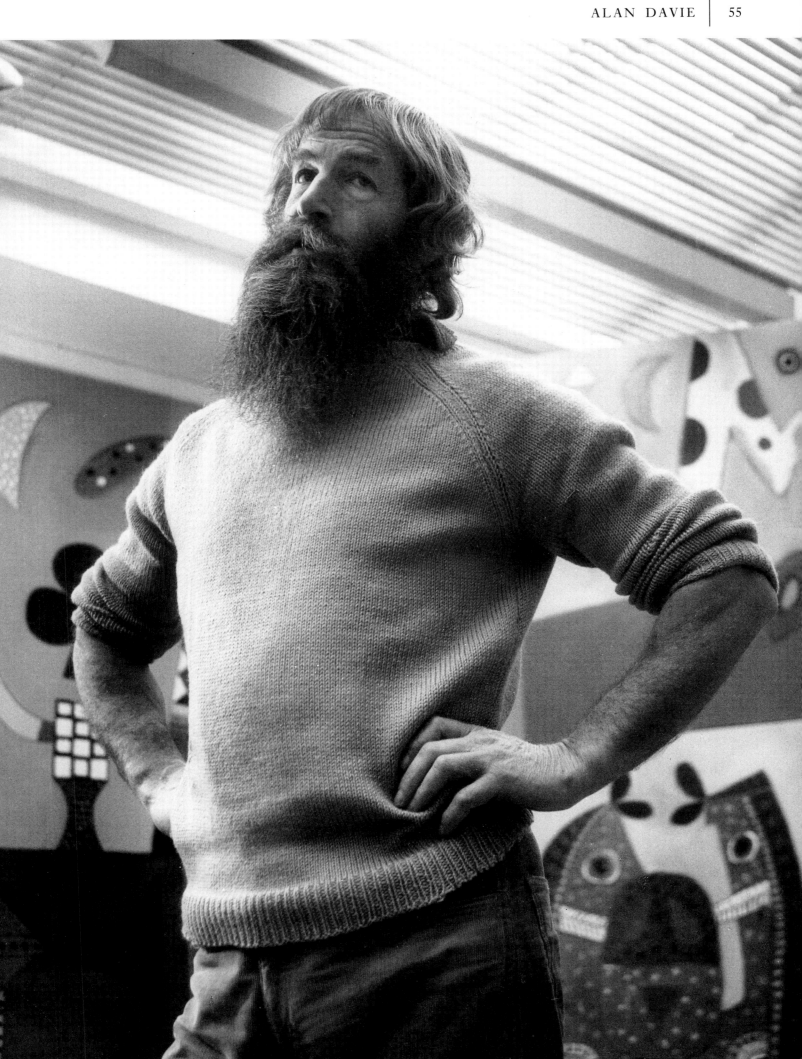

1983

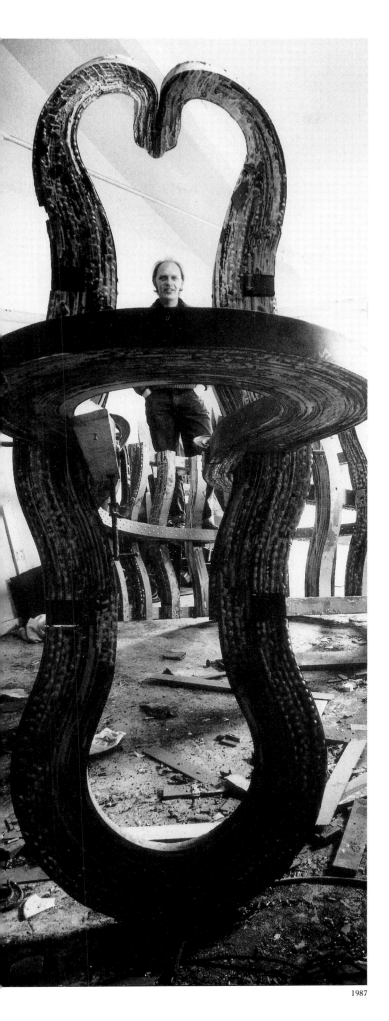

1987

RICHARD DEACON is a bright young star. I photographed him in his first important one-man show in 1983 and was struck by his stunningly conceived sculptures. Critics were equally impressed, but what was more fortunate for the artist was the interest shown by one of the most important contemporary collectors in Britain, the Saatchi brothers. They bought the whole show and since then have acquired a further half dozen of Richard's sculptures, which look well in the huge art gallery which the Saatchis built in North London for their collection.

Deacon, in spite of his success, remains unspoiled and unperturbed. He still works as hard as before in a large, quite primitive studio/shed in South London. Several other sculptors, including Katherine Gili, work in the same complex. I recently visited him there; the temperature was below freezing outside and not much different inside, but Deacon seemed not to notice.

PAUL FEILER is not represented in many collections of the work of British modern painters here or abroad. In fact his name is hardly ever mentioned when contemporary abstract art is discussed, and yet eventually he is bound to be rediscovered and acclaimed, simply because his work is among the subtlest and visually most enticing and satisfying that I have seen.

Paul's neglect (his travelling retrospective exhibition in 1985/6 was not sufficiently noted) is at least partly his own

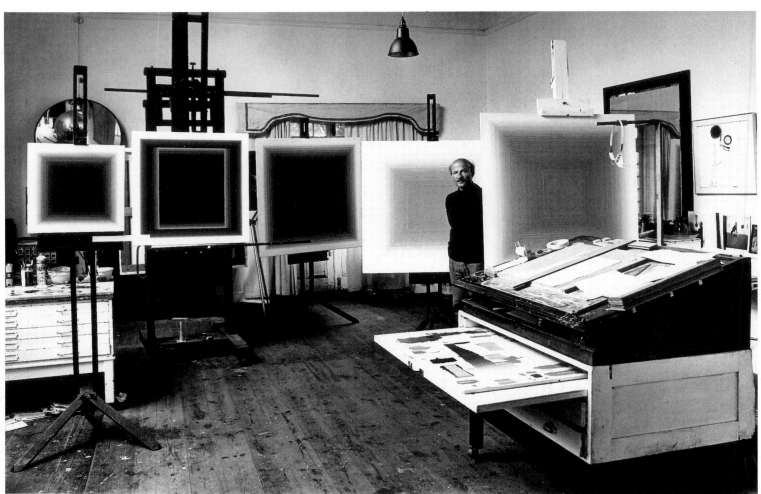

1976 (*opposite:* 1964)

fault. As early as 1964 he purchased a disused chapel in a fairly remote area of Cornwall and converted it into a small, beautiful residence. He converted part of a neighbouring farm building into an extensive, comfortable studio. You need exact instructions to take the right turn into a narrow country road to visit him. But he lives happily in this seclusion with his wife and their twin sons, and hardly ever ventures out. It is possible that the kind of paintings he now creates required some ten years of patient exploration and introspection. His work falls under the general heading of 'optical' painting, but is much more than that: a profound visual exploration of light and space.

Although his studio, at first sight, is cool and rather impersonal, with paints grouped in a specific order, precise colour-mixing charts neatly arranged, and several paintings symmetrically placed on their easels, the artist is far from cool and detached. It is certainly worth while to find the right turn on the Newlyn-St Ives road. The reception in the Feiler household is invariably hospitable and the paintings are not to be missed.

Paul Feiler

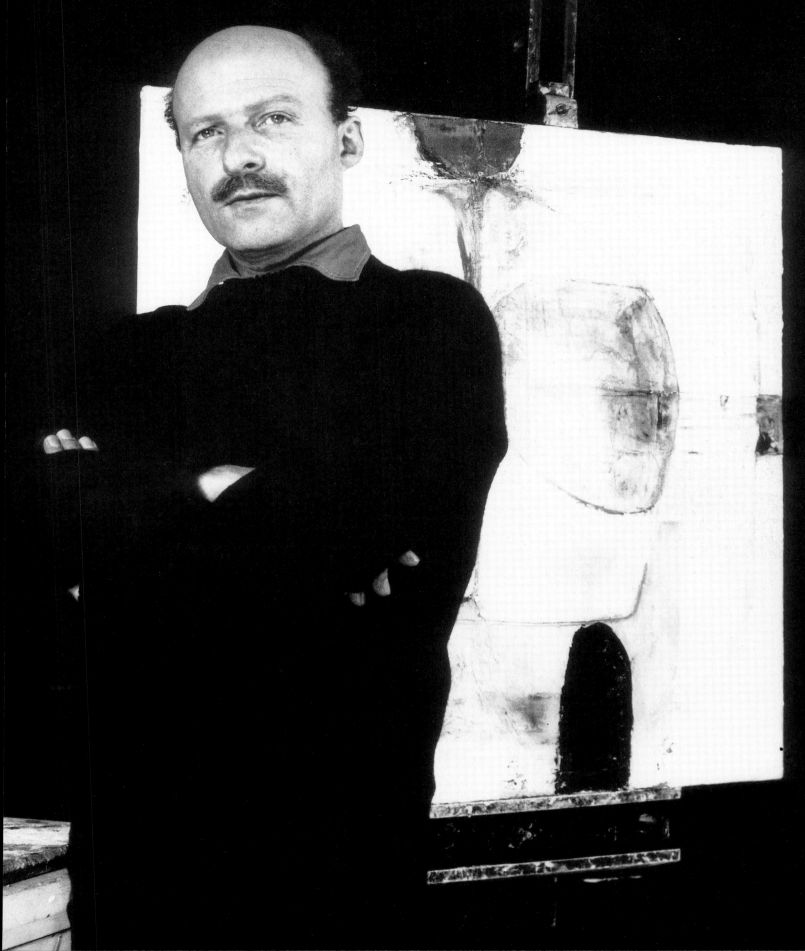

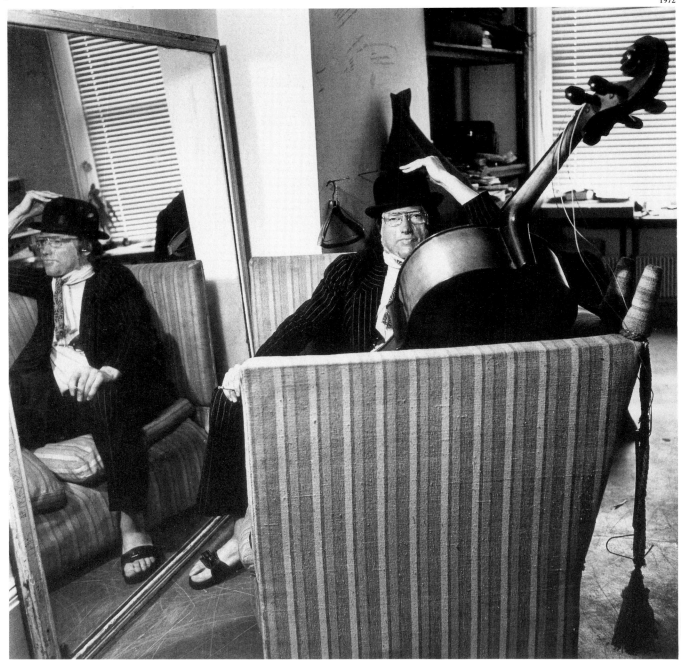

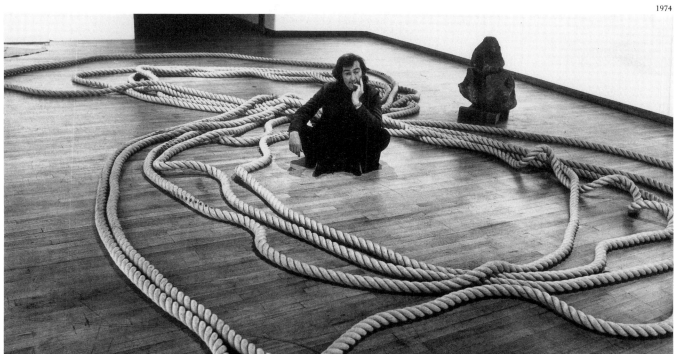

1983

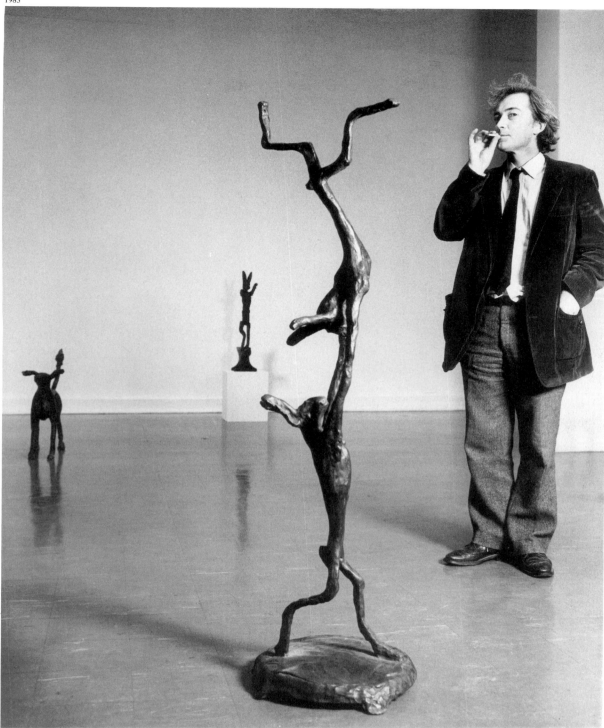

THE FIRST TIME I arranged to photograph Barry Flanagan in 1970, the appointment was made for 11 a.m. at the Rowan Gallery, at the time still in Bruton Place off Berkeley Square. I arrived promptly, looked at Barry's sculptures ready for the opening, but the artist was nowhere to be seen. When I inquired of the receptionist, she said, 'Why don't you look for him in the square?' Mystified, I grabbed one of my cameras and went out. Soon I spotted a tramp, wrapped up in an overcoat, a woollen cap on his head, curled up asleep on a bench. It was Barry, of course. On a subsequent meeting in Barry's studio, he insisted on being photographed in a close-fitting rubber mask.

One can never be sure what he will do next. I have photographed him half a dozen times, and each time the environment and décor were entirely different. This unpre-dictability applies even more to his work. My successive photographic sessions were neatly punctuated by changes of material and style: from rough pieces of torn rag hung on poles, to long twigs arranged as Indian wigwams, to stuffed canvas pillars and rubber masks. Later, inscribed and lightly fashioned stone slabs and pieces of marble appeared, to be displaced by thick long ropes curling on the floor. Recently, whimsical leaping, cavorting and dancing hares in bronze made a welcome appearance. Most of these are new forms, baffling, full of inventiveness and fun.

The artist is part of his art; humorous, approachable, unselfconscious, generous with his time but also reluctant to put his concepts into words. The spectator is left to enjoy or to disapprove, and to find his own meaning in Barry's subtle permutations and extravagances.

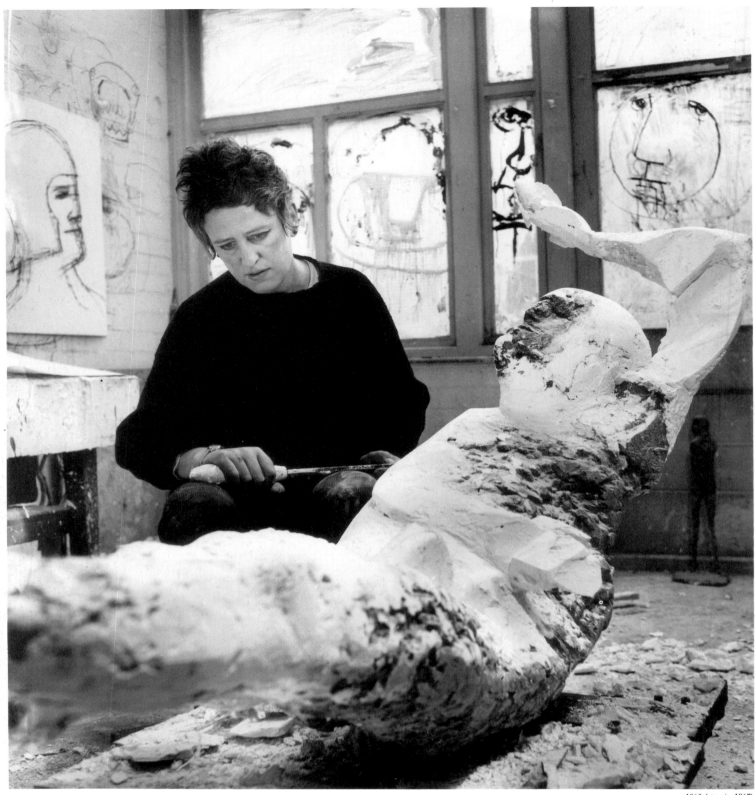

1963 (*opposite:* 1967)

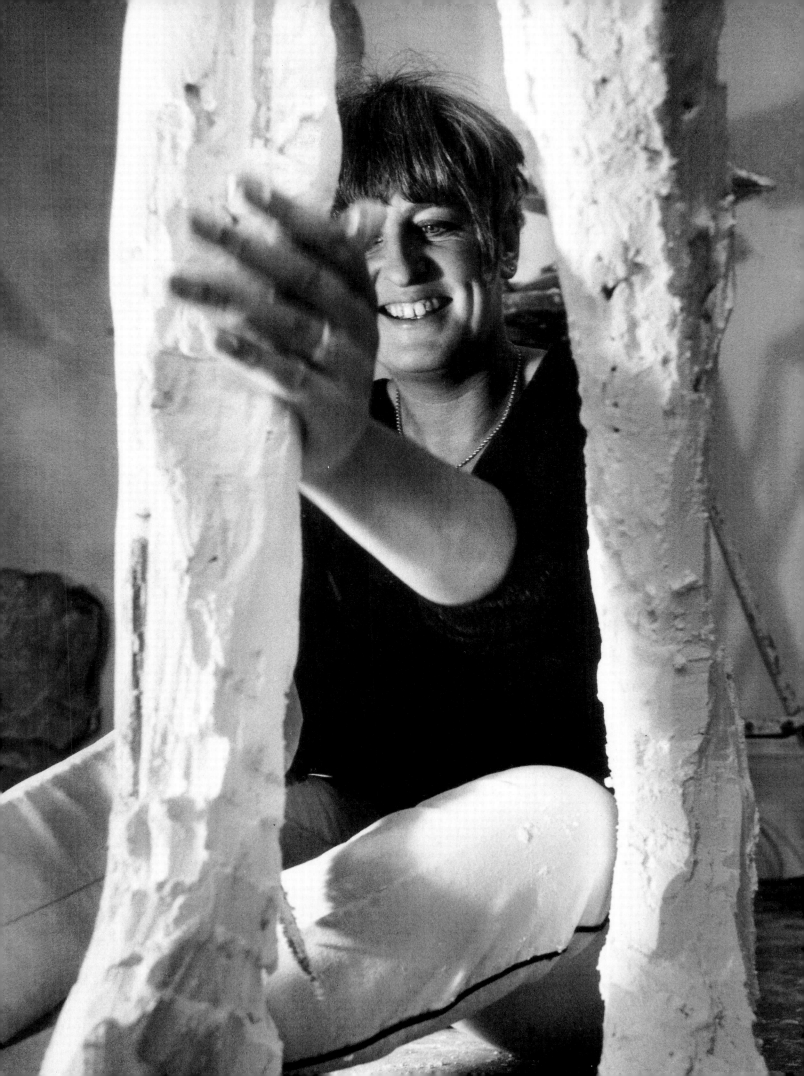

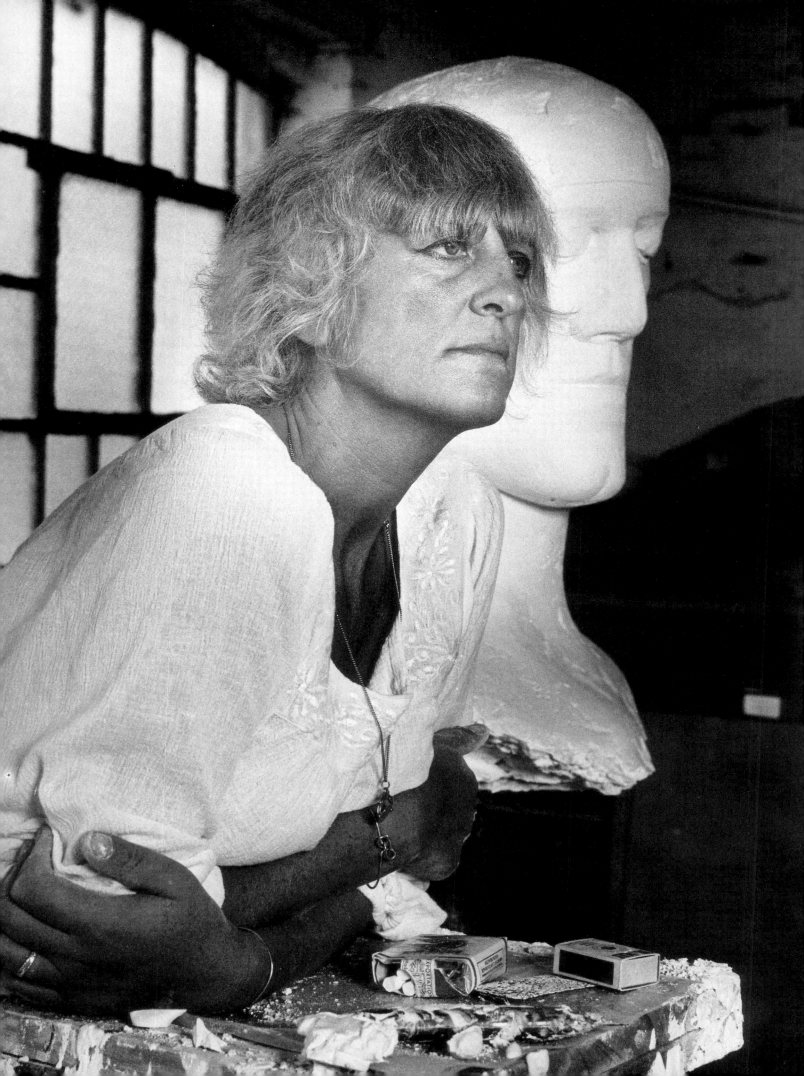

THE VIEW FROM Bulbarrow Hill is breathtaking. To the north-east patches of fields undulate into the distance, the continuous pattern interrupted by a few houses and to the south by dark green expanses of woods. You take the road winding steeply down to the right, with a sheer drop on the left, and in a couple of hundred yards you see the steeple of a church, then take a sharp turn to the left into Dame Elisabeth's kingdom. The ground dips down from the house towards the lake and a row of beautiful trees, and whichever way you look sculptures punctuate the open spaces. Centre stage is reserved for a splendid bronze horse, flanked by two running men, and to the right, towards the stables (horses are a passion of the artist and of her husband Alex Csáky), you see a line of great male heads. The purpose-built modern sculpture studio hugs the hill to the right of the house.

Woolland in Dorset presents a striking contrast to Dame Elisabeth's other studios which I have visited in the last twenty-five years, three of them in London. The first one, in Chelsea, was very photogenic because of the sculptures and drawings, a few of them drawn directly on the windows.

Although some of her sculptures, especially the early eagles, warriors and goggled heads, could be considered aggressive, she herself is a charming, warm and attractive person. Her more recent work has acquired a greater sense of balance and serenity in line with her secure and peaceful life in the Dorset countryside. In spite of the cold-shoulder she occasionally encounters from some artistic quarters, few would deny that Dame Elisabeth Frink R.A. holds the premier place in British sculpture.

Frink.

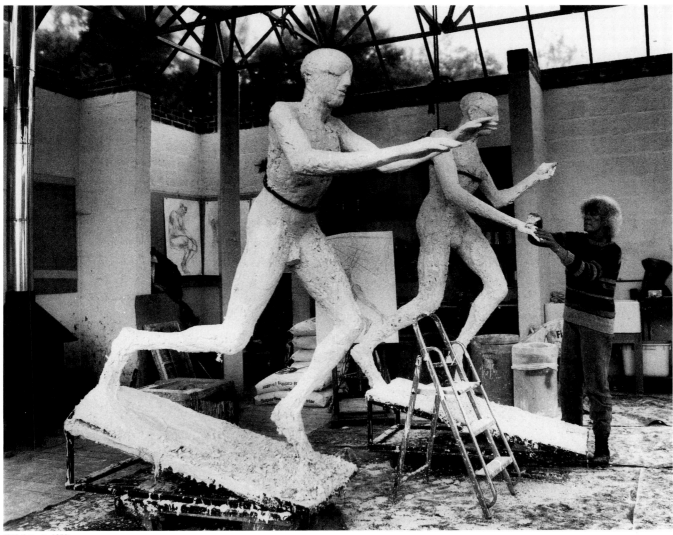

1982 (*opposite:* 1973)

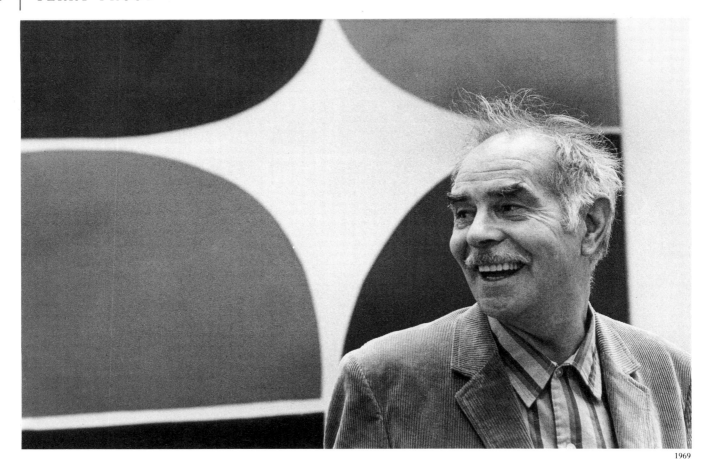

1969

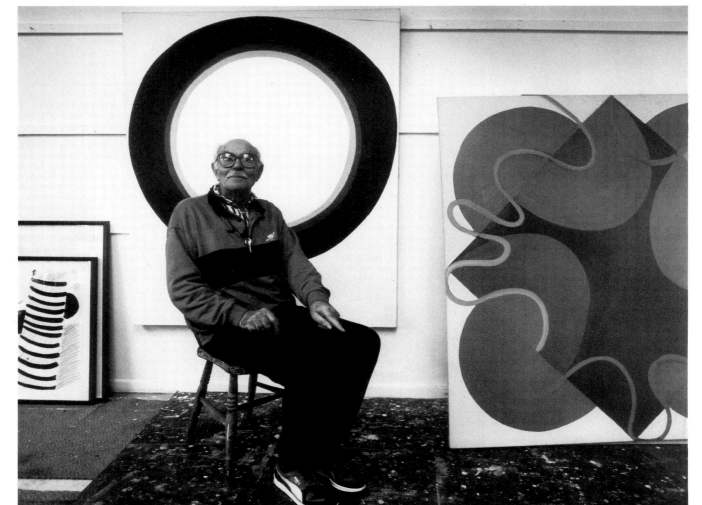

1987

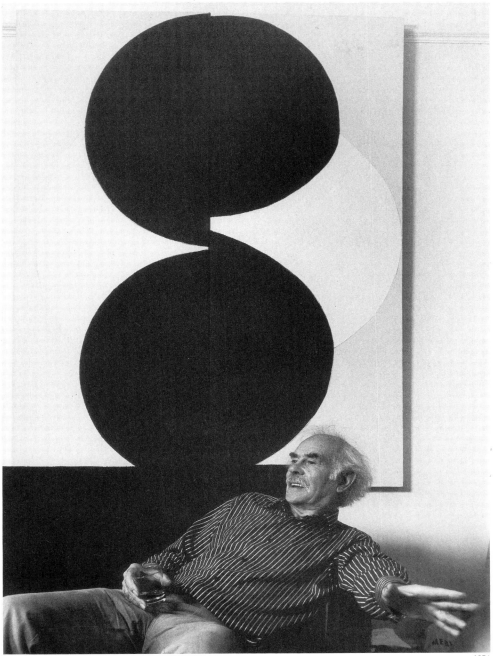

1974

'THERE ARE A FEW PEOPLE who make us feel good simply because we know they exist', John Hubbard wrote in his preface to the catalogue of Terry Frost's retrospective exhibition in 1976/77. Reading it, I thought that this is precisely how I and other people who know Terry feel about him. Terry as a man, a friend and a painter is a joy to be with. His radiant and optimistic abstracts lift the spirits. But, even more remarkable, this jolly, open-hearted, generous man, without an ounce of malice or jealousy, struggled in poverty and virtual neglect for much of his life.

He started to paint full time only after his war-time service, aided by a soldier's allowances and back-pay. This did not last long and Terry and his wife had to take a succession of menial jobs to survive.

I first met him in Banbury in 1963 when the worst times were almost over, since he was able to live on his work and on part-time teaching. Even then his heart was in Cornwall where he had lived for several years from 1946 and where he spent his holidays. A few years later he decided to buy a cottage in Newlyn. It is set on top of a steep hill, well above Newlyn and Penzance. A beautiful large tree in the Frosts' garden frames a panorama of the bay, the horseshoe of houses of Penzance and in the distance St Michael's Mount.

It is a mystery to Terry's friends how he, a tall man, his wife, their five sons (all six feet and over) and a younger daughter fitted into his medium-sized Cornish cottage. But they did and happily too. Later Terry converted a shed as his studio. On entering, you are struck by a riot of pure colours on the walls and on the large table.

Terry Frost.

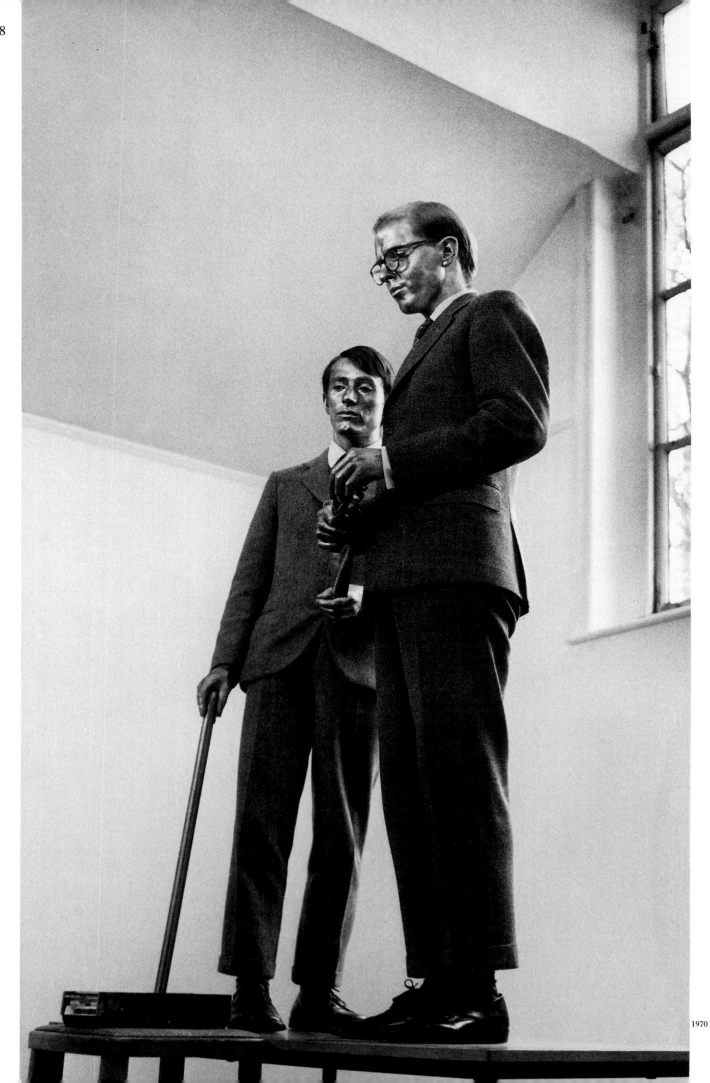

MY FIRST ENCOUNTER with Gilbert and George in November 1970 was the most unexpected. A friend who knew of my involvement with modern art suggested that I visit an exhibition at the Nigel Greenwood Gallery. Since I had failed to read about it in the press, the encounter was startling. The gallery room was empty except for a small table by the large window at the back. On top of it two young men with bronzed faces and hands slowly rotated, quietly singing 'Underneath the Arches'. These were Gilbert and George performing their 'living sculptures' act. Every few minutes when the tape recorder, also on the table, stopped, one would climb down, rewind the tape and climb back on to continue the performance – some six hours a day for a fortnight.

Gilbert and George met while studying at the St Martin's School of Art in 1967 and soon teamed up as 'living sculptures'. This one idea could not last them a lifetime; they later took up photography. Their huge 'photo-pieces' contain many snap-shots of themselves – now still-life-sculpture – but used in contexts that often exploit social themes and preoccupations.

As a photographer myself, I cannot see much skill in their photographic work, and most of their elaborate allegories and pompous treatment of themselves leave me cold. Many treat the pair as significant and serious artists. I may well be in the wrong.

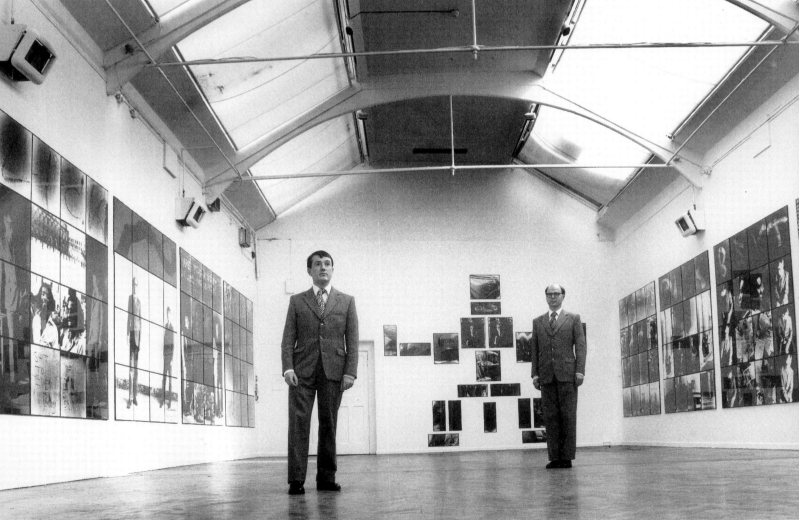

1982

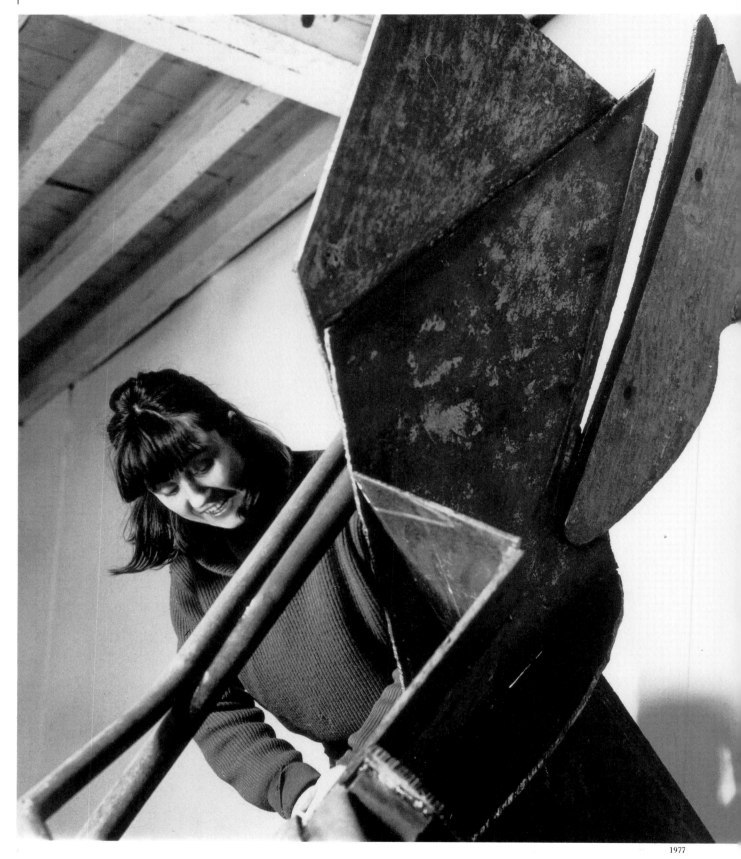

1977

KATHERINE GILI is a rarity even among women sculptors. Outside the studio she is simply a charming young woman, of medium height, small-boned and slender – almost frail. But look at her sculptures, look closely. Life-size figures of (perhaps) dancers in strange positions, but what are they made of? Pieces of forged steel, each intricately shaped, then soldered with other similar pieces, bit by bit. Each component part was once a rough lump of steel which this woman repeatedly heated in a forge and then hammered, with a large blacksmith's hammer, slowly and painstakingly into the desired shape. Each small piece may have had a hundred or more blows of the hammer. If you multiply this by the number of pieces in each sculpture, and the number of sculptures she has made, the sheer labour is remarkable.

Katherine has worked in this demanding medium for some fifteen years. She is a founder member (with Anthony

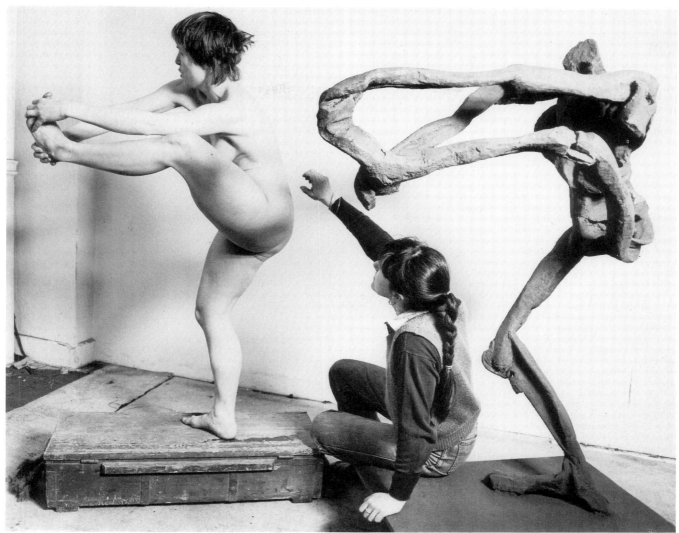

1983

Smart, Robert Persey – her husband – and Robin Green-wood among others) of a group of artists, previously based at Stockwell Depot, working for the most part in forged steel from a live model (unusual among the modern avant-garde). They do not work directly from one model, but study human form with a nude model performing all kinds of poses and exercises which they direct and observe closely. A mental image is recorded which later takes shape under the repeated blows of a hammer.

The dedication and perseverance of this group is extra-ordinary. Katherine is not only a member but almost the leader, by example if not *de facto*. She works several days a week in a cold, dark studio/shed in South London, between her days at St Martin's School of Art (where she has taught since 1975). Teaching is her chief source of income, since her work has not yet caught the imagination of the galleries or buyers.

On a recent visit to her studio I found the large hammer has been exchanged for a smaller one. Katherine was preg-nant, but of course this did not stop her.

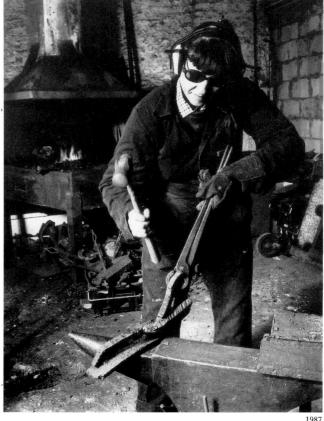

1987

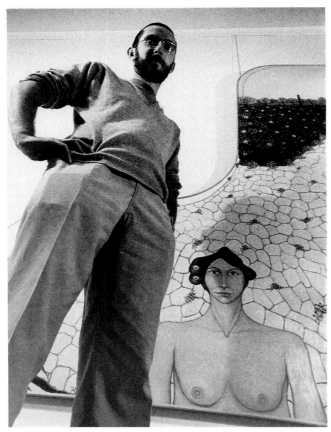

1969

ANTHONY GREEN is odd-man-out in any grouping of painters or people. Unclassifiable and unpredictable, except in one respect: his choice of subject matter. His paintings are always autobiographical. Anthony himself: the star of the show. His beautiful and beloved wife Mary: the female lead, temptress and sole slave of his harem. Their immediate family and close friends occasionally enter his pictures. If an outsider is admitted, it is as if by accident or oversight.

The setting for the performers is a quite modest flat in North London, their respective parents' homes, or places they visit – hotel rooms, holiday resorts etc. Invariably in Anthony's paintings one looks from above, as if through a non-existent ceiling, with a crazy perspective and meticulous details. He details certain events (wedding anniversaries are occasions for all sorts of goings-on, mainly amorous), but he also represents some of his dreams. He used to see himself as a cyclist in a Tour de France, in the yellow vest of the leader (he was once an excellent racing cyclist).

Anthony and his wife are amusing, gregarious, hospitable, and totally self-absorbed. Their flat over the years has become a crazy personal Aladdin's cave, the walls covered with paintings of various sizes and shapes, all chronicling their life, love and devotion. Anthony Green's mother is French and his father English. The mixture produced a gentle English eccentric with French extroversion, both traits exaggerated, just as in Anthony's paintings.

1972

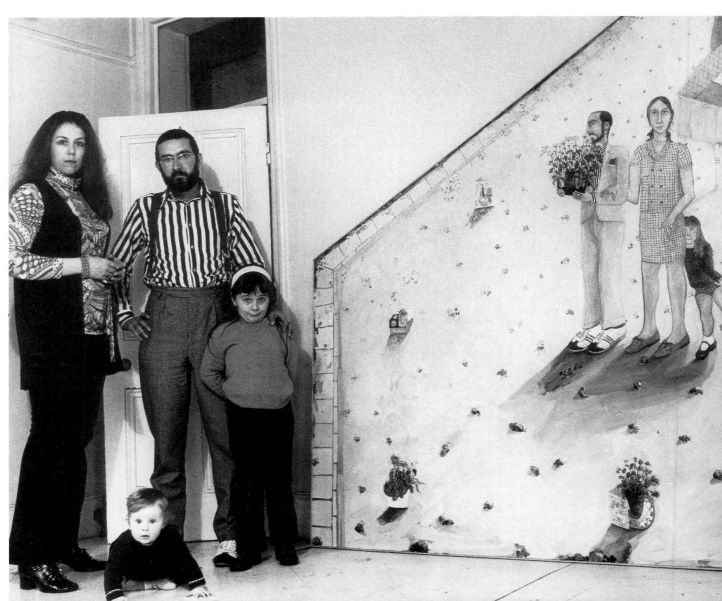

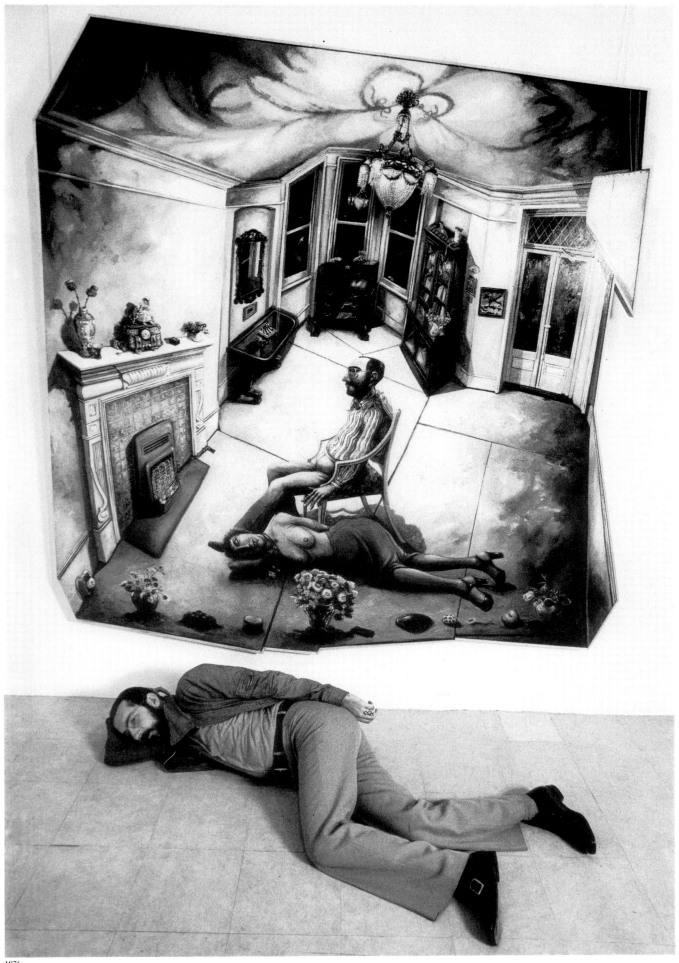

1976

1966

RICHARD HAMILTON'S studio was entirely unlike one's image of a painter's place of work. It looked like a professional designer's atelier. Everything was spick-and-span and neatly arranged: rulers, pens, pencils and various graphic designer's implements were more in evidence than paint and brushes. This impression of his studio fitted my preconception of the premier British intellectual 'pop' artist. A leading disciple of Marcel Duchamp, he is mainly fascinated by 'the experimental, the mechanical and the banal'. The nuances of fine painting techniques are anathema for Hamilton; the products of American-oriented mass-produced advertising graphic art his main subject matter. When I first visited his studio, he was busy glueing a piece of thin mahogany to the back of an armchair drawn on a canvas representing a very ordinary office. On the second occasion he was painting an action scene directly from a news photograph of the arrest of Mick Jagger for the possession of drugs, when he was led away handcuffed to a policeman.

Photography was and still is high on Hamilton's list of the tools of his art. But though he uses it extensively, he does not think highly of photography as a creative medium.

1968

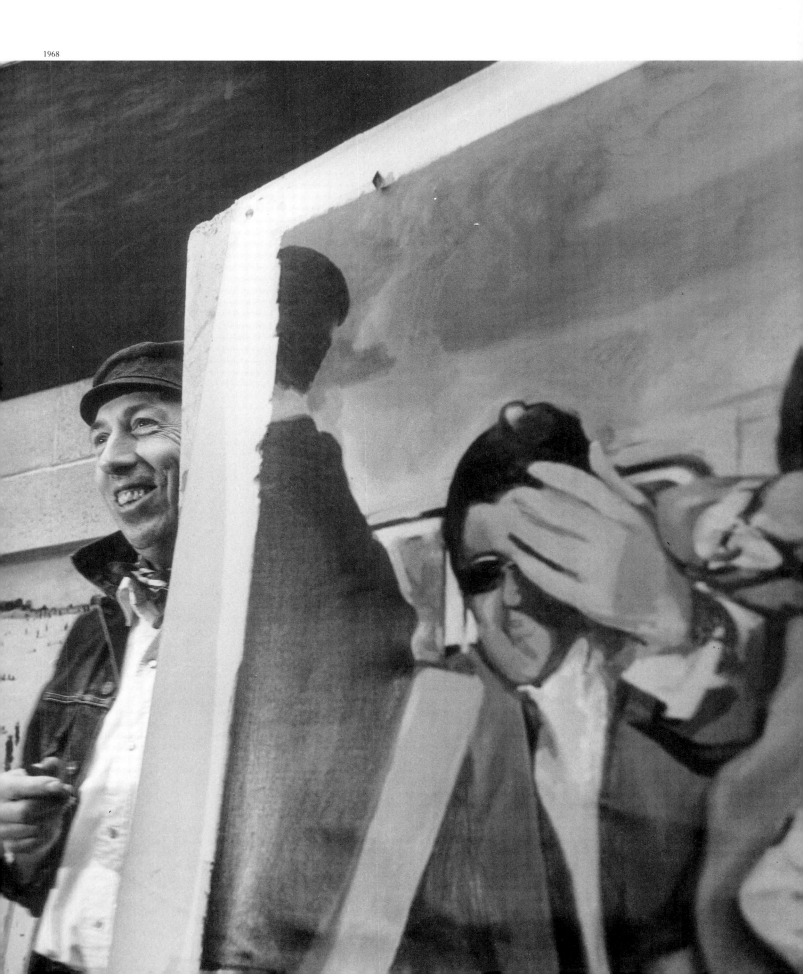

1970

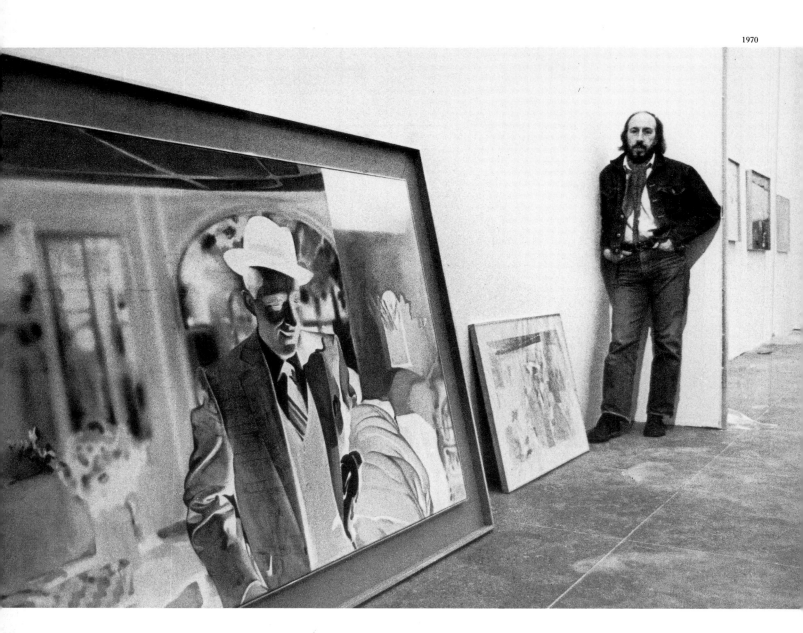

R Hamilton

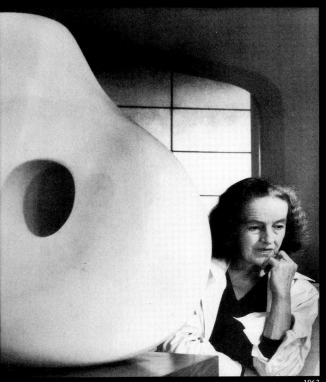

1963

I DID NOT KNOW or photograph Dame Barbara Hepworth early in her career, when she was building her reputation, full of ambition and vigour. I met her for the first time in 1963, when she had just passed her sixth decade, had been living in St Ives in Cornwall for twenty years, and was already famous and lonely. By then Ben Nicholson, her second husband and father of their triplets, had been in Switzerland with his new wife for more than ten years, but he was still in her thoughts and even in her heart.

Most artists must evince a degree of egotism and self-absorption. In order to achieve a mature artistic style some aspects of personal life have of necessity to be sacrificed. In this respect Barbara Hepworth was no different from other major artists. Perhaps in earlier years she gave too much to her art, not enough to her family? Now she was universally respected but often alone.

Her beautiful house in St Ives, set on a steep hill, with her enchanting sculpture garden overlooking the sweep of the bay, was hardly a home. The white, impersonal bed-room, filled with cool, polished marble and wood sculpture, all covered with plastic sheets, had an air of reserve. Only

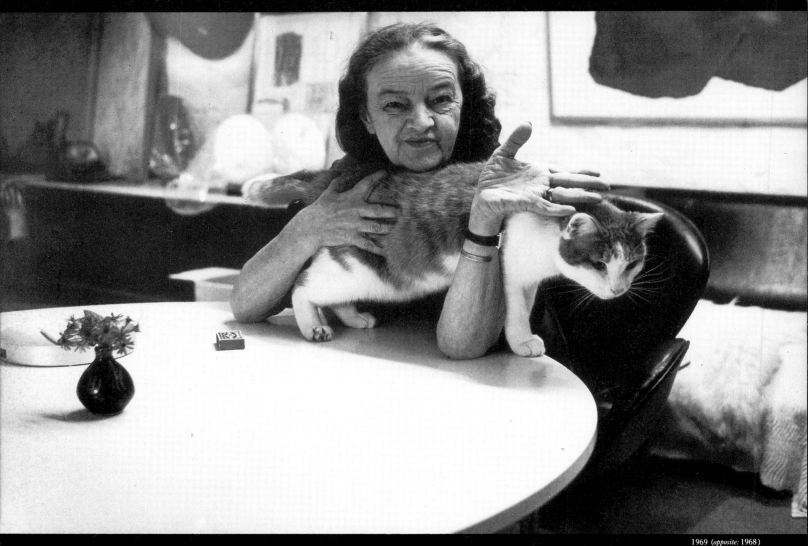

1969 (*opposite:* 1968)

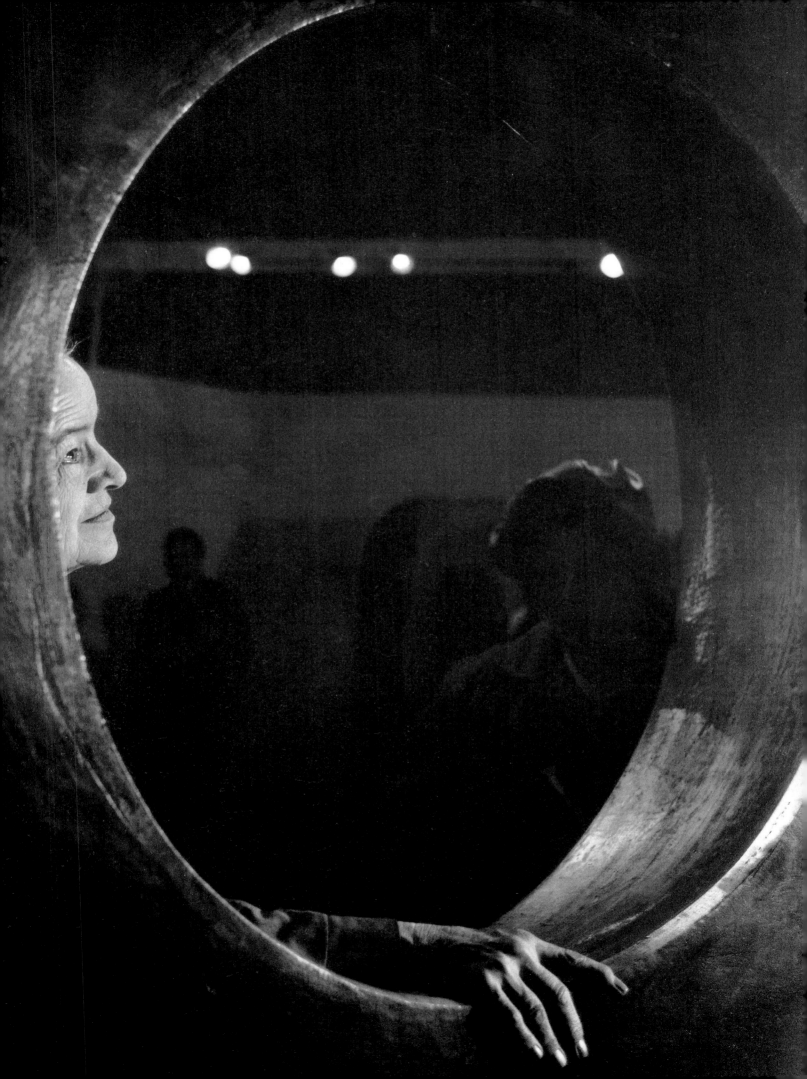

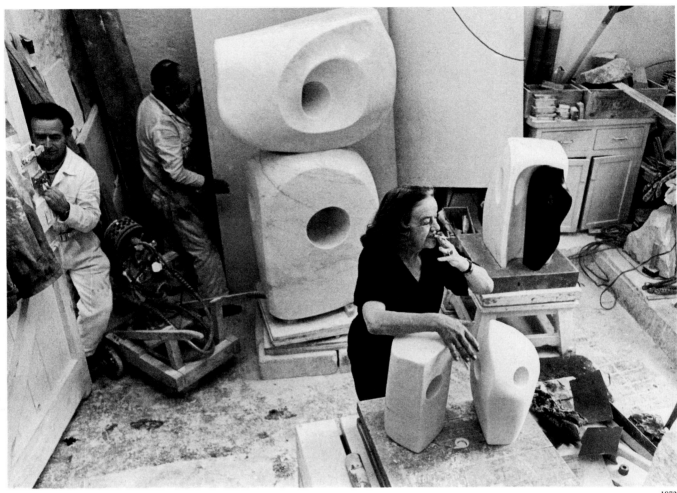

1972

the dining-room with its round table, flowers on the sideboard, and cats (seven at the last count), sleeping on windowsills or gravely washing on chairs and settees, retained a warmth which the rest of the house conspicuously lacked.

With passing years, her ambition to be the premier woman sculptor fulfilled, she visibly mellowed and turned into a gentle, friendly person. On my almost annual visits to Cornwall, I invariably spent an hour or two with Dame Barbara chatting, reminiscing, smoking and drinking excellent whisky. She was exceptionally generous with her time and eminently approachable. She enjoyed showing her garden, while feeding innumerable birds; or her working studio, full of slabs of stone, wood and plaster casts in various stages of finish (by then mainly carved by her assistants but under the watchful eye of the artist); or her 'exhibition' studio, a converted 'palais-de-dance', across a narrow alley opposite the house. Before, the dance hall had been alive with noise and music late into the night. In desperation she bought the hall lock, stock and barrel, with its mirrors and fittings. Now only her sculptures were calmly reflected in the mirrors and the artist could sleep at last undisturbed. But perhaps had the hall still been occupied by dancers, someone might have noticed the smoke billowing from Dame Barbara's windows. In May 1975, the help came too late and the great British woman sculptor died alone, surrounded by her shrouded creations.

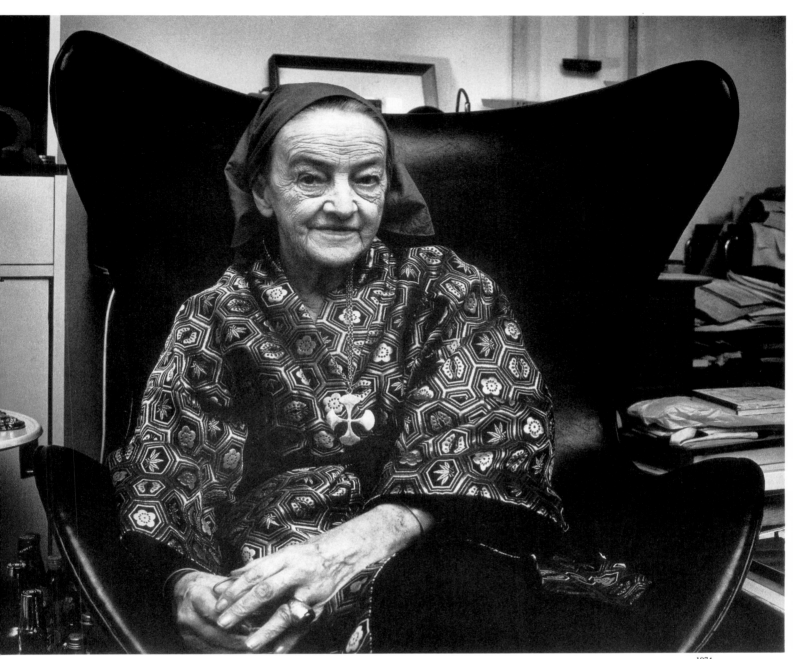

1974

Barbara Hepworth

OFTEN THE ENVIRONMENT an artist creates for himself, especially his studio, is closely in keeping with his art. Josef Herman's sombre, heavy figures of miners, fishermen and nudes, and their predominantly muted tones, fit well with the dark, Victorian interior of his studio in Hammersmith.

One enters through a small ante-room, with an untidy bed and shelves of well-used books. The door leads to a small elevated balcony with a dark mahogany balustrade and several steep steps down to the huge studio. Josef's superb collection of African sculpture dominates the room, with brooding warriors, medicine men, nudes and masks on shelves, tables, mantelpiece and hung on the walls. This of course is only a small portion of his remarkable collection which now includes some eight hundred pieces. The centre of the studio is occupied by a large easel with a painting in progress, next to it a table with a forest of brushes, tins of paint and palette. After years of use this working table seems to be on the verge of collapse and in urgent need of repair. Nearby is a large, well-worn leather armchair which Josef occupies when not working, puffing on one of his pipes or meditating.

The artist fits into this environment to perfection – solid, serene, methodical, slow in movement and in speech, oblivious of the outside world and caring little for the politics of the art establishment.

Polish by birth, Herman came to England during the Second World War and after the armistice spent several years in the remote Welsh mining village of Ystradgynlais. Hence his favourite subject matter: miners, fishermen and peasants. As his success grew, Herman bought a house in London and established his current studio. For eleven years afterwards he also spent a great deal of time in Suffolk, where he suffered the loss of his young daughter and stopped working for a considerable time. Back in his familiar London studio for some years now, he is painting as well as ever, having thinned down the many glazes of oil paint, and deals with contemporary subjects.

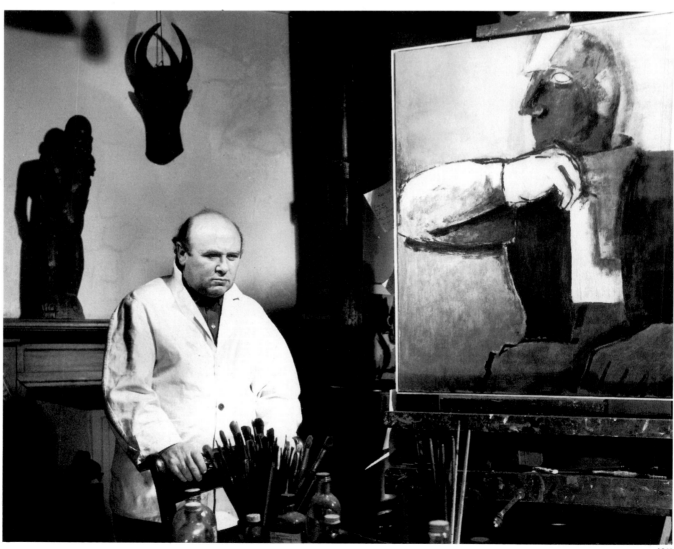

1962

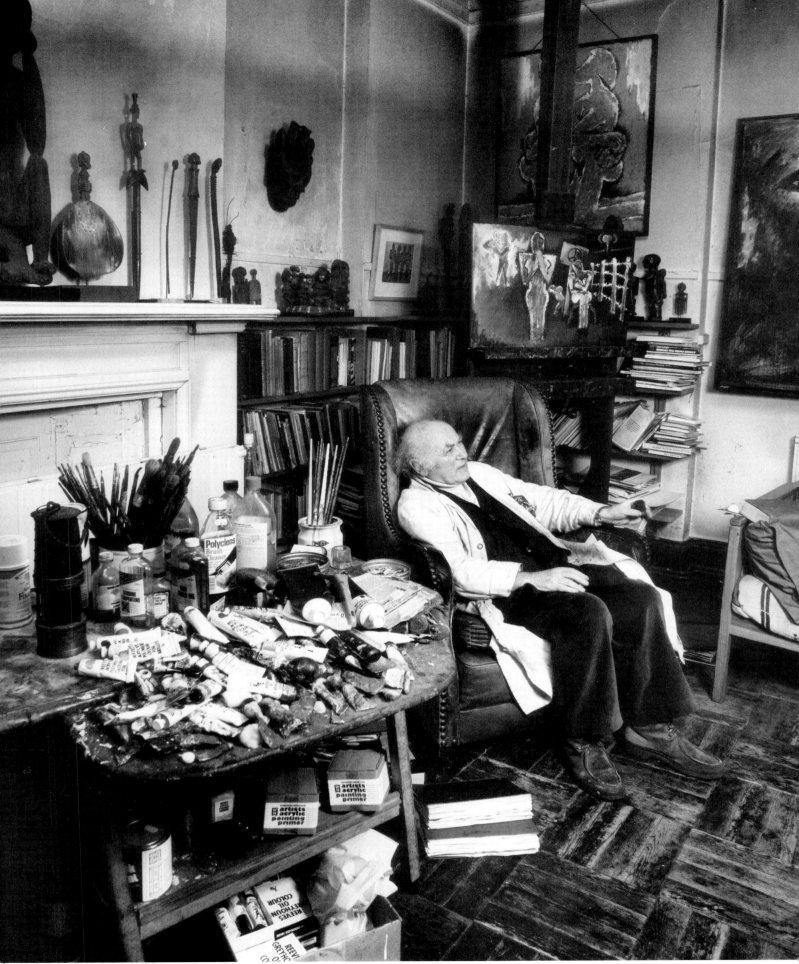

1987

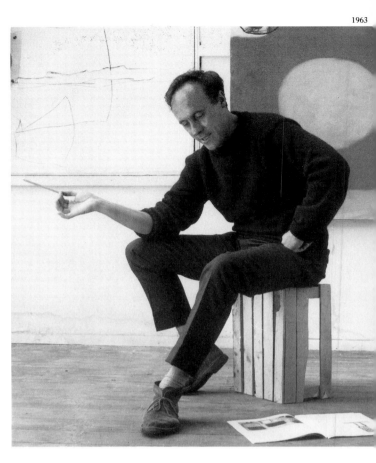

Patrick Heron [signature]

WHEN ASKED which of the artists' houses I have visited I thought most beautiful, I place Patrick Heron's Eagles Nest, some four miles from St Ives in Cornwall, high on the list. It is built on cliffs overlooking the Atlantic, with huge boulders flanking it on one side and the stretch of rugged moors high above it on the other. You can see spectacular sunsets over the wild coast stretching towards Zennor, with only a solitary farm (where D.H. Lawrence lived while writing *Women in Love*) indicating human habitation.

Pat Heron bought Eagles Nest in 1955 but his connection with Cornwall goes back to his childhood. He lived in St Ives with his parents and later returned there on holidays. Though a Yorkshireman by birth, he is now a passionate Cornishman. Being outspoken, he fought many battles with officialdom of all kinds, but his most successful campaign was the protection of a large area of Cornish moors and

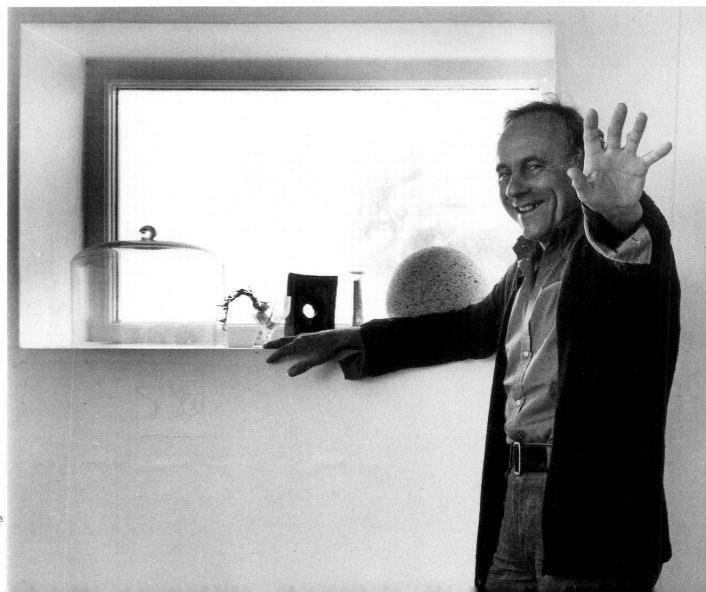

1987

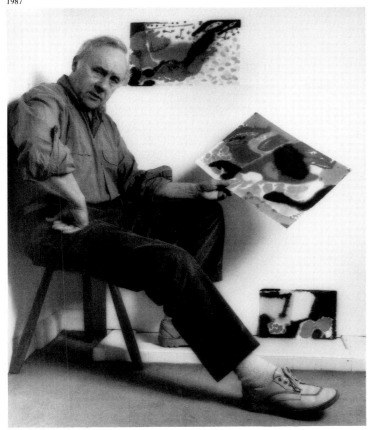

coast against invasion by the Ministry of Defence.

Though one of the largest rooms in Eagles Nest is designated the studio, where Patrick paints his smaller paintings and gouaches, his huge canvases, fifteen or more feet long, cannot be accommodated in the house. He rents a large barn-like studio in St Ives. It used to belong to Ben Nicholson and Patrick likes to show the visitor the door of the studio which was cut progressively higher to allow for Nicholson's paintings as they increased in size.

Patrick Heron is an excellent writer and until he abandoned regular art criticism (for the *New Statesman* and *Arts Magazine*) in 1958 in order to paint full time, he was regarded as one of the most perceptive interpreters of international art. He remains a passionate, erudite and knowledgeable analyst and an evening discussion or 'audience' with Pat is instructive and enjoyable.

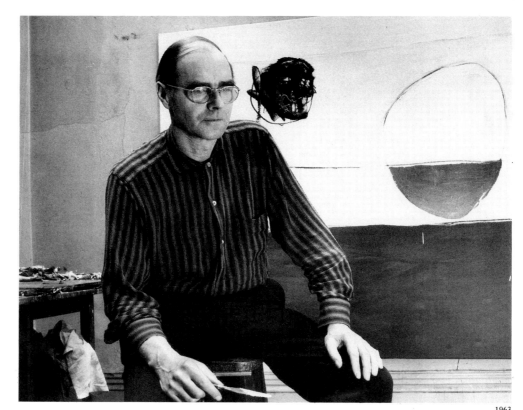

1963
1972

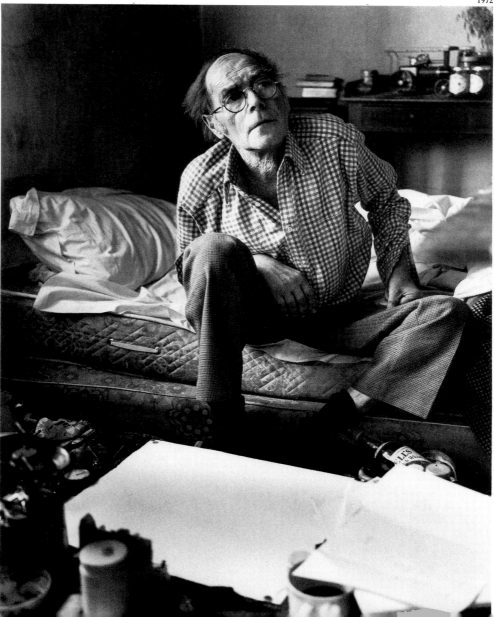

1974

ROGER HILTON was a tragic figure. Immensely talented, with great facility and feeling for form and colour, he was not able to reconcile himself to his constant struggle for financial survival and recognition, partly because of the lack of sympathy from the galleries. Perhaps his wild and unpredictable nature which made him a number of enemies and created untold difficulties for those who tried to support him, contributed to his loss of confidence and the will to continue. I always felt that there were two Roger Hiltons: a kind, generous, erudite and sensitive artist, whom I deeply admired, able to write uncommonly lucidly about art, a pleasure to spend time with; and the other Hilton, under the influence of alcohol, who was aggressive, belligerent and abusive. His career moved in stops and starts and his exhibitions were irregular.

In 1965, in order to survive financially, he moved to a modest, slightly dilapidated cottage outside St Just in Cornwall, where he lived for the last ten years of his life. When I visited him there in 1970 he was painting vigorously in the attic/studio of his cottage and playing football with his small sons. However his 1971 exhibition was not a success and after that he went downhill. In 1973 he was confined to bed for most of the time, but he was still painting lively, humorous and joyful gouaches, on a low table by his bed. From under the bed he fished out a book of Verlaine's poems in French and asked my wife to read the ode 'La Mort', repeating after her: 'Telle l'affreuse mort sur un dragon se montre'.

Even his final splendid exhibition at the Serpentine Gallery in 1974, to which he was brought in a wheelchair, did not help. He enjoyed the fuss and the accolades, but a year later he was dead.

IVON HITCHENS was predominantly a landscape painter – not an English traditional landscape painter in the footsteps of Constable, but thoroughly avant-garde – a latter-day Turner. His landscapes from the early 1950s onwards were, at first glance, almost abstract and yet were vivid evocations of his beloved West Sussex – a seemingly free and even random patchwork of colour brush-strokes conjuring the foliage of the woods, wild glistening streams, sunlit clearings and brilliant flowers.

On my many visits to Petworth in Sussex, where he moved in 1940 after being bombed out of his house in London, the greatest treat was to watch Ivon create one of his landscapes. A Hitchens painting expedition was pre-ceded by extensive preparations. Ivon and his wife Mary would pack a great deal of gear: several empty, but already stretched, canvases of various sizes, small and large easels, a huge paint-box, a dozen or more paint-brushes, cotton

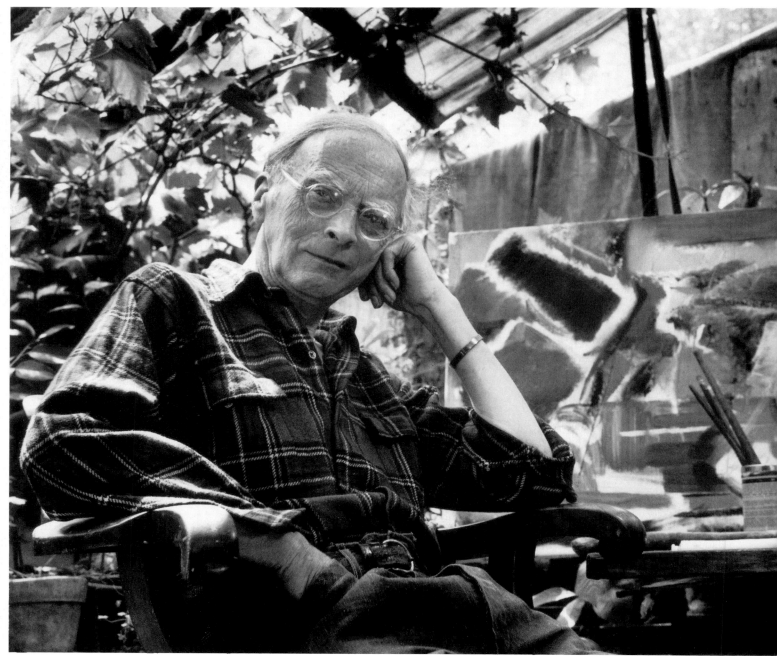

1963

wool, turpentine. Thus ballasted, they would start searching for a location – Ivon in front and Mary following (on occasion their son John would be roped in). The expedition did not have far to go. Their cottage in Petworth was surrounded by a large wooded area, deliberately kept in a wild state, with two small ponds, complete with a moored boat, a stream, a variety of trees and wild vegetation. Hitchens's subject matter was literally on his door-step. In a hundred yards a suitable spot would be found, easel erected, canvas selected and then Ivon would pick a brush, squeeze a few dollops of paint on to a palette and take a position in front of the easel, as if squaring up for a fencing bout. A moment's hesitation, a searching look at the scene in front and then the brushes would start flying. Every now and then he would pick another brush, dip it in the paint and a new patch would appear on the canvas. At times he would hold as many as five or six brushes in his left hand, all charged with different colours. Rapidly the painting started appearing, at first unrecognizable, but after a quarter of an hour, suddenly I would perceive the riot of brush-strokes beginning to cohere into a vivid image. A few more touches of the brush and the painting would be finished.

The session was usually followed by a tea on the lawn in front of the cottage, Mary conjuring up hot scones and tea-cakes. Then I would drive back to grey London, my eyes full of brilliant colours.

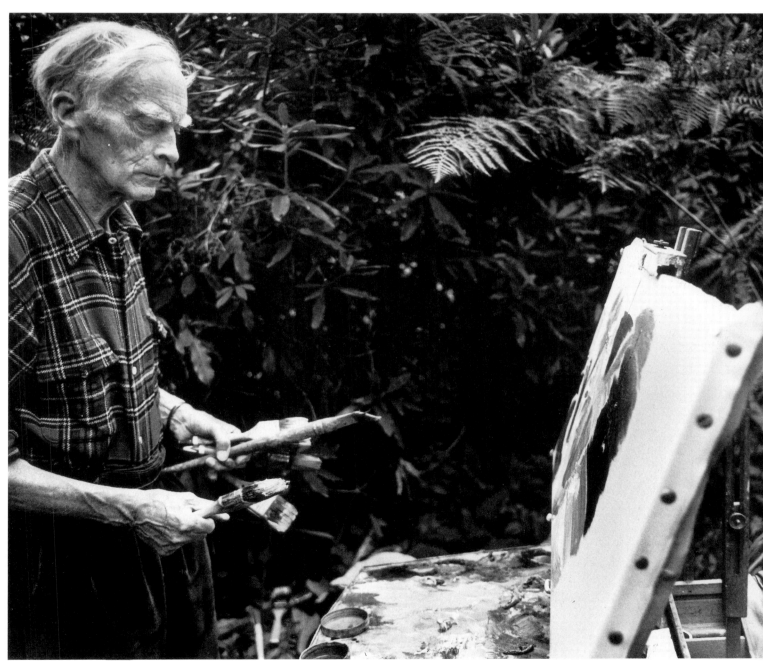

1970

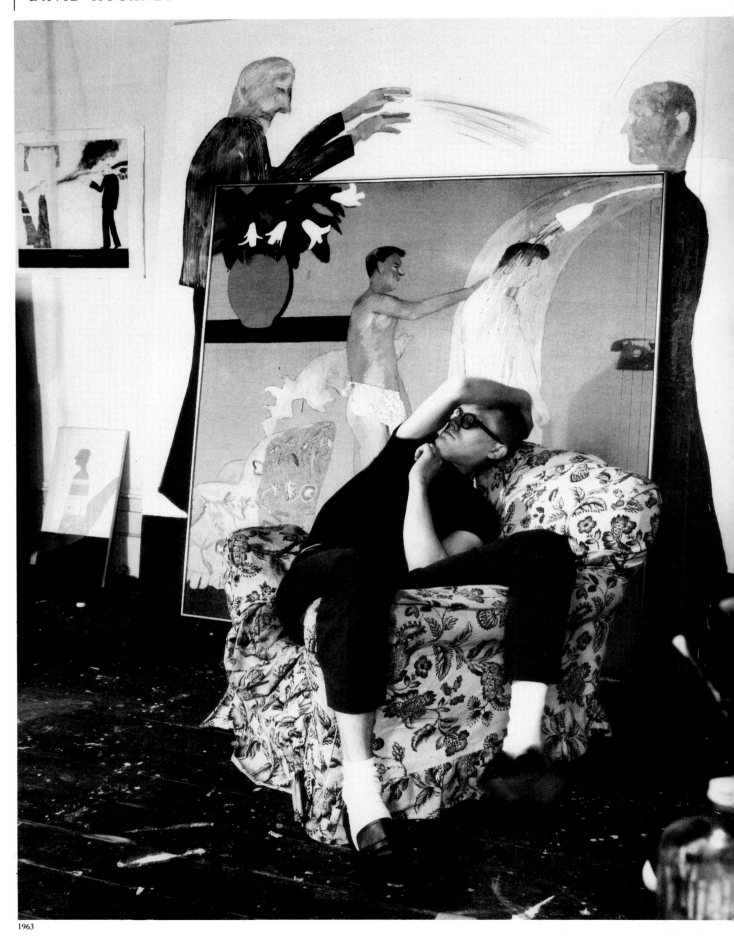

1963

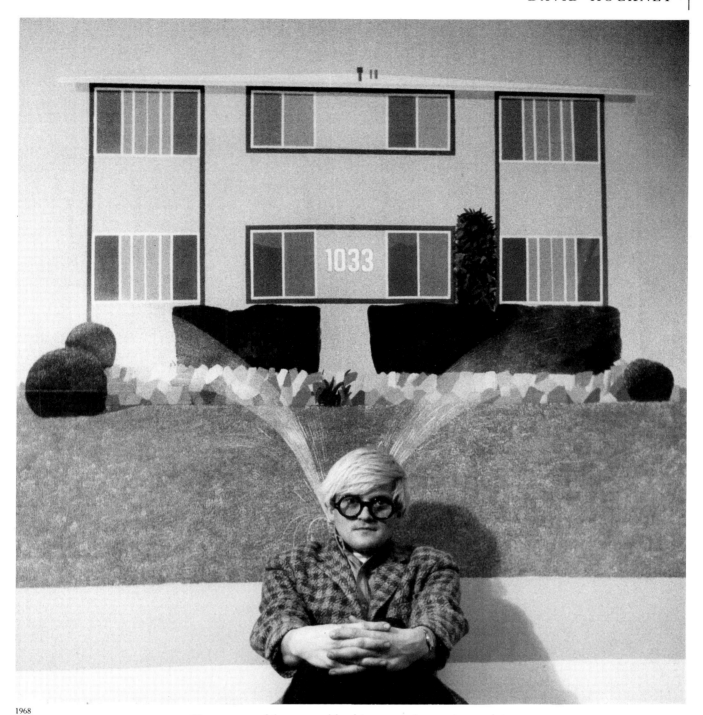

1968

THE STARS of the art world achieve prominence in a variety of ways, some slowly and painstakingly, gradually growing in stature, like Bacon or Moore. Occasionally someone emerges out of nowhere and captures attention overnight. David Hockney belongs to the latter category, acclaimed in the early 1960s when barely out of the Royal College of Art.

I photographed Hockney (and a group of other young painters, soon labelled as the vanguard of the British 'pop' movement), at the beginning of his career, just before he dyed his hair platinum blond, adopted outsize glasses and gold-trimmed jackets. This was in his first studio in not-too-elegant North Kensington. Hockney retained this studio for many years, although he modernized it considerably.

On my first visit in 1963 the paintings in the studio were

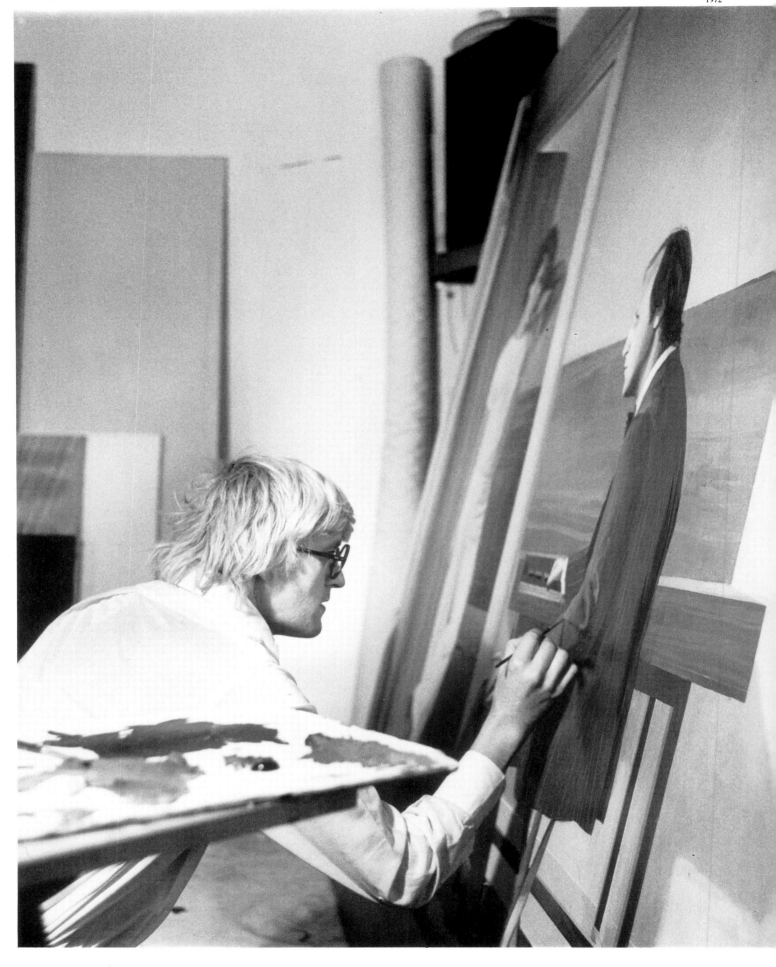

1977

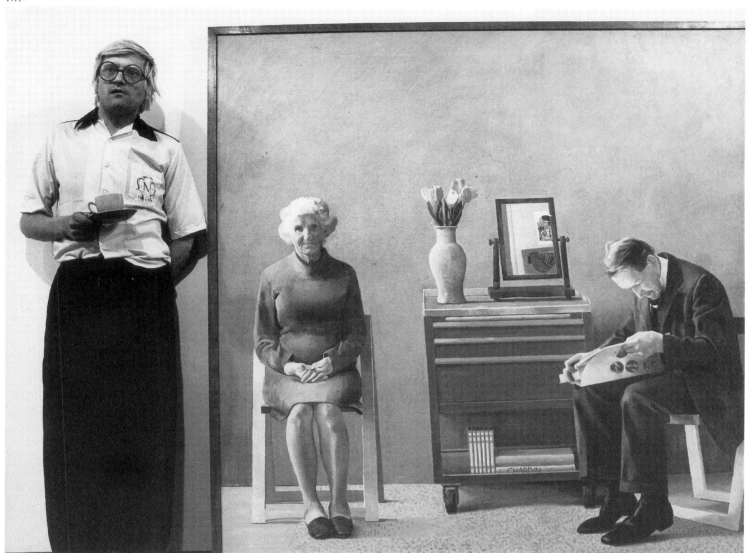

in his characteristic loose figurative style, with graffiti-like additions and inventive humour. Hockney, with growing fame and popularity, and in spite of his adoption of striking clothes and a flamboyant manner, has never lost his charm, approachability and modesty. One of David's early boyfriends was given a large drawing as a present. Some years later he asked David's permission to sell it to finance the purchase of a house. Hockney urged him, 'Do it quickly. Who knows, my prices may not hold for ever.'

On subsequent visits I have watched Hockney's progressive involvement with photography, from the use of polaroids as an aid to his paintings, to the use of series of polaroids to create large assemblages, to his more recent brilliantly imaginative collages involving hundreds of separate photographs or cut-outs from large cibachrome prints.

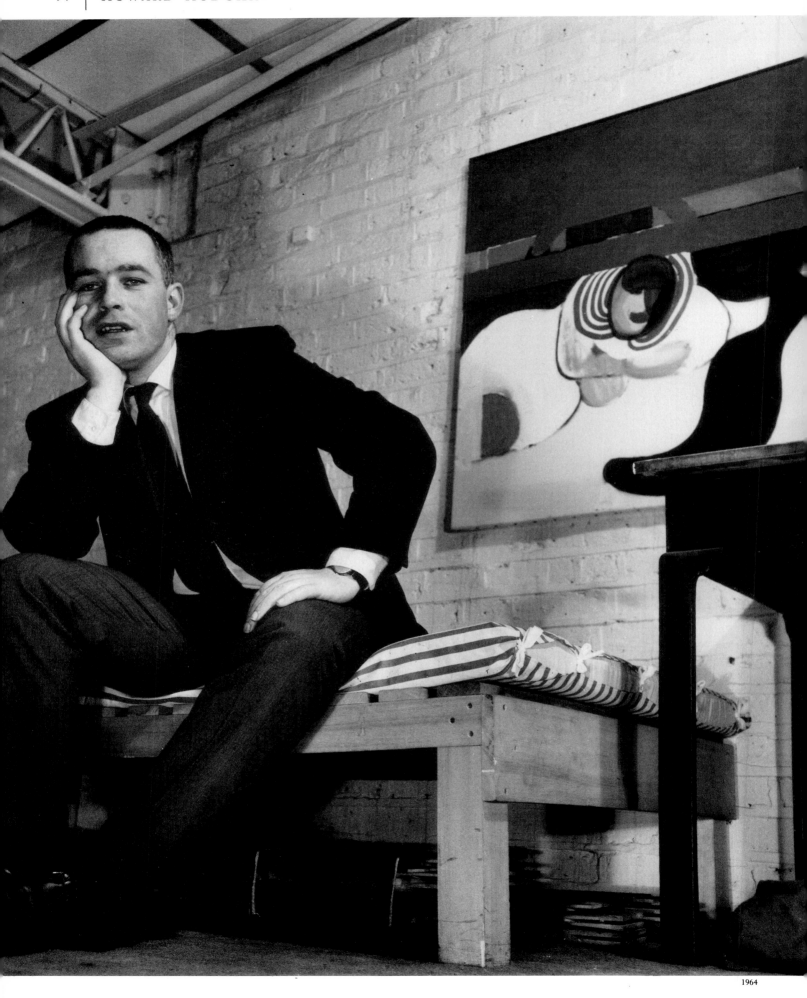

1964

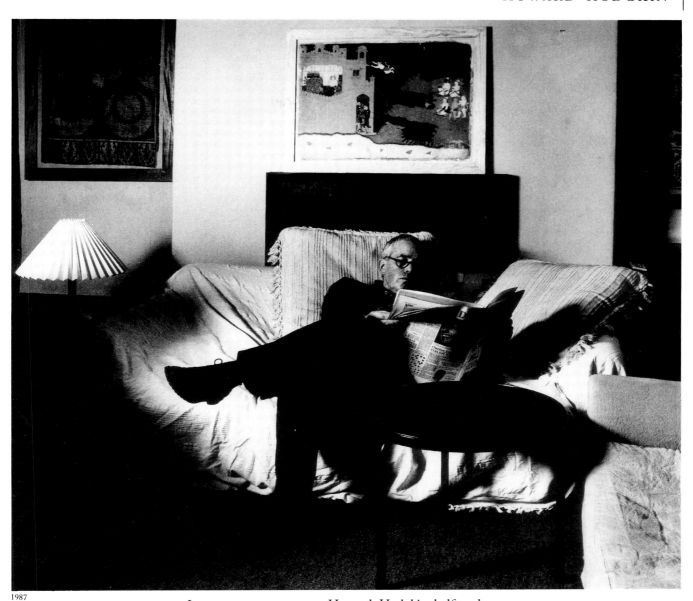

1987

I HAVE PHOTOGRAPHED Howard Hodgkin half a dozen
times, each in a different environment. The first occasion
was in 1964 in a large bare attic studio in West London.
Subsequently Hodgkin (together with several other artists,
among them Blake, Richard Smith and Joe Tilson) moved
to the country near Bath. There he occupied a large farm-
house. More recently I found him back in London in the
vicinity of the British Museum.

At first sight Hodgkin is an entirely modern and fashion-
able painter, highly regarded by the present-day art estab-
lishment, painting striking contemporary images. His own
flat is the reverse of what one would expect. It is cosy,
secluded and rather old-fashioned. It seems to suit its owner
well; he is quiet, urbane and self-contained. His paintings
seem at first sight abstract and impersonal; in fact they are
the reverse. They are generally occasioned by a specific
memory of a person, almost always Hodgkin's artist friend
or a collector. Usually the subject is seen or met in an envi-
ronment containing paintings by other artists. They are
neither abstract nor impersonal. They are often small and
intimate – they are anything but brash creations of a modern
abstract painter. Like their creator they are subtle, intricate
and highly subjective.

Howard Hodgkin

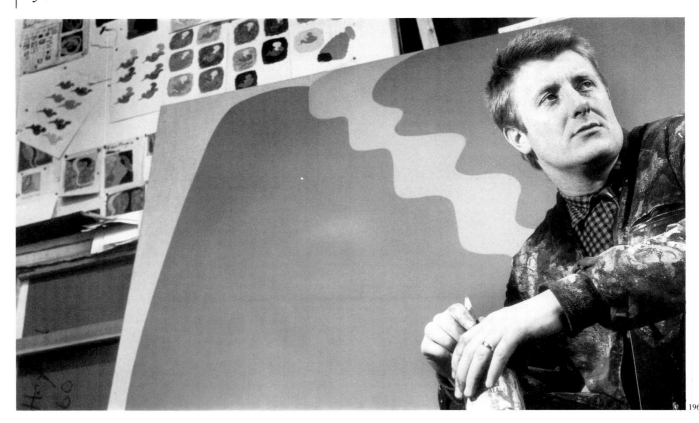

1964

JOHN HOYLAND seems to resemble his abstract paintings in appearance: a little heavy, square-cut, chunky, with no-nonsense about him – even when he was young. I photographed him first in 1963, in a cramped, dim and untidy flat in North Kensington when he was not yet twenty. Most of his paintings were in a square format, with hard-edged flat areas of interacting colour, but with wavy shapes and some youthful wiggles. Soon afterwards he went on the first of many visits to the United States, to be confronted with abstract-expressionism. The change in his work was immediate. His paintings grew in size, the edges became more important and the hard divisions between areas of colour became progressively blurred. Since then I have photographed Hoyland several times, mostly at his regular shows at the Waddington Gallery. Each time I liked his abstracts better.

As his paintings grew gradually freer and more assured so did his success. Now in his fifties, he lives in a comfortable apartment-cum-studio in a large converted office block in the City of London (Allen Jones lives two floors above him), and with the changed environment his paintings have acquired more sonority and the exuberance of full maturity. In his 1987 show the circular form became dominant 'and the new abstraction is as open as the sky', one of the critics remarked.

John Hoyland

1987

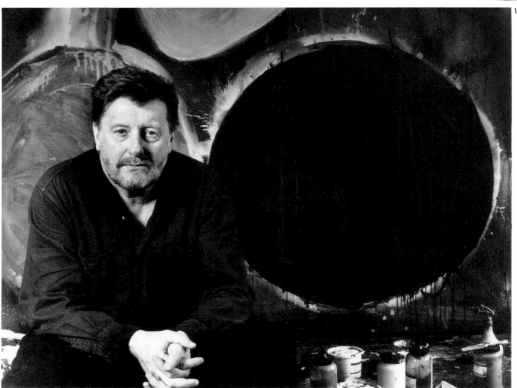

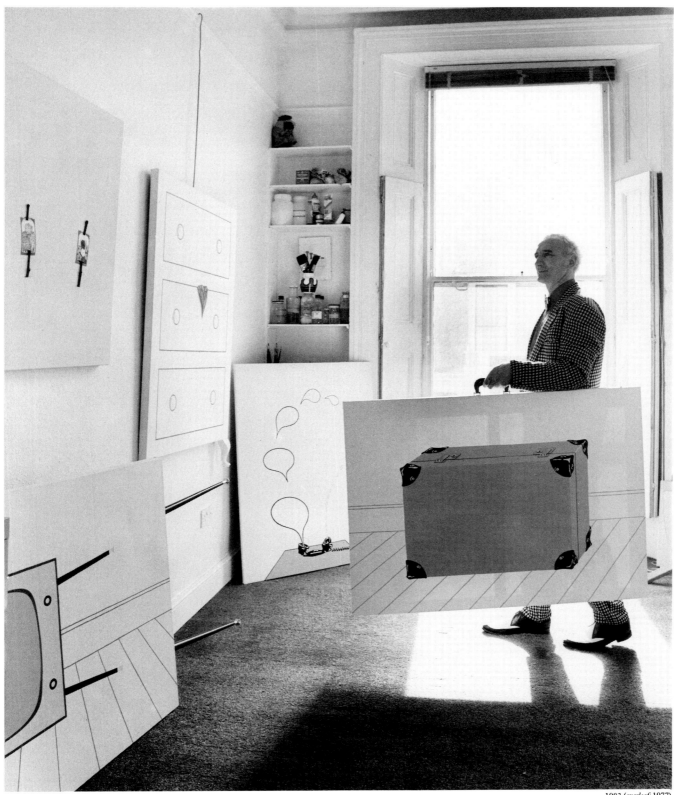

1983 (*overleaf*: 1977)

I HOPE PATRICK HUGHES, whom I count among my friends, will not mind my calling him the court-jester of British art. You go to his exhibitions not to admire the nuances of his technique (which consists of the simple use of flat commercial paint), or to ponder the evils of our civilization, or to get involved in socio-political debates. One invariably leaves his show or a visit to his studio in a better mood than one entered it: diverted, amused and full of admiration for his consistently inventive imagination and wit. But it would be wrong to say that Patrick's work is light-weight; while many of his visual inventions make us smile, they also stimulate reflection. He says his work deals with, 'Visual paradoxes. Serious humour. Formal figuration. Solid space. Perspective inside-out. Black and white rainbows. Oxymoron and pun. Substantial shadows. Real reflections. Vicious circles'. Even this list does not exhaust his range.

I photographed Patrick in 1966 during his first marriage and in his first house in South London, and then followed him – as he changed his dwellings and his ladies/companions/wives – to Chelsea, West London, St Ives in Cornwall, missing his sojourn in New York but catching up with him back in London.

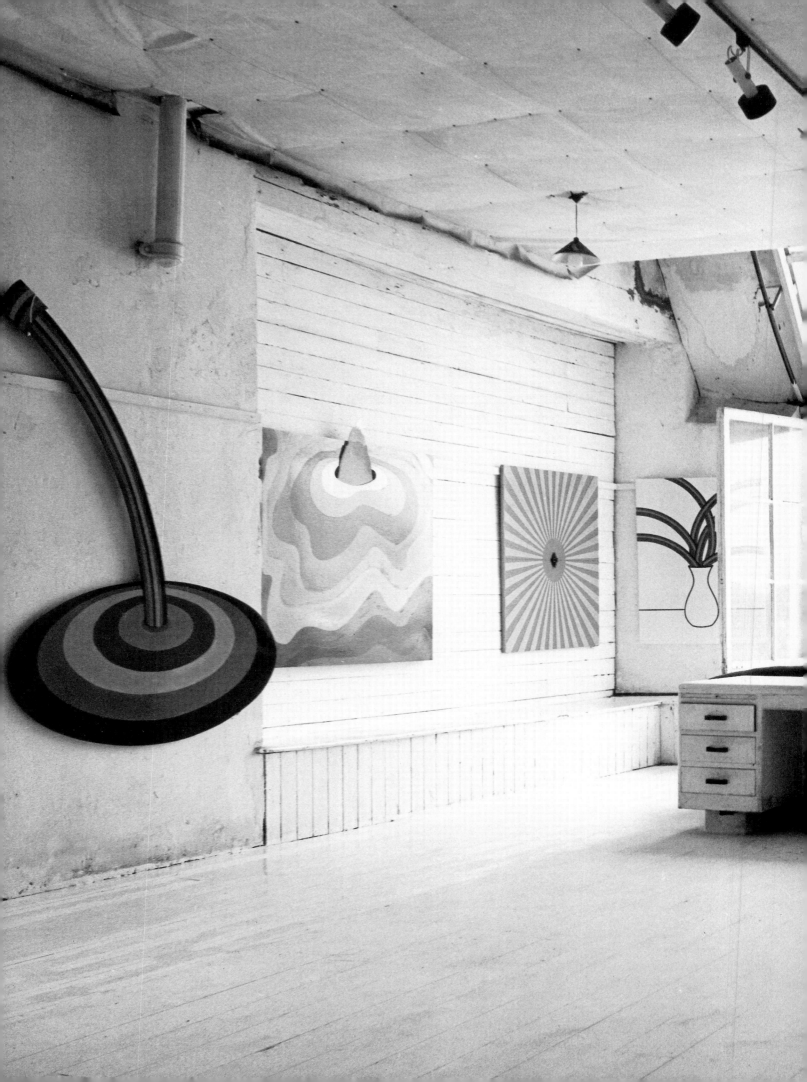

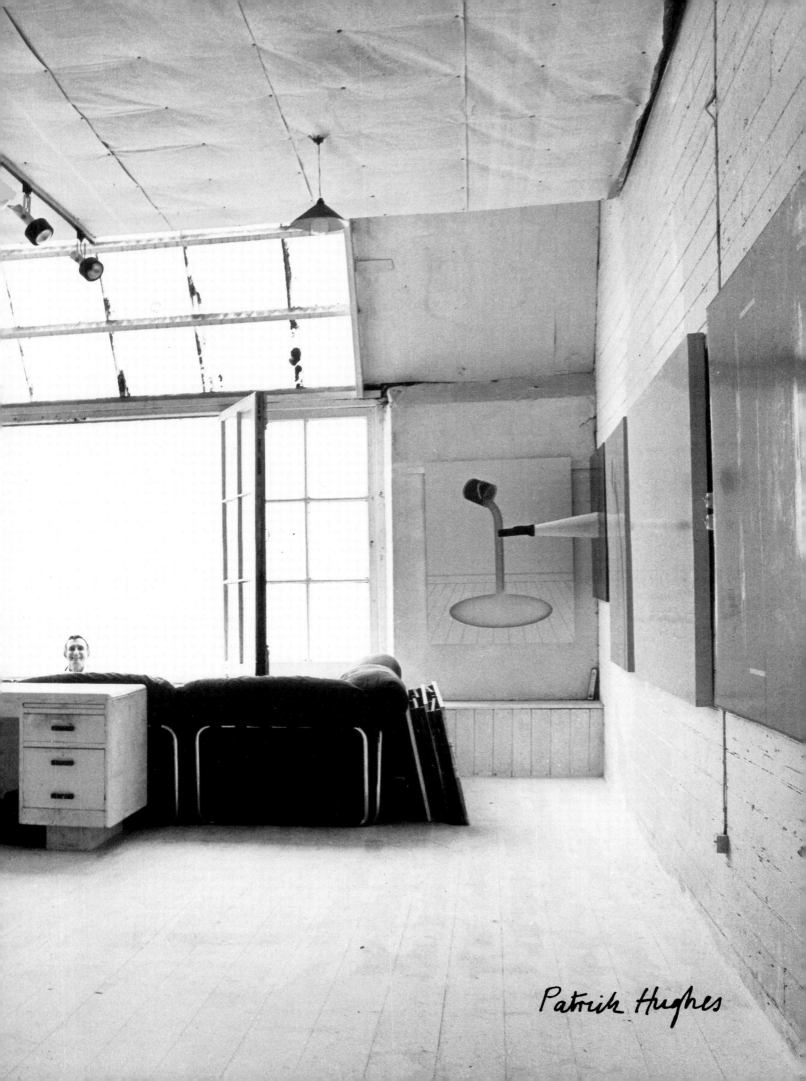

Patrick Hughes

Irvin '87

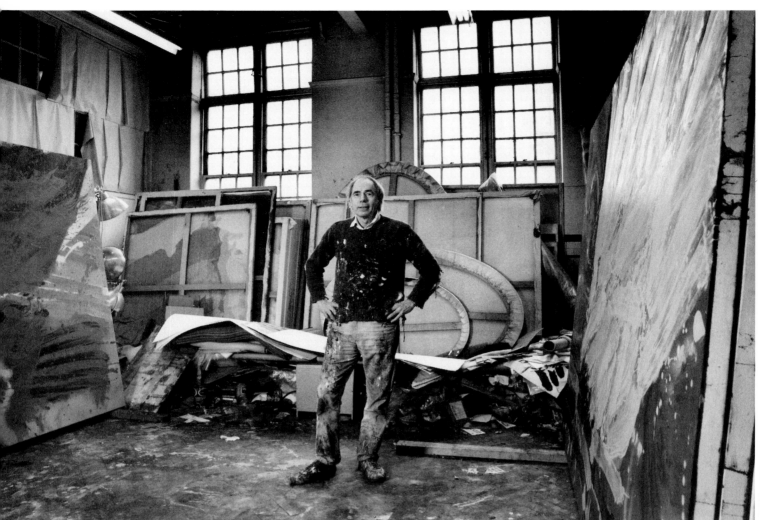

1983

'I'M IN LOVE with painting,' writes Albert Irvin. 'I rejoice in the manipulation of the paint. It's joyous, but it can be a bastard. I want the painting to happen as inevitably as tomorrow will happen; to be a natural occurrence.' Now on the wrong side of sixty, the lure of paint is as strong for Bert as it was forty years ago. He loves the act of painting – applying paint with brushes or anything that comes to hand.

Only this passion kept Albert Irvin going through many difficult years. Occasional exhibitions, hardly remarked, few sales and fewer critics' reviews. He supported his growing family by teaching until, as if by magic, things started to happen. In 1980 the Acme Gallery staged a well-presented show in the spring and John Hoyland, making a selection for the annual show at the Hayward Gallery in the autumn of the same year, gave Bert a prominent display. A year later Gimpel Fils gave him a large show, and soon afterwards 'Albert Irvin '77-'83', an exhibition travelling to Glasgow, Aberdeen and Birmingham, completed his emergence.

He was at last able to paint full time and teach only occasionally, with the security of his own large studio. His large canvases always required huge working areas; a small studio at home was like a cage for a lion. For some years he rented disused warehouses, at first through Riley and Sedgley at St Katherine's Dock, and later, when these had to be vacated, he got an alternative space in a disused school building in Stepney. Recently six of the artists working there, including Bert, bought part of the school outright. For him life began at sixty.

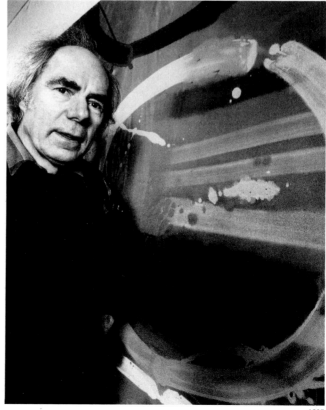

1987

1967

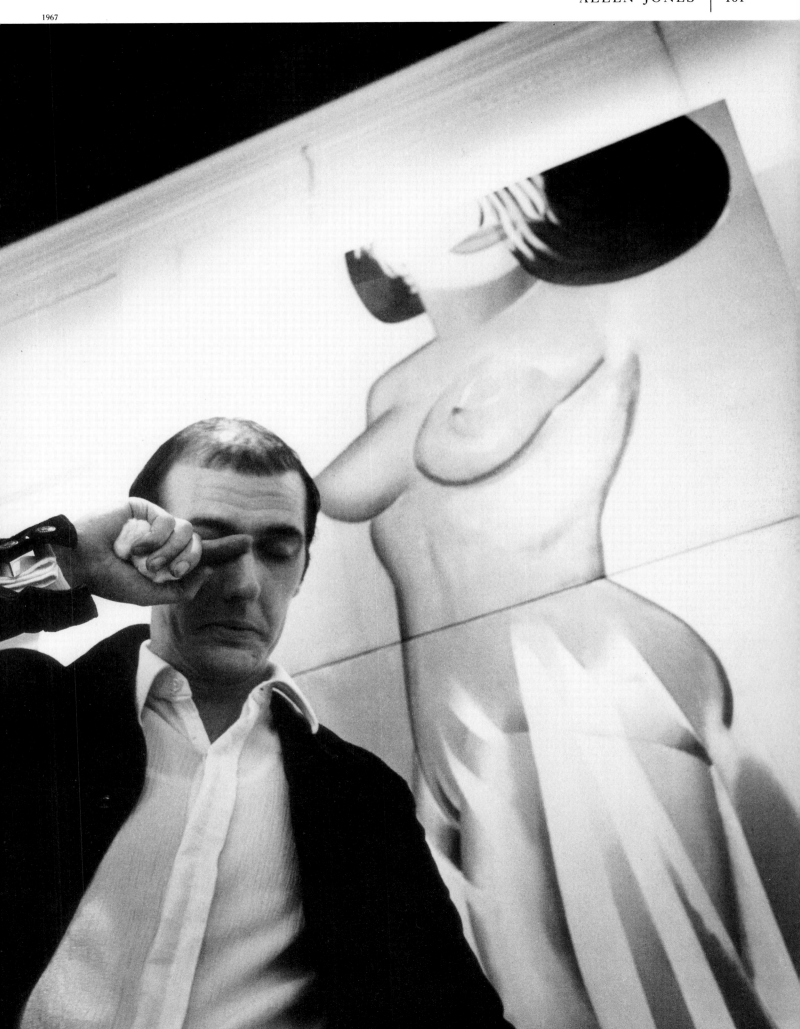

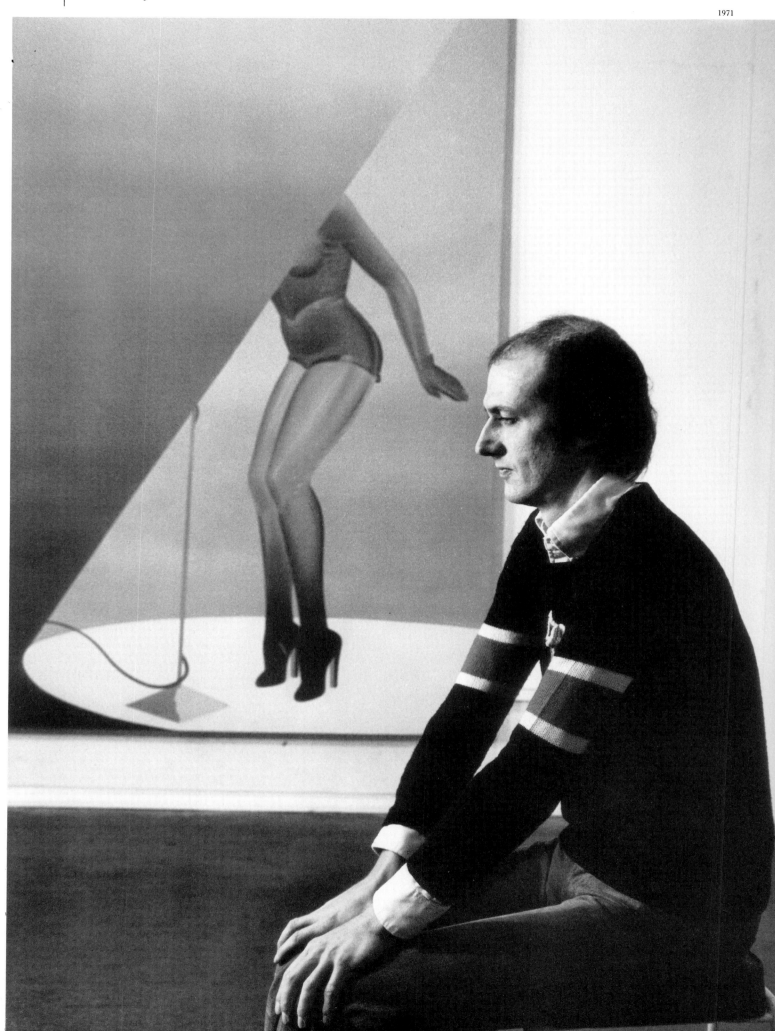

1976

1982

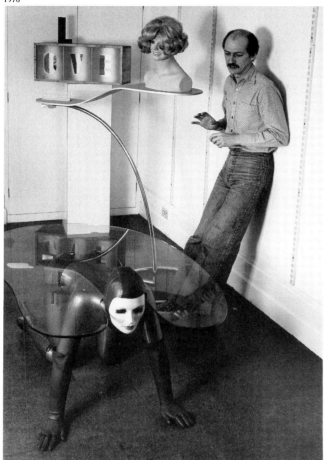

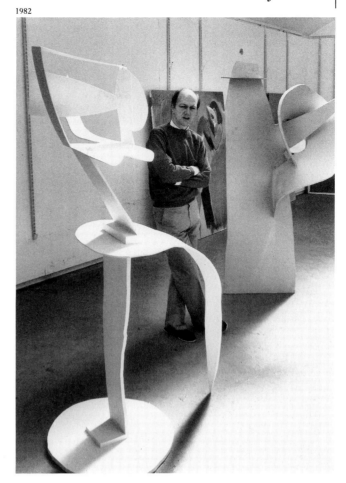

ALLEN JONES has been dubbed 'Britain's foremost sex artist'. Certainly no other serious artist has drawn, painted and, more recently, sculpted more shapely legs and rounded buttocks than Allen. But his interest in the voyeuristic aspects of sex was never entirely single-minded. When Allen Jones became famous in the early 1960s, together with the 'pop' artists from the Royal College of Art (though Allen himself was 'ejected' from the College after one year), it was not on strength of the erotic imagery which preoccupied some of his contemporaries, like Peter Phillips, but because of a brilliant series on planes, parachutes and especially buses. I missed the buses and caught up with him in 1962, when he was exploring his next subject, the hermaphroditic figures which mingled male and female roles, although the female figure was gaining the ascendancy. Allen had just married the beautiful Janet Children: her superb figure and legs managed to tip the scale. She was Allen's model for many years.

When I photographed Allen a few years later, the subjects were no longer ambiguous. The female 'dream-doll' – the male voyeur's ideal – was firmly established, with the emphasis on legs, high-heeled shoes, black stockings, fancy underwear and seductive bosoms. It was only a short step to his notorious sculpture/furniture with shapely, underclad girls supporting a glass table, acting as hat-rack or contorted into obscene armchairs. But these concoctions of the early 1970s were the climax of his preoccupation with sex objects (though I remember photographing him in 1976 painting an erotic portrait of a top American fashion model from photographs – a commission for an American millionaire who had ordered variations on the theme of the model from several top artists). The sexy 'dolls' have become more subdued, the theatrical voyeuristic setting more pronounced, and he lays greater stress on the painterly quality of the images.

On a recent visit to his sumptuous studio/apartment converted from two floors of an office in the City of London, I found he had turned towards semi-abstraction and the creation of three-dimensional abstract figures of dancers, made of painted plywood, no longer erotic but still beautifully shaped.

Allen Jones.

Tom Keating is best known as a forger who escaped pro-
secution for his skilful 'Samuel Palmers' only because of
serious illness. Though Keating failed to make a name for
his own work, he was a very gifted and knowledgeable painter.
His television series on Great Masters, their styles and
methods of work, was unique.

I photographed Keating for the *Observer* just before his
trial. He lived in a tiny house/lodge in two small rooms with
a young lady whose skills did not seem to include domestic
tidiness. Keating took me to his temporary studio, a large
classroom let to him during school holidays. It was filled
with paintings in a wide variety of styles: Renoirs, Picassos,
Lautrecs, Manets. Pride of place was given to a large portrait
of a middle-aged lady, painted in a passable imitation of a
Rembrandt. Keating explained that it represented his mother.
His mild joke was that this 'Rembrandt' included a realistic
still-life of a couple of herring wrapped up in a piece of *The
Times*.

A great talker, he very nearly convinced me that he forged
his Palmers to play a joke on incompetent art-dealers. Judging
by the 'Renoirs' and 'Manets', it was difficult to understand
how he had managed to get away with it. Perhaps these
were not the best of his creations and the Palmers, which
I did not see, were more convincing.

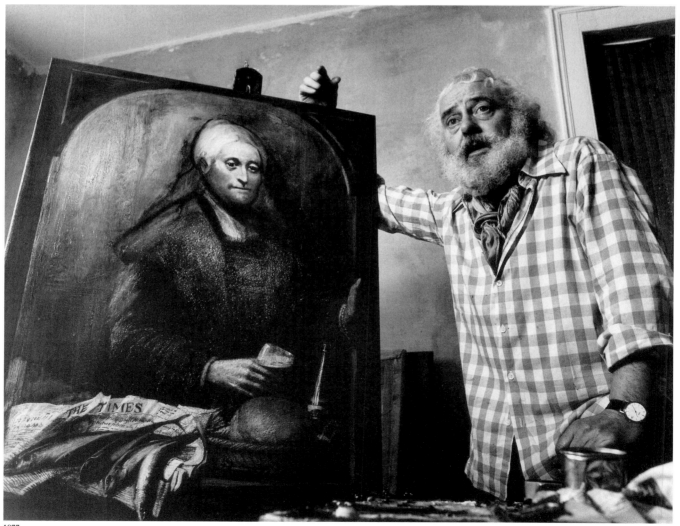

1977

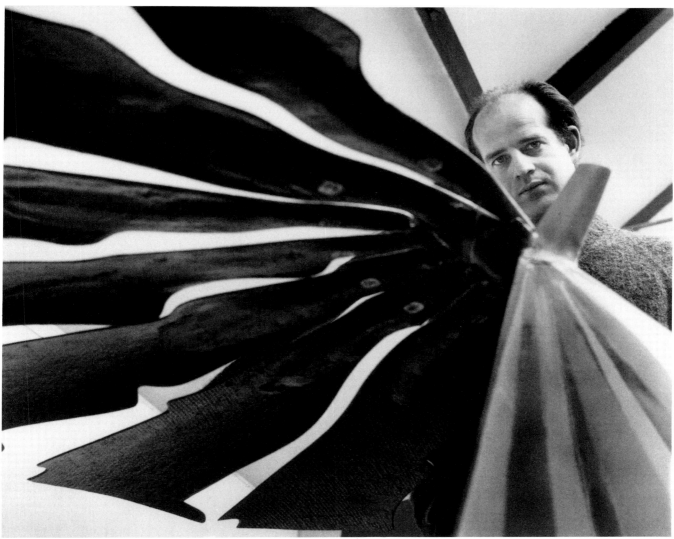

1964

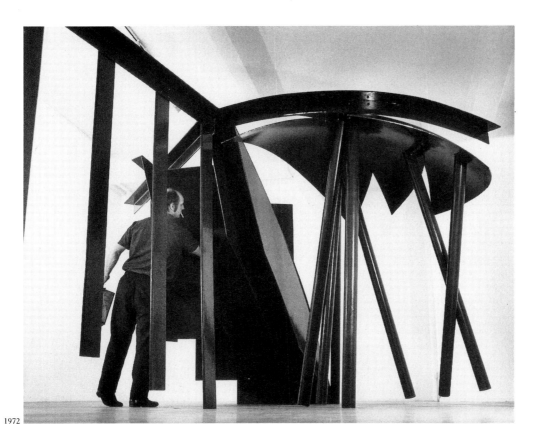

1972

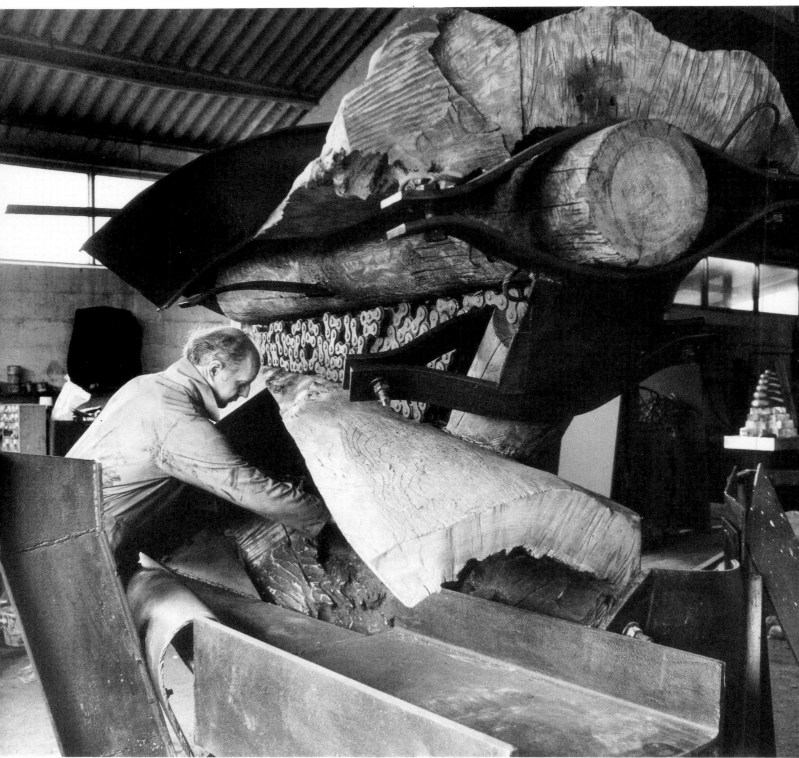

1981

SCULPTORS PROVIDE eloquent subjects for a photographer: their sculpture is a striking setting. This is very much the case with Phillip King. I enjoyed his early work especially: colourful, optimistic, light as a feather.

I first photographed Phillip in 1964 in a rambling attic studio full of light from slanting roof-windows, light which enhanced the floating effect of his light-hearted, twisting and turning fibre-glass creations. Five years later his work looked even stronger in the large areas of the Whitechapel Gallery, Phillip by then was working for the most part in black plastic.

Soon after this show he moved his studio out of London to Clay Hall Farm near Whipsnade, where he acquired a large hangar-like prefabricated shed. He had to move: he

had abandoned light plastic materials in favour of heavy, roughly finished steel and wood and, unusually for a sculptor, had started to experiment with slate from Welsh quarries. The change in materials changed his working methods. His huge workshop is now full of overhead cranes, large cylinders of gas and heavy-duty cutting instruments. The contrast between the work of 1964 and that of the late 1970s is enormous. I remember fondly the warmth and symmetry of the first session. While the work has changed, the artist has retained his charm and courtesy.

Phillip King

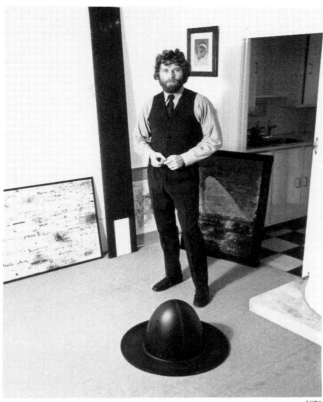

kitaj

1970

KITAJ IS A COMPLEX man and artist. His painterly paintings are full of literary and narrative elements and associations. Basically self-educated, with brief periods of study in various institutions, Kitaj has acquired a deep knowledge of history, art and philosophy, which finds its way into his work. He is an intellectual painter.

American by birth, Kitaj settled in England after the Second World War and studied at the Royal College of Art on a GI Bill (1959-61), where he influenced a number of 'pop' artists including Hockney, who became a friend.

I first met Kitaj in 1963 in a modest suburban house in South London, full of books but without paintings. On my second visit in 1970 – this time to a large West-End apartment – a black plastic hat in the middle of the floor alluded to his involvement with the poets of Black Mountain College in the United States. On the easel was an action portrait of a fashion model.

Since the end of the 1970s, Kitaj has lived with his second wife, the American painter Sandra Fisher (his first wife died in 1969), in a modern studio off the Kings Road. Books, nineteenth-century photographs and prints line the walls. Light streams through large windows overlooking the back garden.

1963

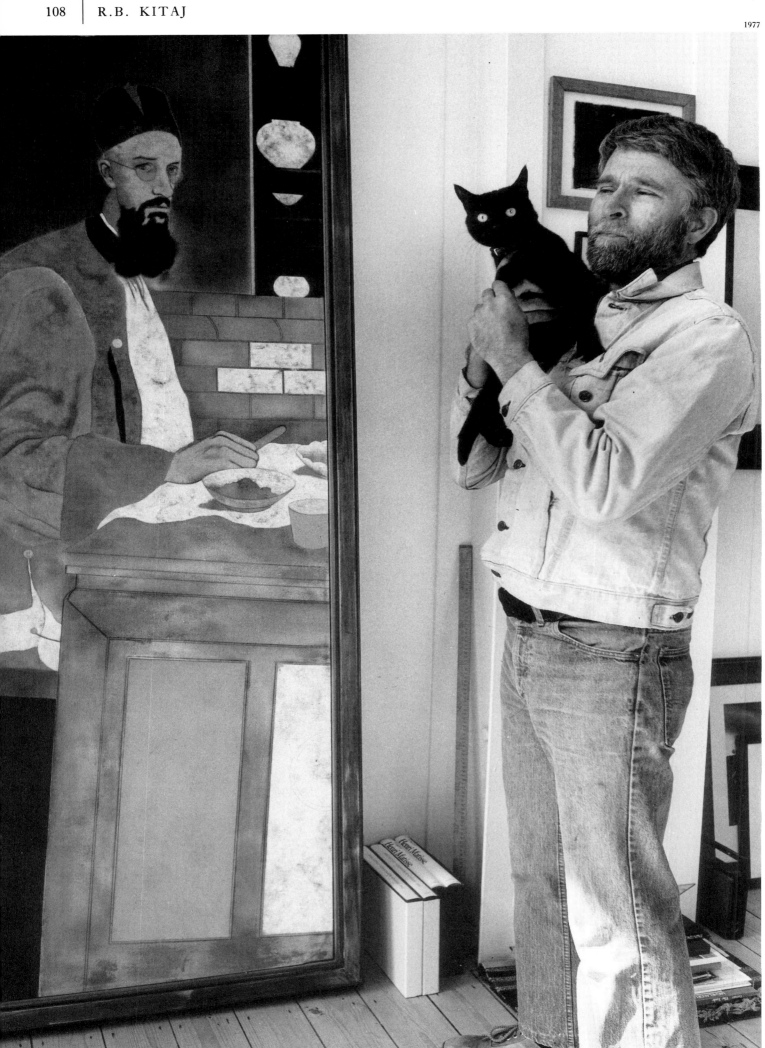

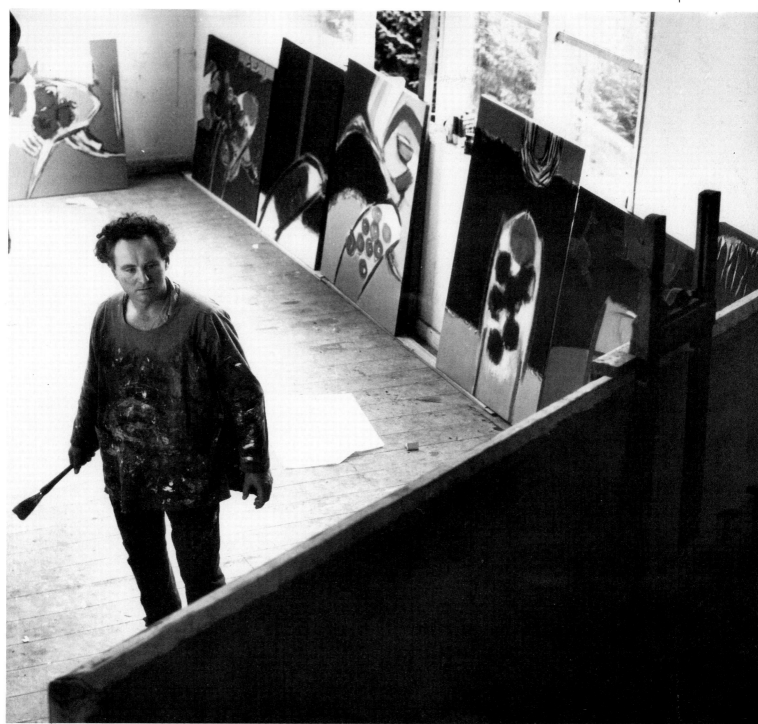

1962

STEFAN KNAPP is a Polish artist who settled in England after the Second World War. Our very first encounter was at a large costume ball organized by the Polish Combatant Association in the early 1950s. I noted a tall, handsome, dark-haired man dressed as a skier and dancing with a pretty girl. The face seemed familiar but I could not place it. Later in the evening he approached and said, 'Don't you remember me? We spent twelve months together in a cell in the Soviet Union.' In my defence I must add that the cell contained more than two hundred people.

Stefan Knapp, though a fine painter specializing in a subtle method of painting with a spray-gun, gained worldwide recognition for his paintings on enamel, fired in a kiln which he invented and perfected. He has fulfilled numerous commissions for huge murals, including one for Heathrow Airport, the Polish University of Kopernicus, and several in Germany, France, Canada and United States. I regret that I did not know about his commission for a mural for the Alexander Stores in New York which measured nearly one hundred feet in length. Stefan hired an aircraft hangar to assemble it and I would love to have photographed him gliding on his skis over the vast enamel surfaces.

Another commission was for a series of enamels to decorate the palace of an emir in Dubai. This one Stefan completed in his Surrey studio in Wormley, where he has converted and modernized a delightful seventeenth-century cottage.

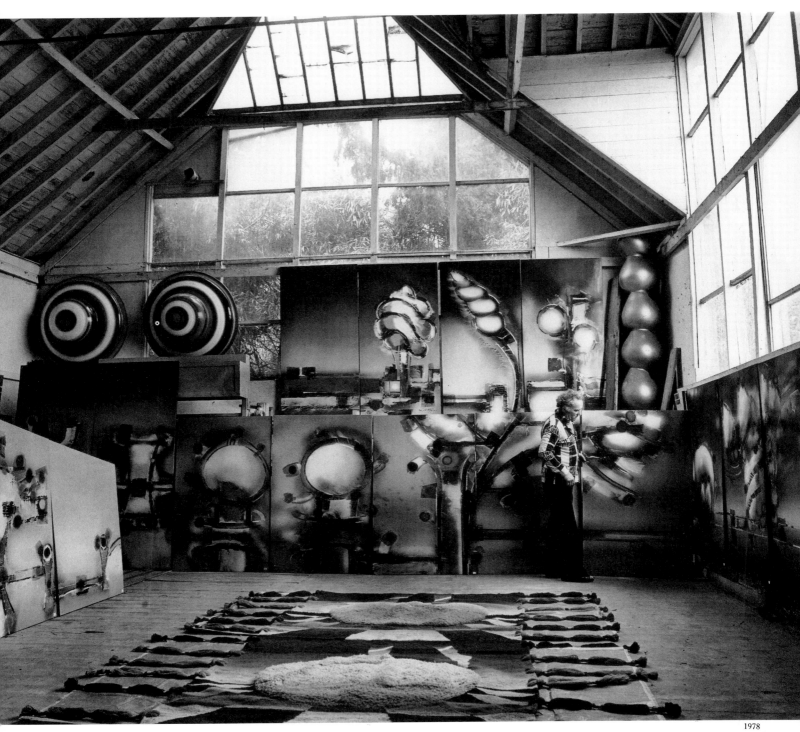

1978

LEON KOSSOFF works and lives in a neat detached house in North London. In the hall not a speck of dust on the floor, the walls immaculate in cream colour, the carpet freshly cleaned. To the left, a door is slightly ajar: in the opening a pair of boots, a work of art in themselves. Their surfaces are covered with thick multi-coloured oil paint and even the laces have stiffened over the years with dried paint. These are Kossoff's working boots. The studio lies beyond the mysterious door.

The sides of the large room are uncluttered and give the impression that the centre of the room is cordoned off, as in a museum. This central stage, where the artist works, is a little elevated – over the years it has risen on dried scraped paint and successive layers of newspapers. Several paintings are propped on both sides – the works in progress – and tins of paint, some full, some empty, are everywhere.

This is the second of Kossoff's studios that I have visited. The first was a large dilapidated shed in the middle of an untidy railway property adjacent to Willesden Junction. Within the dark, cavernous shed/studio there was no clean area – the whole shed was a huge painting.

Kossoff, like Auerbach, uses very thick layers of oil paint, applied to the surface of the canvas with broad, generous strokes of the brush; the painted surface is allowed to dry for a considerable time and when congealed is given another coat, then another until the painting is complete. Both painters focus on similar subjects: nudes, portraits and building sites. Kossoff loved Willesden Junction, its maze of railway-lines, trucks, smoke and movement.

Kossoff and Auerbach are dedicated painters, though it was Auerbach who initially caught the attention of the galleries and the public. But Kossoff is a fine artist, and a gentle, amiable man who has come into his own.

1971

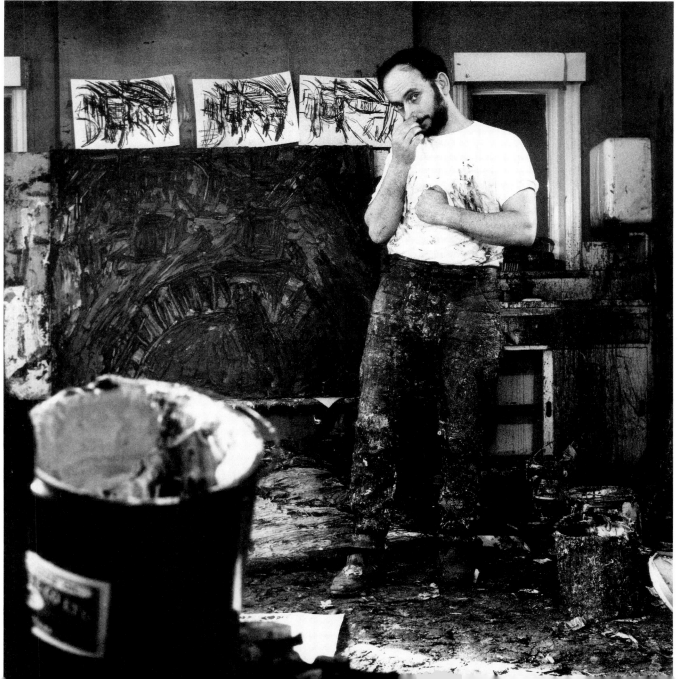

I PHOTOGRAPHED Peter Lanyon once only, in 1963. A few years earlier he had taken up gliding, in order to see his beloved Cornish landscape without interference. He said, 'The pictures now combine the elements of land, sea and sky – earth, air and water.' A year after my visit he died in a gliding accident.

Of all the painters of the St Ives School, Lanyon was the only true Cornishman, born and bred there; Cornwall became his overriding passion both in life and in his paintings.

He lived with his wife and six children just outside St Ives, in a large, rambling house surrounded by trees. A newly-built shed housed the glider and next to it was his studio – a high converted barn. At the time of my visit Lanyon was painting a very large mural. It represented a slice of Cornish landscape seen from the air: swirling rapid brush-strokes of brown/violet for heather, blue/green glimpses of the sea and patches of yellow overlapping. At first sight an expressionistic abstract, but Lanyon's paintings were never abstract: they were faithful impressions of the land he loved.

1963

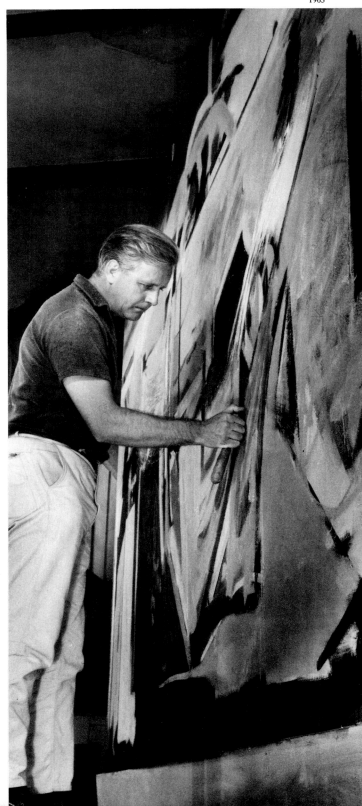

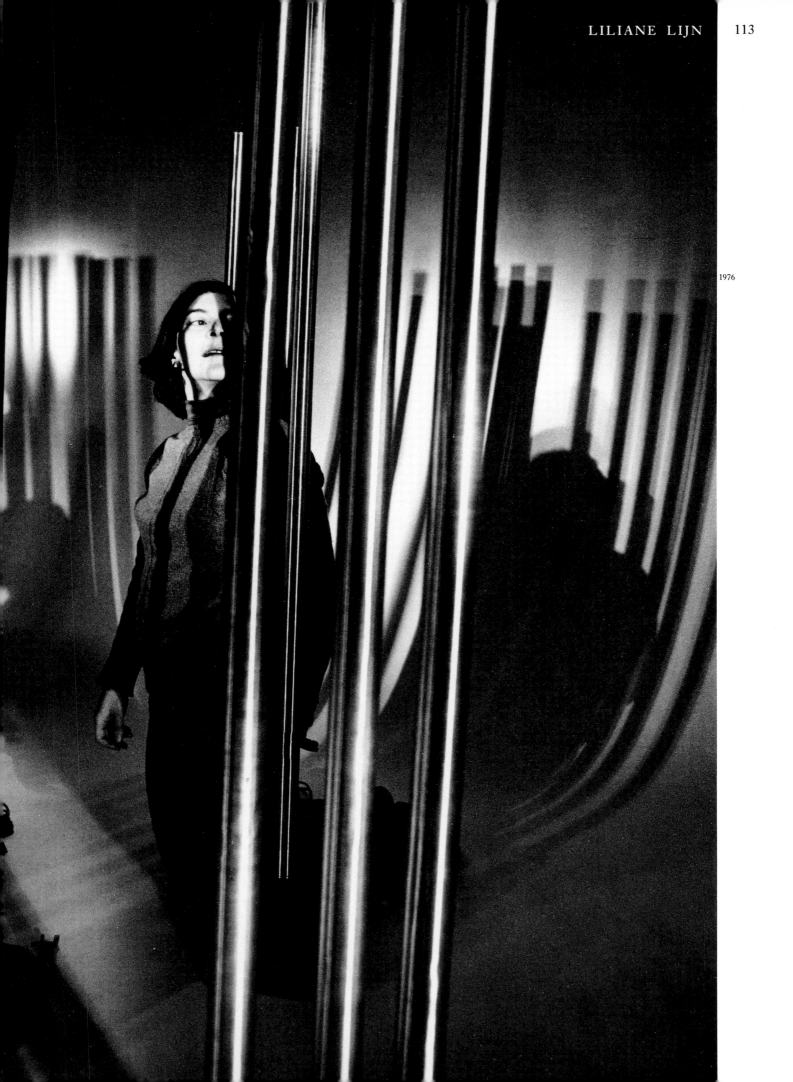

1976

IN THE SPRING of 1968 I was invited to a house in Hampstead to view some of the owner's new acquisitions. The object which caught my eye the moment I arrived was in the garden. It was already well after sunset and in the dusk I saw multi-coloured bands of light performing an intricate dance. It turned out to be one of Liliane Lijn's kinetic pyramids. I managed to get an invitation from the artist to visit her studio near Holland Park, and I have been hooked on Liliane's magical structures ever since. Over the years I have seen many of her inventions: she has never repeated herself.

Although many of her sculptures move, driven by electric motors, and perform functions regulated by built-in computers, she is not strictly speaking a 'kinetic' artist (like her first husband Takis), but an artist working in light. Light is Liliane's medium: functions and transformations of light fascinate her. Movement is incidental. Had she worked in France or the United States, her work would have been celebrated. Her comparative neglect in Britain is due to the blindness of those who run official art organisations and to Liliane's own reluctance to push herself. Nevertheless, even as I write, Liliane is setting up her new exhibition at Fisher Fine Art Gallery. Her remarkable 'Goddesses' which sing, emit steam and communicate by laser beams, ought to be a hit.

Of Ukrainian parentage, American by birth (Lijn is an adopted name) she now lives with Steven Weiss (a fine amateur photographer and an industrialist) and their two children in Camden Town. Her studio is a few hundred yards from her house.

1987

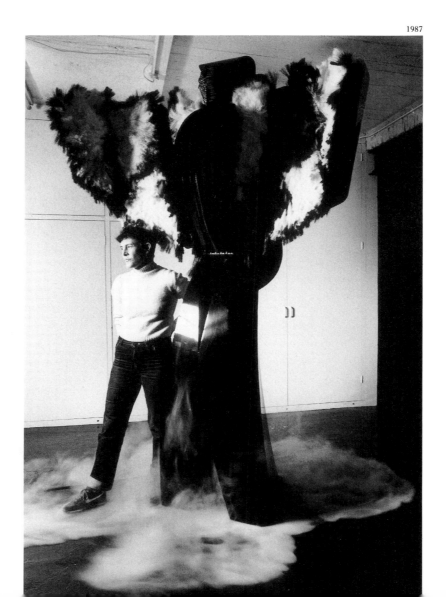

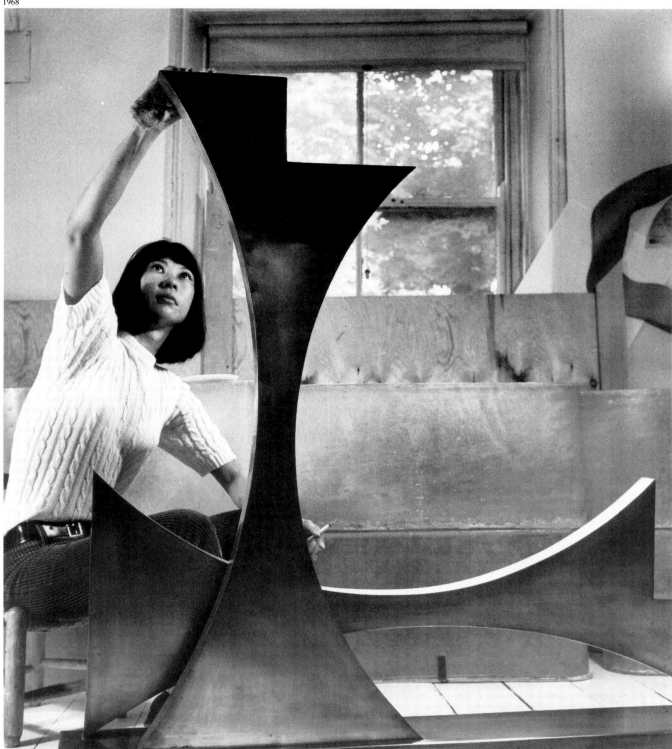

KIM LIM, Chinese by birth, has been resident in this country for most of her life. She is slim, delicate and graceful – very much like her work. Her sculpture is entirely abstract and now mainly in white stone or marble. Sometimes two or three pieces of stone are combined in simple design, but with exquisite balance and elegance of suggested curvilinear indentations and incisions. Some of her sculptures resemble Japanese garden sculpture in spirit – serene, harmonious, meditative.

Kim Lim has concentrated on sculpture in stone for some years; before that she used plaster which she sometimes painted. Even then (I photographed her first in 1968) her shapes and lines were simple and delicate.

Kim has long been married to Bill Turnbull and they have two sons. When the boys were growing, regular sculptural work was difficult and Kim turned for a time to photography, especially of sculpture: her own, her husband's and other sculptors'. She also concentrated on print-making and later held an important exhibition of prints at the Tate in 1977. Now again photography is only a sideline, her beautiful sculptures the main focus.

MY PORTRAIT of L.S. Lowry is the 'fake' in this collection. It was not taken in the personal environment of the artist nor among his works. I never managed to get an appointment to photograph Lowry in his house in Mottram-in-Longdendale, three miles from Glossop in Derbyshire, where he had lived since 1948. Instead, I was allowed to photograph him on one of his rare visits to London. By then he was already seventy-seven years old, but still in robust health and full of life. He did not mind being loaded into my car for a short excursion from his regular hotel near Russell Square to a dilapidated industrial area in the vicinity of King's Cross. Since I had selected a location for the portrait (reminiscent of Lowry's favourite settings), it did not take very long. In fact Lowry enjoyed the experience and we spent an hour or two talking about contemporary art (which Lowry did not think amounted to a great deal); the meeting concluded with tea and fruit-cake in a real transport café. When I apologized for photographing a Manchester artist away from his usual haunts, he consoled me by saying that a few of his paintings were set in London.

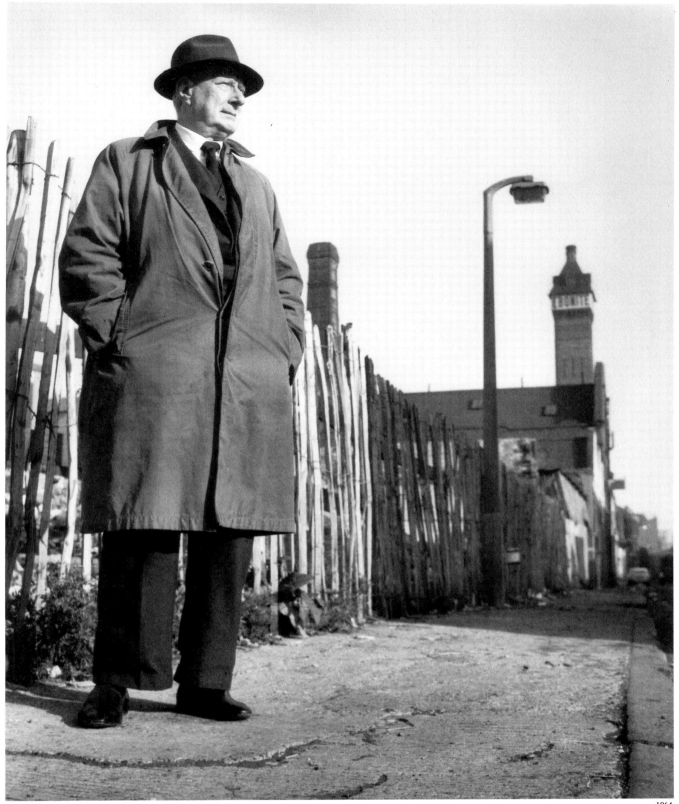

1964

L.S. Lowry

DENIS MITCHELL'S workshop/studio is at the end of a particularly perilous drive up a steep hill rising from the harbour in Newlyn, Cornwall. A converted, grey school building stands on the right. Visitors must find a parking-space in an exceedingly narrow lane and remember to set their hand-brakes securely.

Denis usually works outside in a spacious yard overlooking the bay. A small workshop inside is reserved for work on maquettes and miniature sculptures. Denis made the transition from realistic sculpture and painting to abstraction around 1949 and has never wavered since. At more or less the same time he started to work for Dame Barbara Hepworth, becoming her chief assistant in 1959. Eventually he left Hepworth and took up part-time teaching. In 1967 he abandoned that and since has sculpted full-time.

For most of his adult life Denis has lived in St Ives. The personality of Dame Barbara has shadowed him and his work. Even though some of Denis's work bears a resemblance to the carvings of his master, he is a very individual and strong talent in his own right. Much of his work is near in spirit to Brancusi's, but it was difficult for Denis to shake off the constant presence of the finest British woman sculptor. Had he lived in a different part of Britain, he might have made his mark sooner.

1974

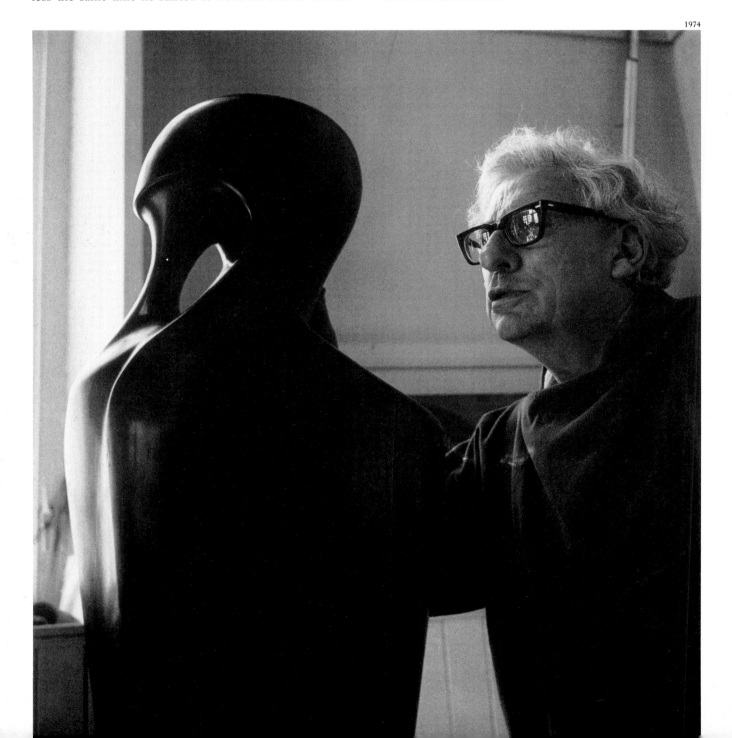

1962

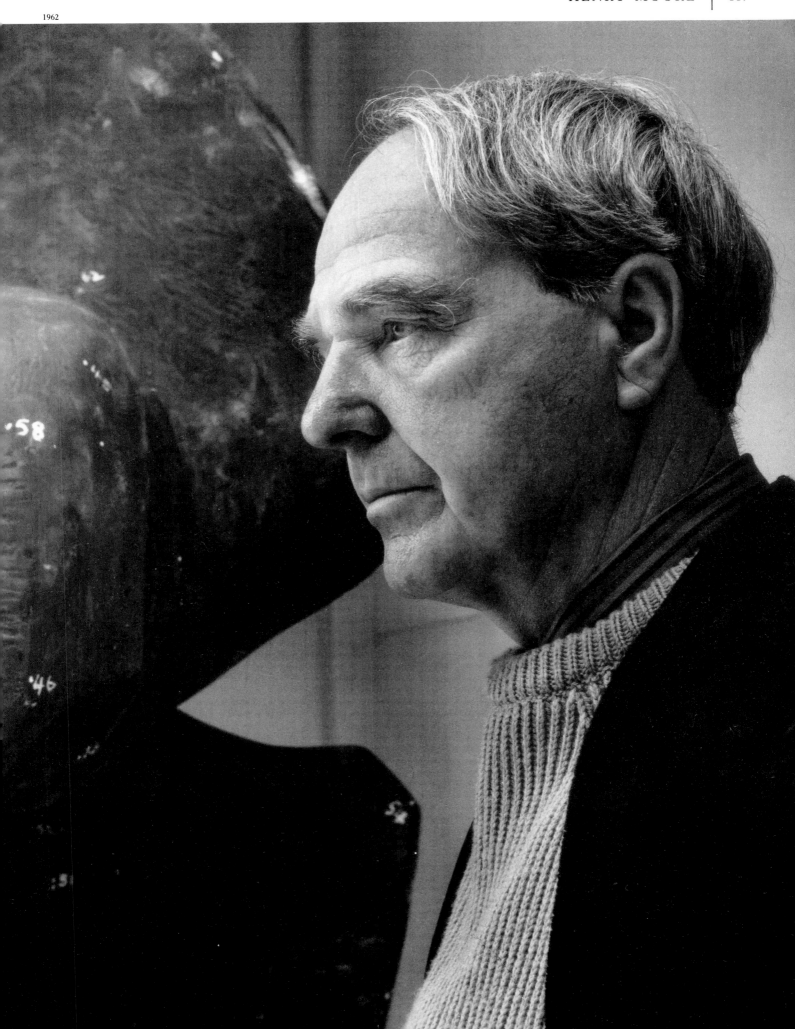

AFTER 1940 when his studio in London was bombed, Henry Moore moved to the village called Perry Green, near Much Hadham in Hertfordshire. You left the main road at the pub, splashed through a ford, climbed a winding road, and there it was across a patch of green. An unassuming, old-fashioned bungalow, white and neat, with a small building beside it. This was the first studio and workshop to be built. It came to be used for small sculptures, drawing and meditation.

Slanting rays of sun from the skylights illuminated quiet corners, revealing small forgotten statuettes, tiny maquettes long since grown up into famous sculptures scattered around the world. It also contained pieces of stone, bone and other materials – *objets trouvés* – which Henry Moore loved to collect. He often fished one out of a heap on the table and turned it in his fingers, feeling textures and forms. Some of them provided starting points for a new sculptural shape or image.

From this small studio one crossed a narrow hall with overcoats, raincoats, galoshes – necessities for the English climate. A bicycle was propped outside the door – Henry Moore's means of conveyance to the outlying studios. Then past Mrs Moore's domain – a beautifully kept flower and vegetable garden – to the wide lawns and grounds stretching half a mile or more. In the distance the squat shapes of three newer studios, a small square pond – provisional site for a smaller version of the Lincoln Memorial sculpture – and all around, Henry Moore's sculptures as if emerging from the ground, at home with the trees and the landscape. Most of his sculptures were conceived for outdoor viewing, and they look best under the open sky. The background of trees and clouds, the diffused outdoor light made them formidable and dignified. From time to time Henry Moore bought odd parcels of land adjacent to his property, extending his holding, so that his sculptures never crowded one another. Long before his death he bequeathed this area to the nation.

I had the privilege of visiting Henry Moore in Much Hadham on many occasions, first in 1963. He took trouble to show me everything, explain patiently every detail. He kept no professional secrets and no unreasonable request would be denied. He was a gentle, urbane host, always courteous even to an interloper like me.

1963

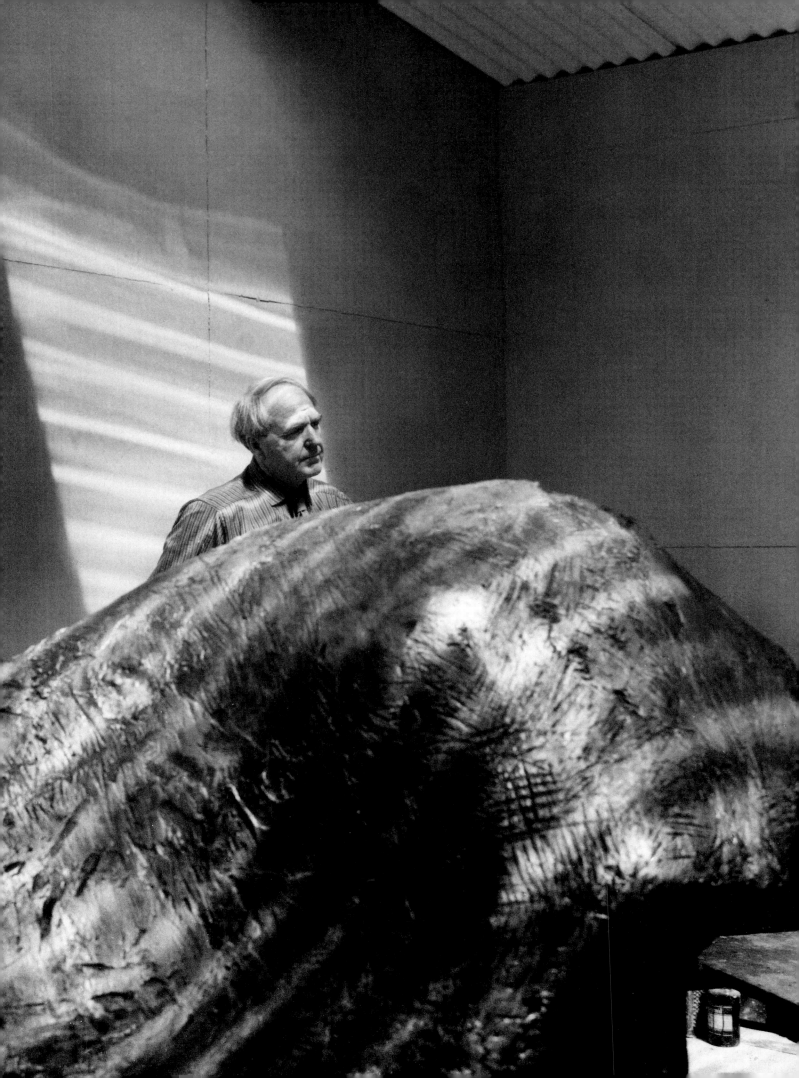

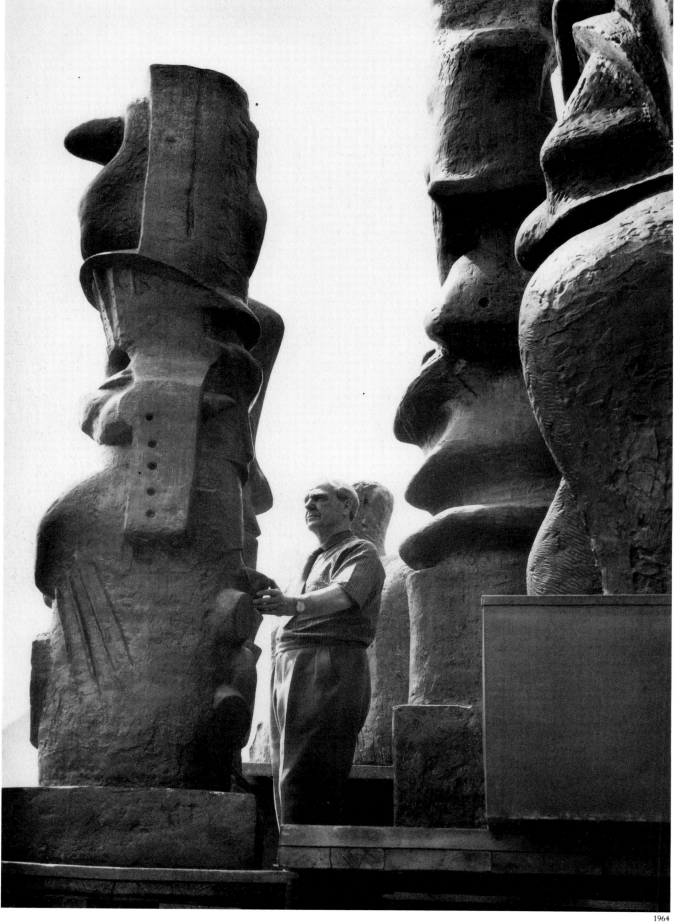

1964

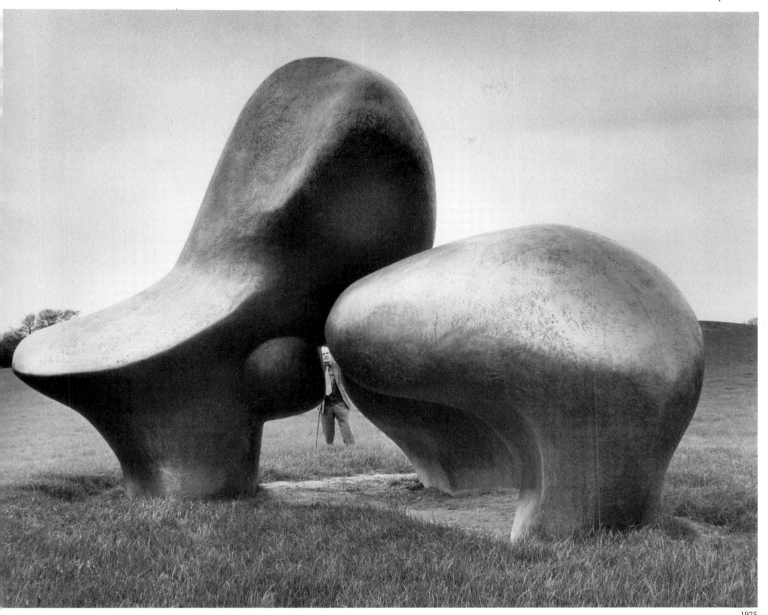

1975

Henry Moore

1987

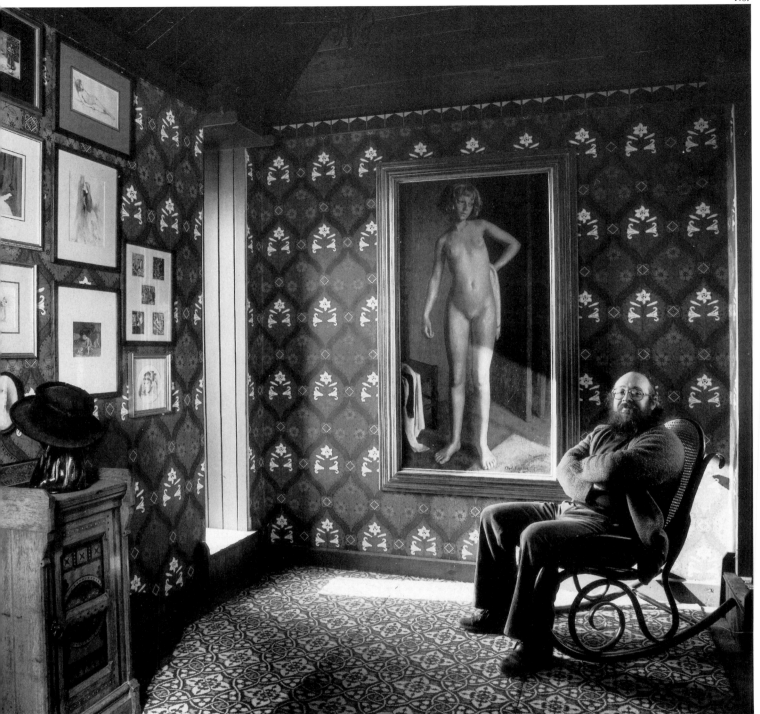

GRAHAM, IT SEEMS TO ME, was born by divine miscalculation one hundred years too late. Had he been born around the time of Queen Victoria's accession, he would have made an outstanding member of the Pre-Raphaelite Brotherhood. He even looks a little like the portrait of Rossetti by Lewis Carroll: shaggy beard, battered wide-brimmed hat, open shirt. But Rossetti was more of a dandy, and rather neurotic and unstable, which Ovenden is not. But his style of painting – meticulous in detail, smooth in texture, brilliant in colour and totally realistic – would have been in context then; Graham's work is certainly technically superior to Rossetti's.

The walls of the mansion-castle which Graham is slowly building out of slabs of granite in a remote part of Cornwall are covered with a superb collection of Pre-Raphaelite drawings and paintings, and he feels closer in spirit to Carroll or Morris than to any modern artist. He used to paint and

photograph girls in the nude, attracted by the innocent beauty of their young bodies. One series of paintings was inspired by Carroll's Alice.

Ovenden tried to revive the spirit of the Pre-Raphaelite Brotherhood of painters, fired by common ideals and objectives, and was instrumental in organizing the Brotherhood of Ruralists with David Inshaw and Peter Blake. They held a number of exhibitions and the Brotherhood still meets regularly.

Like Carroll, Graham has a passion for photography. He is a fine creative photographer, and he was among the first to collect Victorian photographs, discovering many unknown masters.

Graham S. Ovenden

1963

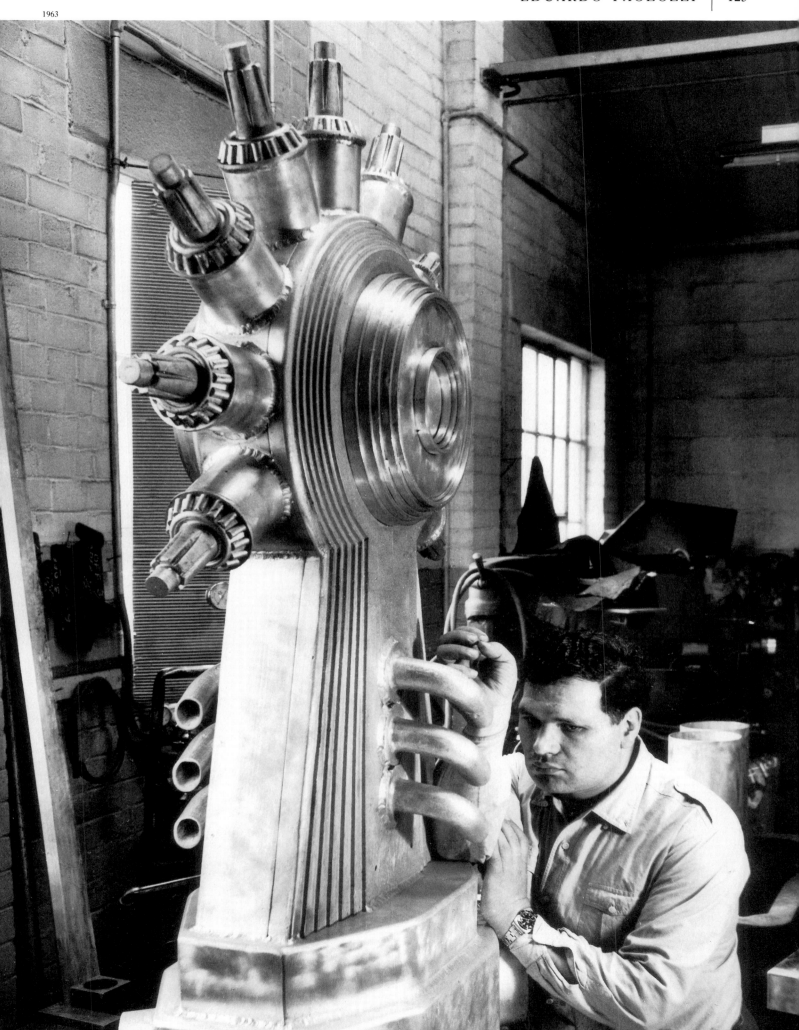

Eduardo

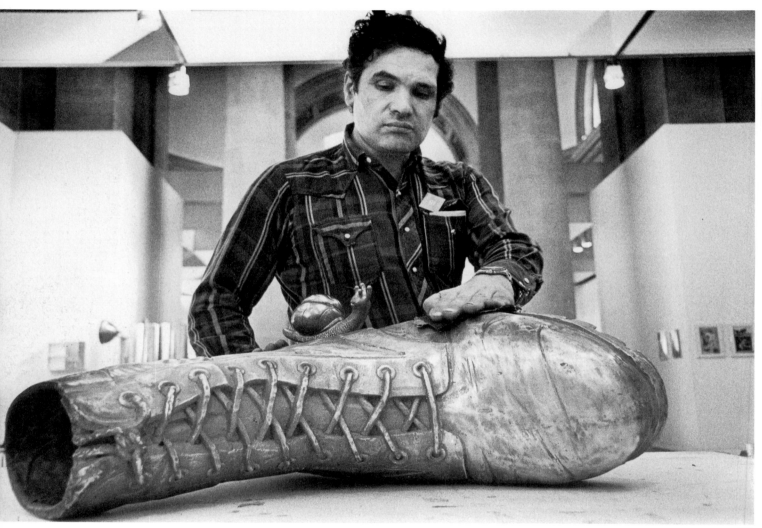

1971

EDUARDO PAOLOZZI is a huge, not especially tall, nevertheless exceptionally powerful man. He used to practise judo and achieved a high grade of proficiency. He gives an impression of barely contained energy. He is often brisk, almost aggressive in movement and speech. The domain of his art is huge too, perhaps the most far-ranging of all the artists I have met in intellectual scope, interest and obsessions. Paolozzi once said, 'All human experience is a collage.' This is his creed. His sculptures and prints are based on an intricate collage of images, objects, impressions and experiences. Everything he does is on a grand scale, whether it is a series of multi-coloured and intricately designed prints or huge, robotic sculptures or the brilliant décor for Tottenham Court Road Underground station, installed in 1985.

Paolozzi [signature]

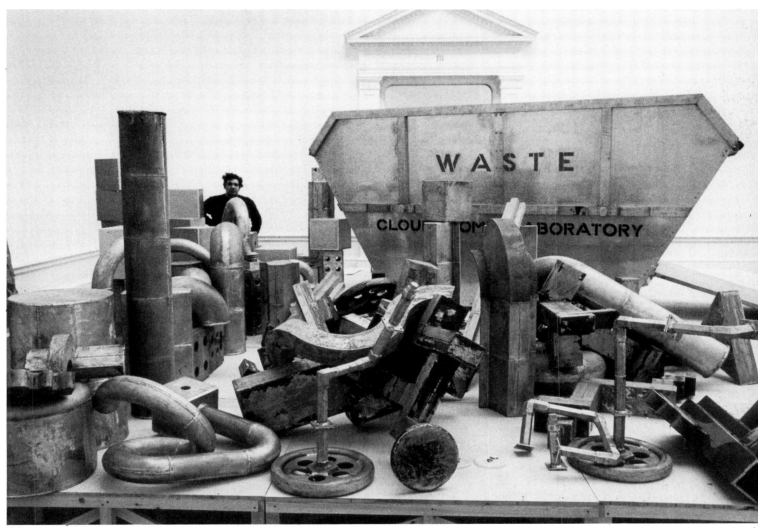

1971

I first photographed Paolozzi in his large London studio-workshop, full of machines and pulleys, but dominated by sculptures resembling vast juke-boxes. The second workshop I visited was a substantial part of a large mechanical workshop in Essex. Huge lathes and other machines were manufacturing specific parts for Paolozzi's sculptures and the artist hovered purposefully with knotted brows and a scowl on his face, supervising the assembly of large shiny sculptures. Later he painted some of them in flat colours.

Paolozzi is an artist of moods. At times amiable, accessible and gracious, at other times he becomes curt and gruff, especially when things do not go according to plan. His grand retrospective at the Tate Gallery in 1971 was stormy. Some people objected to the random way he insisted on showing his work. The artist was not pleased.

VICTOR PASMORE now lives and works in a Regency house overlooking the green expanse of Blackheath in south-east London, or in his house in Malta. The beautiful London house attests to Pasmore's success as an artist.

Pasmore has had two artistic careers. The first was in the 1930s and 1940s and was characterized by a delicate, Whistlerian vision of English landscape, with a preference for the Thames Valley view of the river. Largely self-taught, his paintings became fashionable and highly praised. But in 1947/8 he decided that figurative, post-impressionist painting was not for him and turned to a severe and rather cold abstract style, reminiscent of Bauhaus and Mondrian. His faithful followers were not pleased. Pasmore left London and for seven years taught at Newcastle University. But his determination to persist with abstraction paid off (with considerable assistance from official artistic circles) and he is again praised and famous.

From the early 1950s Pasmore also turned to abstract constructions, mainly of painted wood, rather rough-looking and at times sloppily finished, but his taste and an unerring feeling for shape and placement redeemed them.

His spacious studio in Blackheath, which I visited only once and after lengthy negotiations, has the appearance both of an artist's studio and of a craftsman's workshop, with completed and unfinished constructions sharing space with severe, striking abstracts.

Pasmore himself, with a grizzled beard and prominent shaggy eyebrows, cuts an impressive figure – cool and aloof and on occasions decidedly brusque.

1964 (*opposite:* 1984)

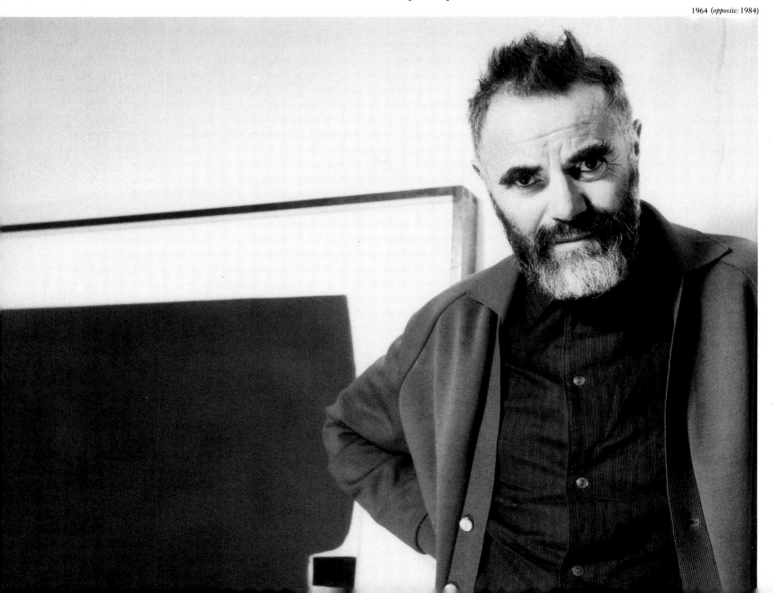

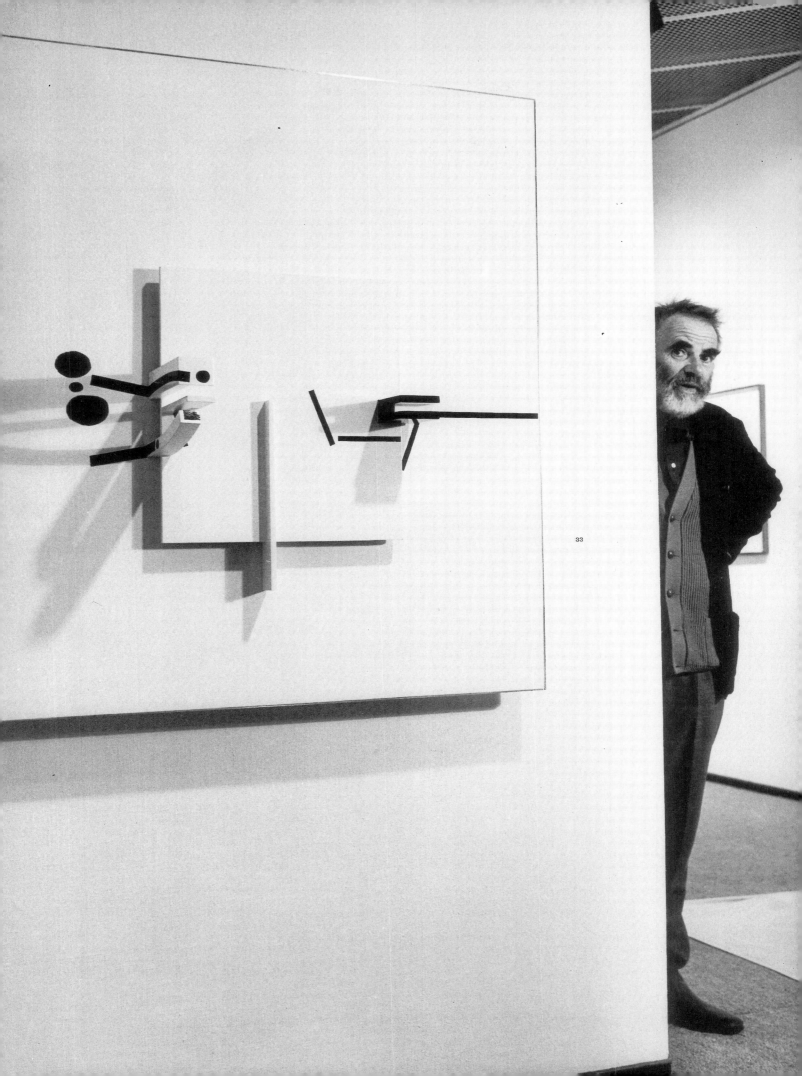

33

1970

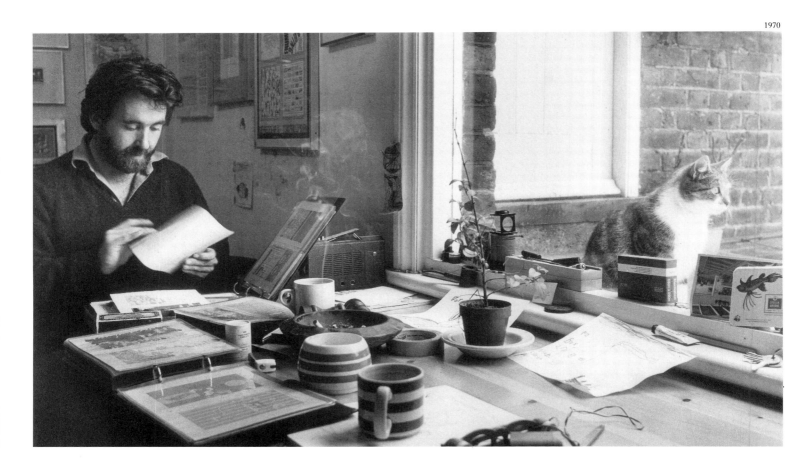

1973

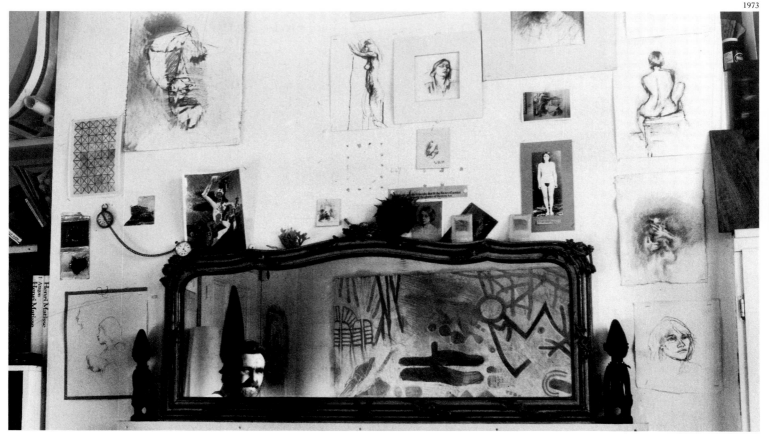

1976

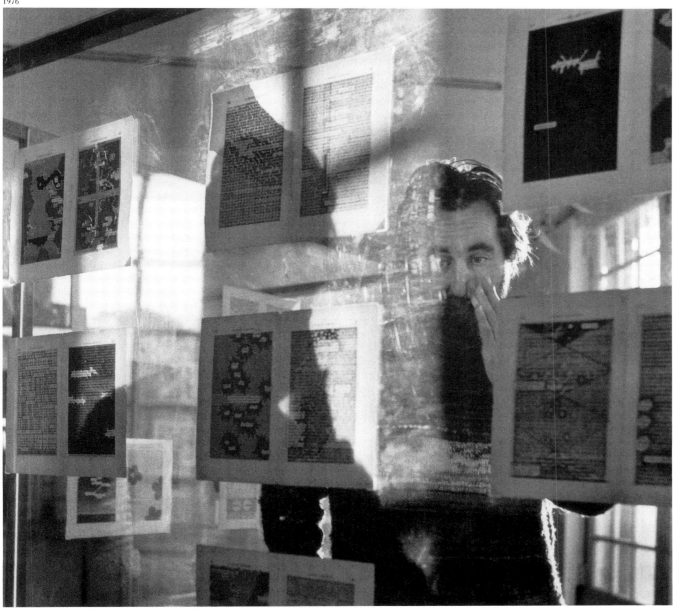

TOM PHILLIPS is a Renaissance artist/artisan with a multitude of talents. Cultivated, erudite, he is a gifted composer as well as a painter, designer and draughtsman. He is also a writer, especially of incisive art criticism which is highly regarded by his fellow artists, and a photographer.

When I first visited him in 1970 he was more than 150 pages into *A Humament*, a creative metamorphosis of a sentimental Victorian novel, *A Human Document* by W.H. Matlock, each page of which Tom converted into a witty and visually brilliant image. At the time he was living in a modest semi-detached house in Peckham, South London, with his studio on the first floor. He simply cannot rest from working. When I arrived I found him working at the breakfast table, pages of *A Humament* among milk bottles, jam-jars and cups.

On my second visit, my wife and I were treated to a concert by the Phillips family, Jill on the piano, his daughter on the cello and his son on the violin with Tom conducting.

By the time of my third visit Tom had moved his work to a studio nearby. Each morning, walking to and from the house, he photographed and collected various *objets trouvés* for a special series. By then Dante's *Inferno* was his main preoccupation. He illustrated it in a book he designed and printed, and he produced his own translation.

My next meeting with Tom is already arranged. On 30 May 1987 he will celebrate his fiftieth birthday by hiring the Oval Cricket Ground and staging a special invitation cricket match with many of his friends. I am enjoined to be quick with my camera when Tom is at the wicket – his batting is not yet another of his accomplishments.

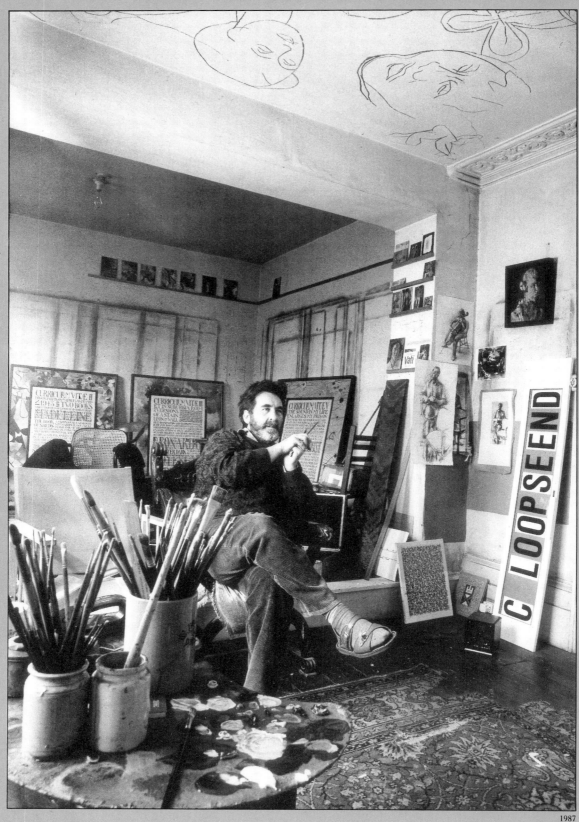

1987

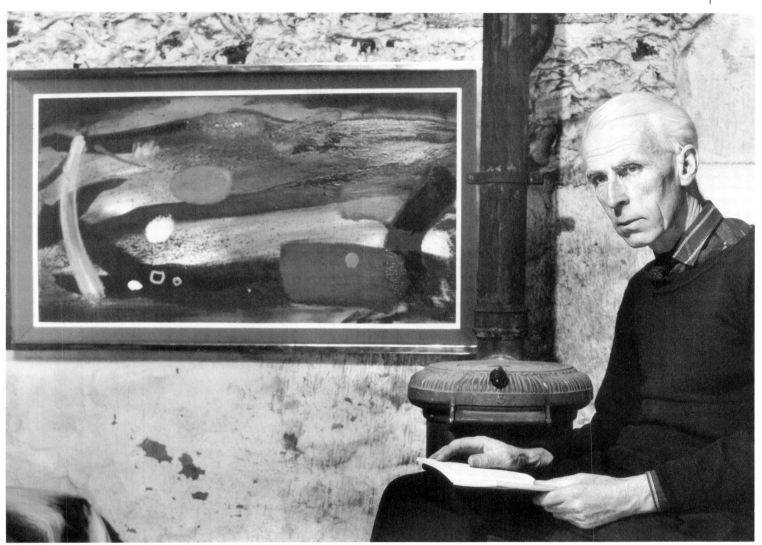

1962

JOHN PIPER is a perfect paradigm of the English gentleman, and also of an eighteenth century artistic dilettante. I do not mean that his work, its quality or its finish, are in any way unprofessional, but his manner of working is unusual: relaxed, leisurely, almost casual, it evokes an image of a gifted aristocratic amateur. Piper's work is anything but amateurish: he is an excellent painter, equally at ease with abstract and figurative idioms, a fine stage designer for operas, one of the best stained-glass designers, an excellent photographer and a consummate potter.

I have photographed John Piper on a number of occasions. He lives in a delightful enlarged cottage in a little village near Henley-on-Thames among the hills of Oxfordshire. The building, simple and white-washed, is full of beautiful pictures and objects.

Piper's studio, built many years ago (principally to provide him with an adequate space for designing the Coventry Cathedral window) is at a right angle to the house, and one glass wall fills it with light. When I first came to Fawley Bottom in 1962, the floor of the studio was covered by a design for a stained-glass window for St George's Chapel, the rays of sun imposing a second pattern on the artist's design.

John Piper, erect and very slim, now in his mid-eighties works every day. For a long time he has been preoccupied with Gothic architecture, which he recreates in paintings and drawings with his inimitable, incandescent style.

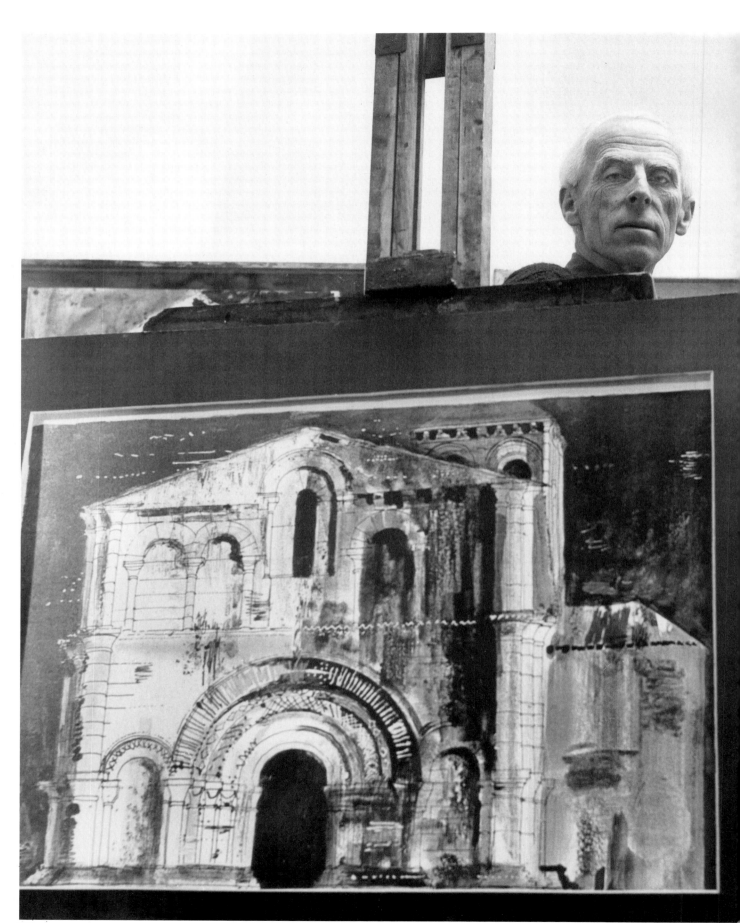

1969

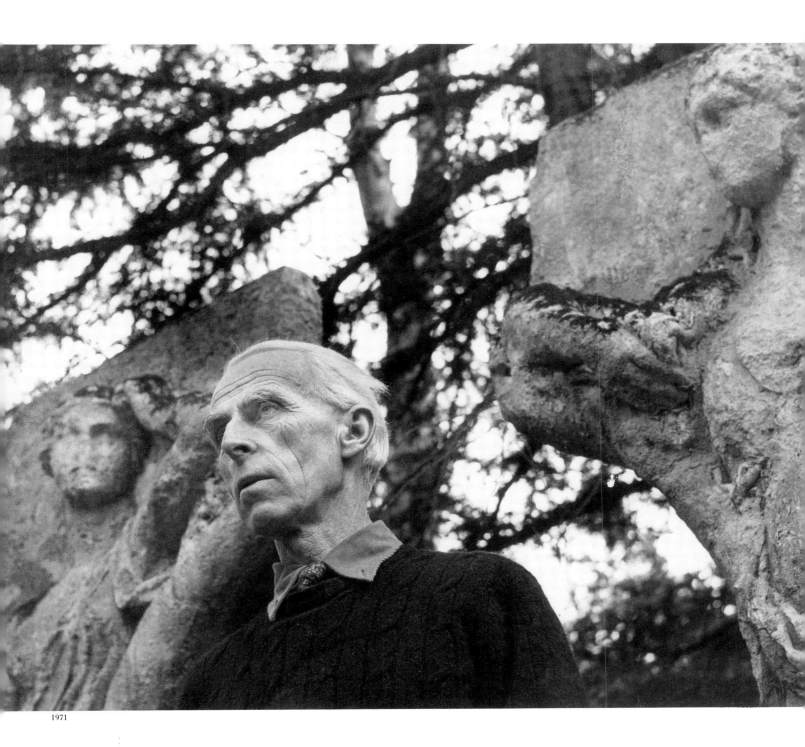

1971

Ever

John Piper

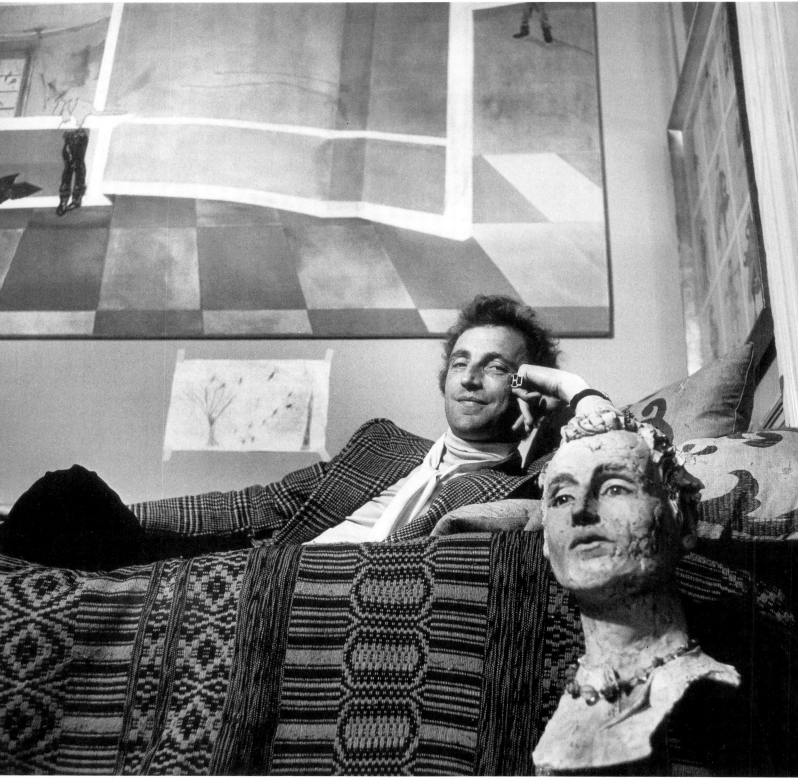

1972

PATRICK PROCKTOR is a paradigm of elegance: in himself
– tall, slender, impeccably dressed – and in his art, with its
portrayal of beautiful young men sprawling on divans, of
the palaces of Venice and the Baroque churches of Vienna.

Since I first photographed Patrick in 1964 he has lived
in a narrow house in Manchester Street, in the west end of

Patrick

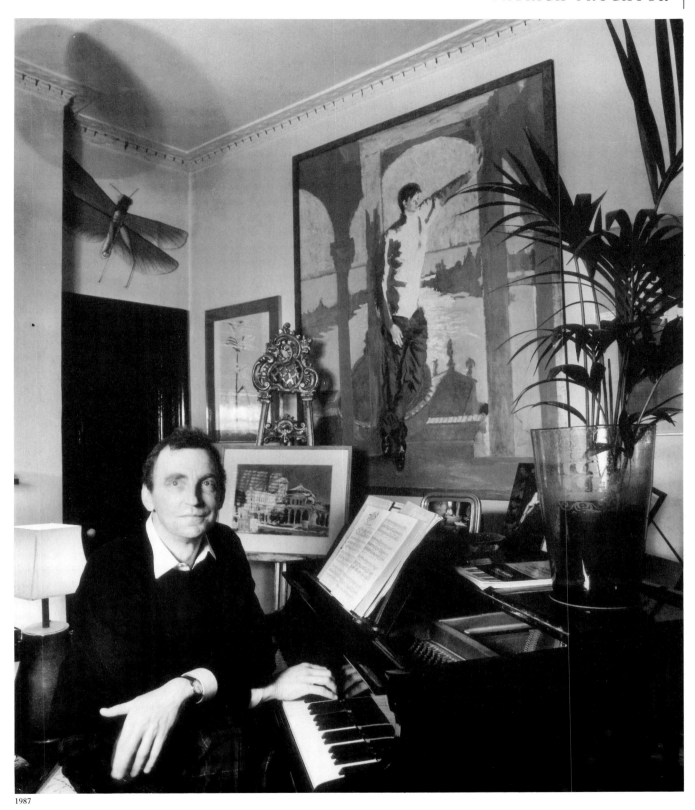

1987

London. The windows of his attic studio overlook a large
public garden, and the walls are hung with his exotic water-
colours. Outwardly little seems to have changed in those
years. In his early thirties Patrick married and had a son,
but the sudden death of his wife a few years ago has marked
him and his art, despite the unruffled surface.

Prockton

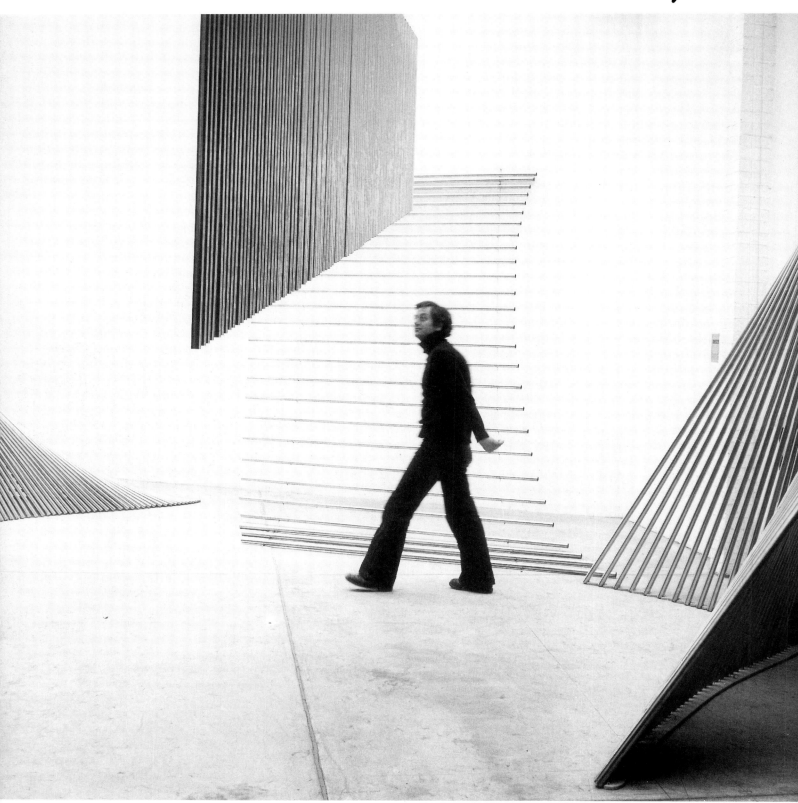

1975

BILL PYE'S studio in Wandsworth, South London, was pur-
pose built with a grant from the McAlpine trust. It is not
particularly large, but it contains a good working space,
enough height for pulleys and cranes, which some of the
sculpture requires, and an office and dark-room, since Bill
does much of his own photographic work. A couple of streets
away from the studio Bill found a spacious garden to rent
and now has a permanent display of his work.

Until a few years ago he worked mainly in polished,
tubular, rust-proof steel. His large sculpture *Zemran* can be
seen on the South Bank in London. In the last few years
he has become interested in sculptural fountains, and several
examples are displayed in his garden. He is fascinated by
the creation of a liquid texture, with water gently flowing
along varying forms and surfaces. He has lately worked
mostly for architectural and garden commissions.

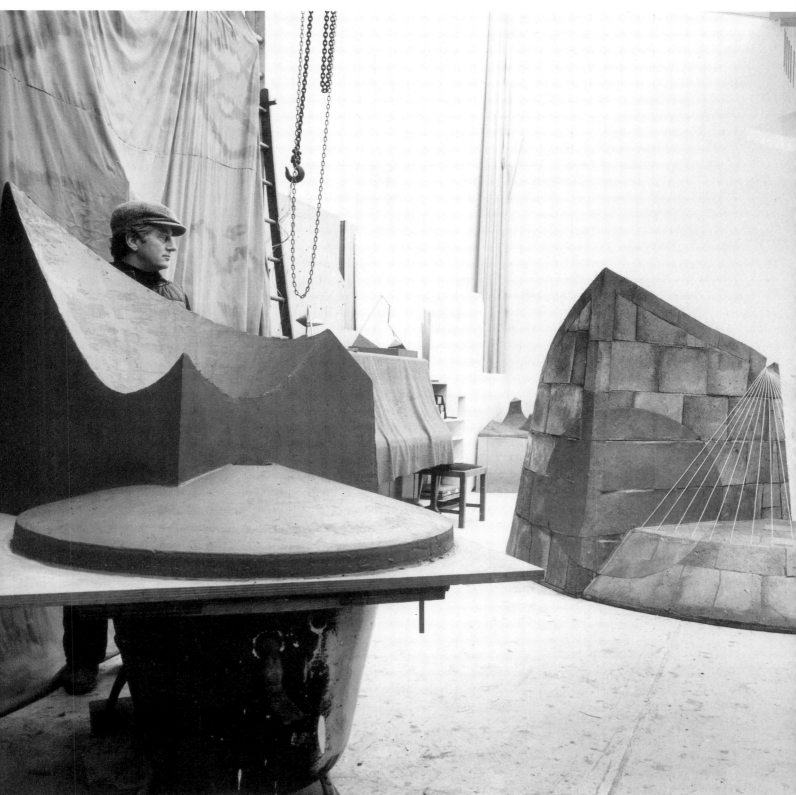

1983

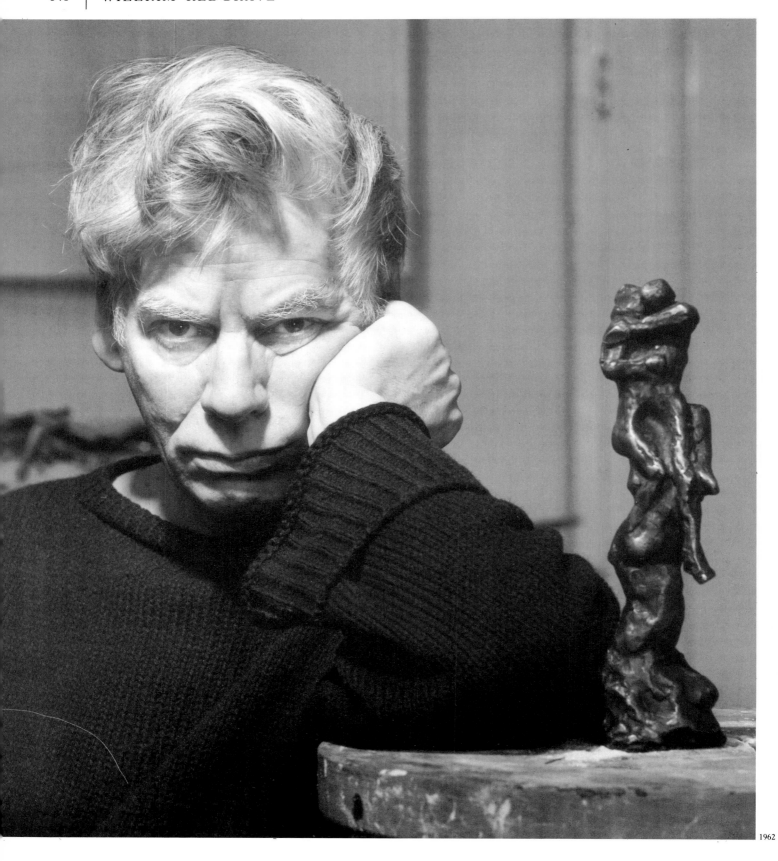

1962

WILLIAM REDGRAVE was the very first artist I photographed. His generosity, friendship and encouragement gave me the impetus to continue. He was also a fine artist, but in the second half of the twentieth century Bill was like fish out of water. At his best his sculptures and drawings could stand comparison with those of Rodin; in fact his style was partly Rodinesque, so that at a time when abstraction was in fashion Bill had great difficulty in making a mark.

His *Event* – a huge wall of very deep bas-relief, filled with a multitude of figures and personalities – was a masterpiece but it was also an anachronism in the 1960s. Despite numerous disappointments and constant financial problems, Bill remained energetic and optimistic.

Wm Redgrave

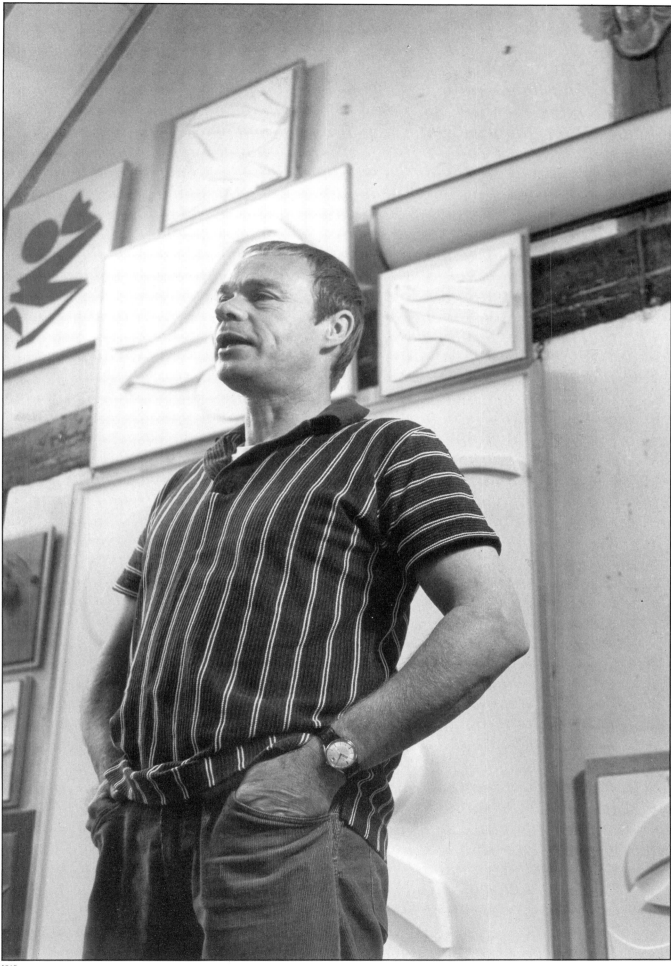

1969

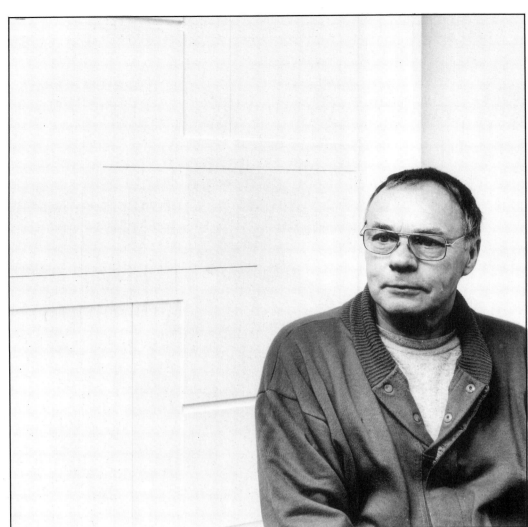

1987

ALAN REYNOLDS suffers for his artistic integrity. 'Suffers' perhaps exaggerates his present situation, since he lives happily with his wife, a headmistress at a local school, in a spotless white cottage in a Kentish village. Up to 1957 Alan Reynolds was a star and a celebrity. Just before leaving the Royal College of Art with a medal in 1952, he was given a one-man exhibition. It was an instant success. At the time he painted figurative landscapes and seascapes. In 1957 he abandoned figuration and turned to abstraction. His previous admirers refused to buy his abstract paintings and he found little assistance from the official art circles. He has never completely recovered his position.

No longer supporting himself by art alone, as he did in the first phase of his career, Alan is obliged to travel to London three times a week to teach at the St Martin's School of Art. The journey takes about five hours a day. He never wavered from his decision (however calamitous it was financially) and at last he is beginning to win through. His two most recent exhibitions were a success, especially the one in Kaiserslautern, South Germany, where the floor of the gallery was painted white in order to present Alan's white constructions to the best advantage.

What is surprising is that it has taken so long for Alan to recover his position in the art world, since his work – especially his magical, mainly white bas-reliefs – is marvellous.

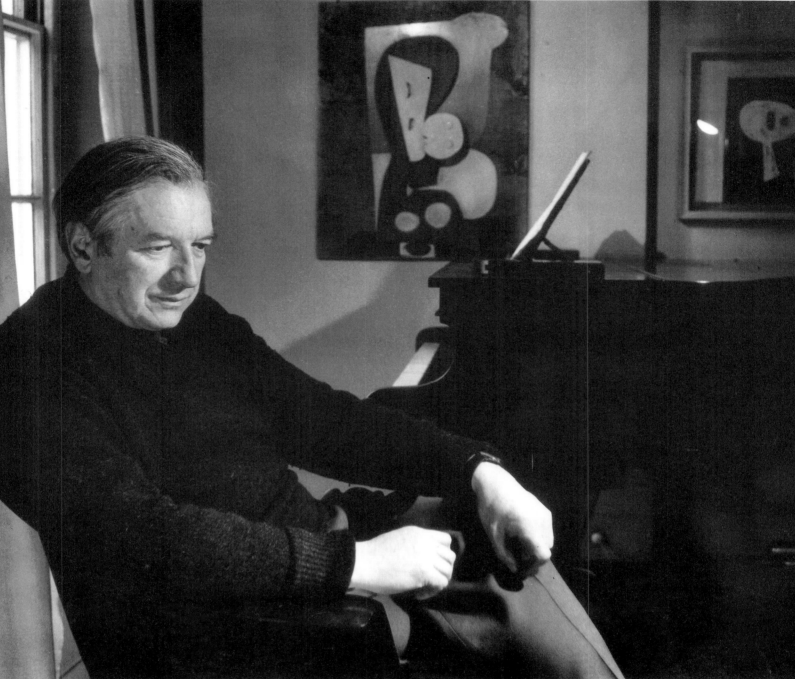

1963

CLIMBING THE STAIRS of Ceri Richards's house in Chelsea, one recalled that most of the important modern abstract painters are often excellent figurative artists as well. The stairwell of Ceri's house was lined with exquisite drawings of nudes and Welsh landscapes that could hang beside those of Matisse. I later learned that Henry Moore had called Richards 'the strongest draughtsman of his generation'. I was astonished by them, since most of what I had seen were Cubist abstract paintings and non-figurative constructions.

I liked to photograph Ceri at or near a piano. Music was the most important single influence on his work. At the time of my first visit in 1963 Ceri was working on a series of sensitive bas-reliefs inspired by Debussy's piano prelude *La Cathédrale engloutie*, painted constructions translating the haunting music of Debussy.

Ceri Richards was the best of the modern Welsh-born artists, a lover of music and poetry (Dylan Thomas was one of his friends and his poetry inspired several of Richards's works), a gentle, generous and handsome man.

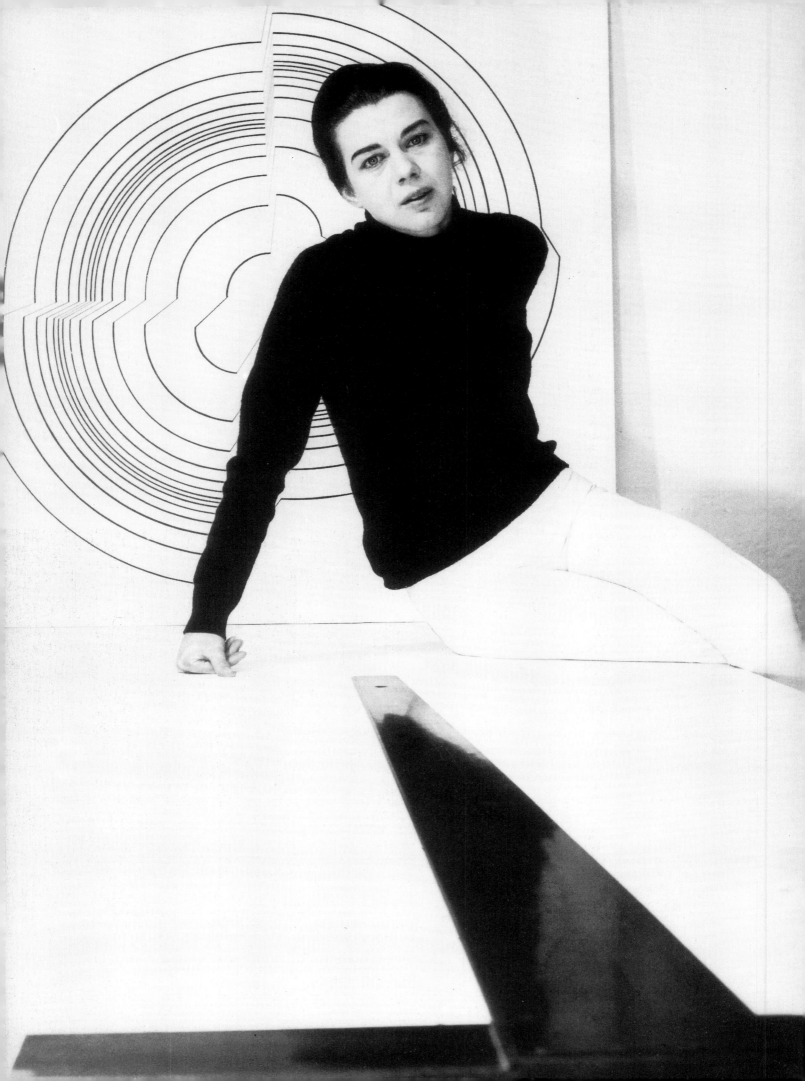

IT WOULD BE DIFFICULT to find a subject more photographically interesting than Bridget Riley. Two factors contribute to that: her strongly graphic, linear and visually striking work, and herself, slim, lively and photogenic. I visited her for the first time in 1964, in a modest flat in Holland Park. At the time her work, already in the 'op' style, was entirely in black and white: like her mentor Seurat, Bridget wanted to master black and white first before progressing to colour. With her sense of the theatre, Bridget was dressed in a black jumper and white trousers – what more could I ask for?

Since then I have photographed her on many occasions: in her attractive house near Shepherd's Bush, with studios on two floors and several busy assistants, and in a superb space she used for several years from 1969 onwards in St Katherine's Dock, in the Pool of London. In fact she and Peter Sedgley masterminded a scheme to provide workshops for artists in abandoned warehouses.

I most enjoyed the photo session in her studio in Cornwall in 1973. By then all her work was in colour and her large studio, filled with beautiful Cornish light, was covered with masses of 'op' drawings in delicate pastel colours – yellow, pink and rose hues predominating. This was, and still is, Bridget's way of developing her ideas: testing various combinations of colours and shapes against each other.

By this time too Bridget Riley's international success was assured, ever since a sell-out of her first American show in 1965 and the success of her retrospective at the Hayward Gallery in 1971, which toured the Continent.

1969 (*opposite:* 1964)

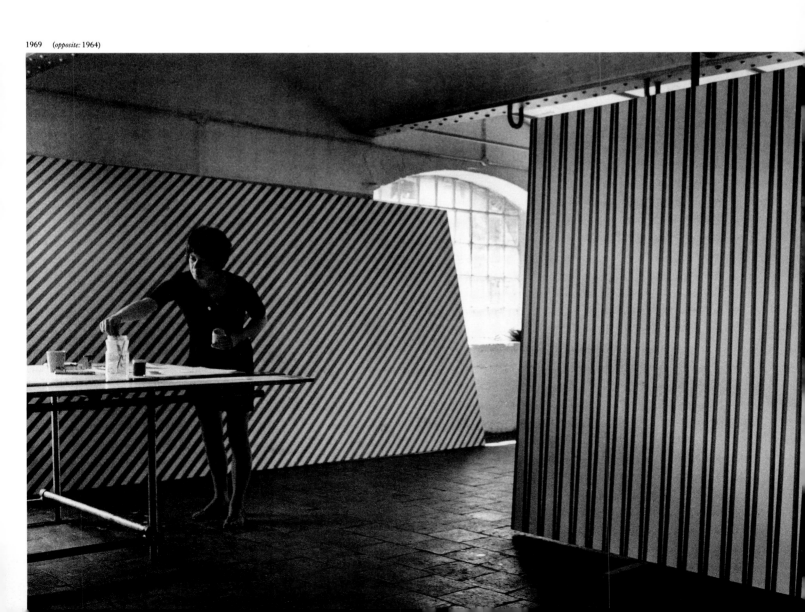

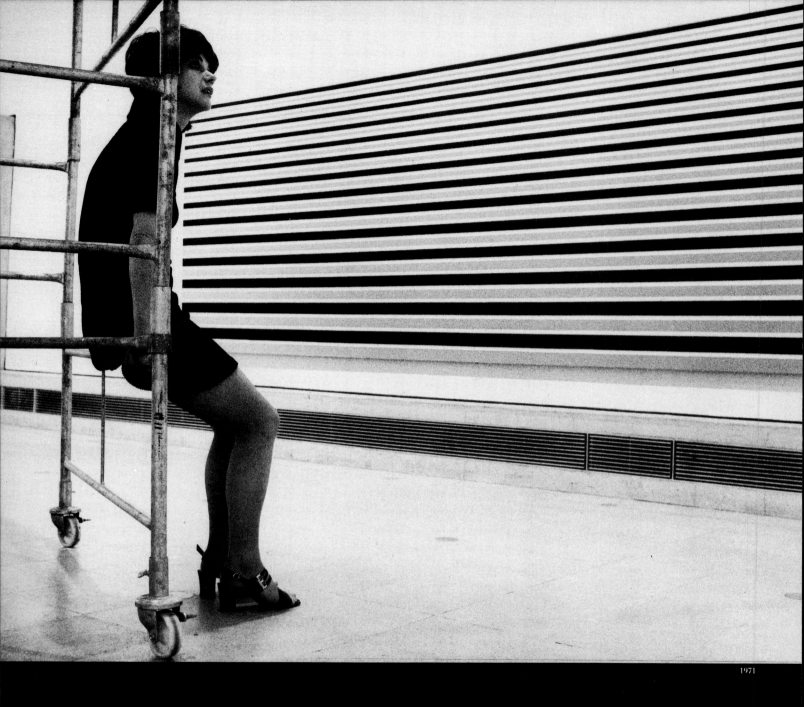

1971

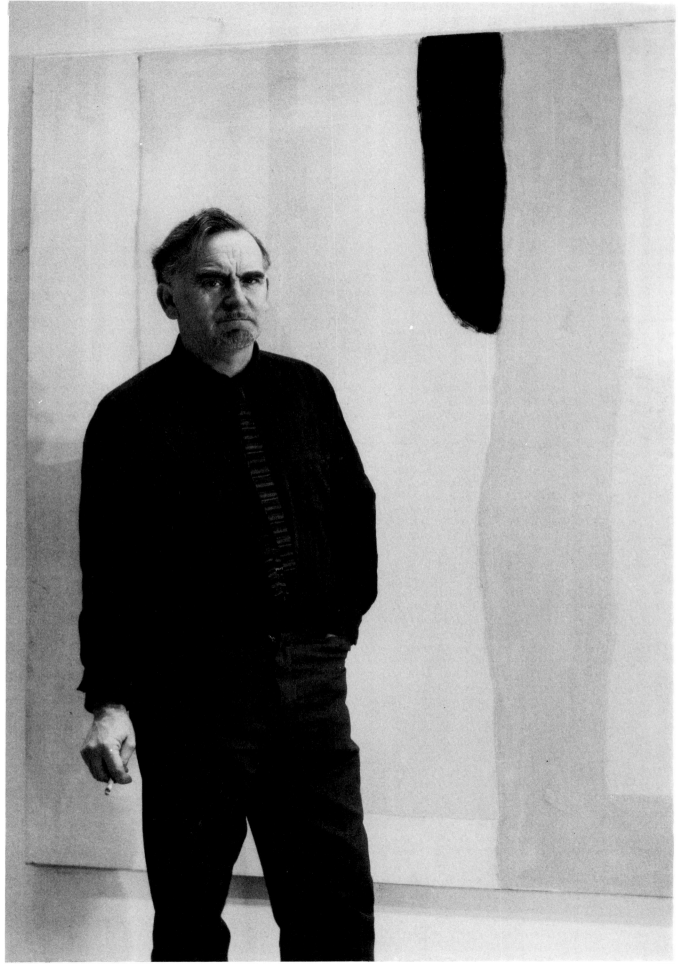

1963

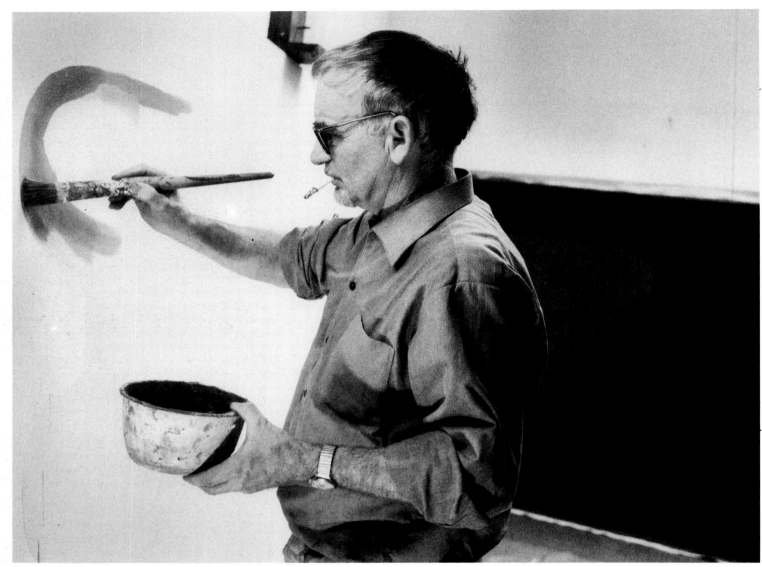

1967

William Scott

SUCCESS IN THE WORLD of art is often an unstable commodity. William Scott is a senior British modernist painter. His place seemed secure in the 1950s, 1960s and 1970s: the sole British representative at the Venice Biennale in 1958, with exhibitions around the world to his credit, a retrospective show at the Tate Gallery in 1972. Yet in the 1980s his presence is less evident, and the exhibition at the Royal Academy entitled 'British Art in the 20th Century' (1987) extraordinarily excluded William Scott altogether.

For me Scott's paintings have a very special significance. It was his magical abstract paintings, especially *Morning in Mykonos 1960/61* (loosely based on impressions of Greece) which I saw at the Tate, that finally triggered my emotional acceptance of abstract art.

But not all Scott's paintings are abstract. He started to paint in a kind of Gauguinesque style before turning to his inimitable abstracted still-lifes, with kitchen utensils prominent in his compositions.

I photographed Scott a number of times, mostly in his elegant modern studio in Chelsea, and the simplicity of his paintings, as well as the unerring sense of design, made them a joy to look at and to use in my photographic compositions with the small, sturdy figure of the painter – always polite and co-operative, if a trifle distant.

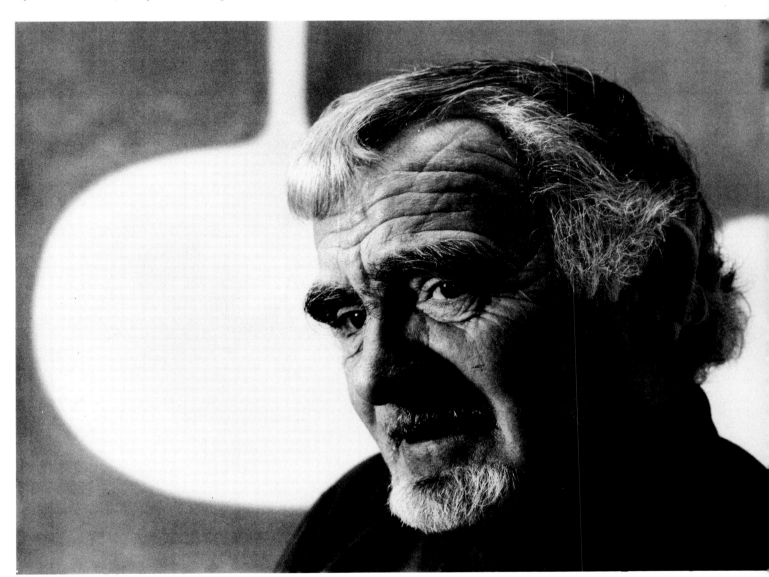

1975

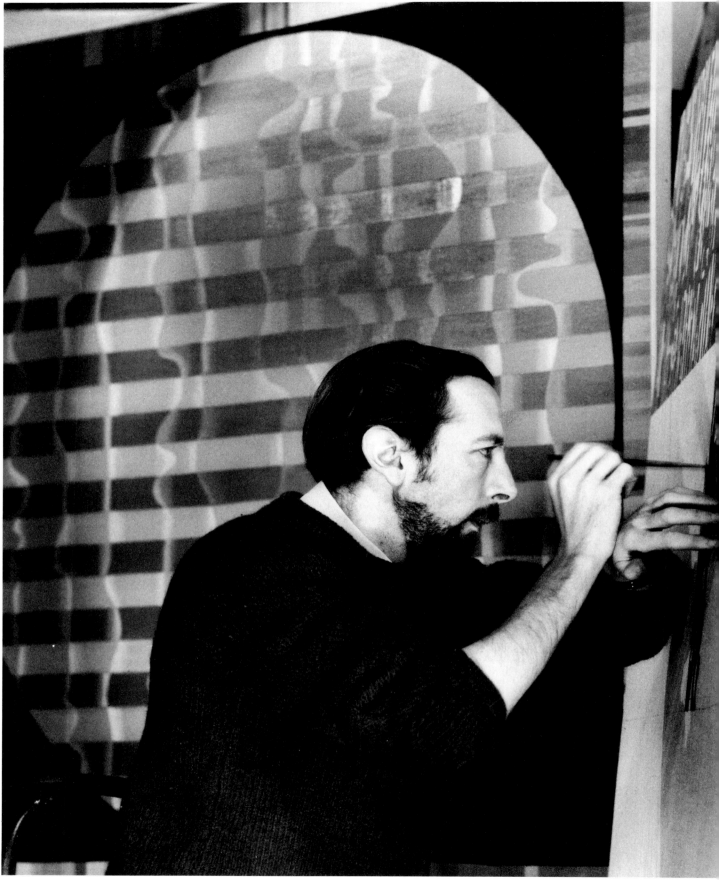

1963

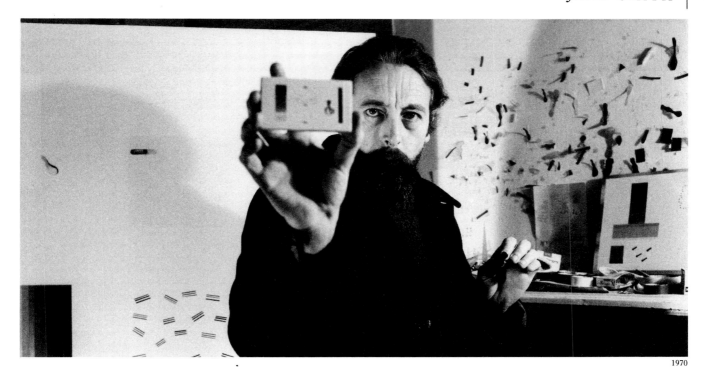

1970

JACK SMITH is a fine painter who in recent years seems to have slipped from sight. In the 1950s he became a celebrity with realistic studies of the low life of the North and got himself prominently featured in *Life* magazine. But like Pasmore, he abandoned figurative painting and turned to a precise and personal form of abstraction, mainly on the theme of music and abstract musical notation. As with Pasmore, Jack's collectors abandoned him and stayed away for a long time.

When I first met him in 1963 he was beginning to re-emerge and re-establish his artistic reputation, but it was a slow process. He and his wife Susan (also a fine painter) lived in a modest suburban house in the East End of London. The comparatively small size of the studio, however, did not matter very much since Jack never painted large canvases, his work depending on minutely exact and specific, almost calligraphic, notations of emblems and symbols representing his impressions of sounds and musical experiences. Since the market for his abstract compositions was never extensive (in spite of a large, successful exhibition at the Serpentine Gallery in 1978), like a great number of modern artists he had to rely on teaching, first at the Hornsey School of Art and later at the Chelsea School of Art. Some years ago Jack and his wife moved to the comparative seclusion of Brighton, where they both teach and work.

1983

1983

RUSKIN SPEAR'S name is synonymous with the Royal Academy of Arts. He first exhibited in the Summer Exhibition at the R.A. in 1932, as a man of twenty, and has hardly missed a year since. One of the best-known of the R.A. portraitists, he is also one of the most controversial. His portrait of Margaret Thatcher in various shades of blue (exhibited in 1975) recently came up at auction at Sotheby's and the bidding was a shade sluggish. Spear commented that it was bought in 1975 by someone in the City who no doubt wanted to get rid of it at any price.

Ruskin Spear now lives in a modern bungalow/studio in Chiswick, London, a much better environment than his previous rather cramped studio. He is not as mobile and energetic as he was a few years ago when I first photographed him, because of severe arthritis.

His paintings ('One must begin to think about the next Summer Show even now in January') are spread around the studio and his eight cats wander among them. He glances at a painting of a nude sunbather and comments that something must be done about one of her legs, it appears shorter than the other.

These days Spear rarely exhibits, since it is almost impossible for him to collect enough paintings for an exhibition: 'The collectors come here almost daily. I just sold two paintings yesterday.'

Ruskin Spear

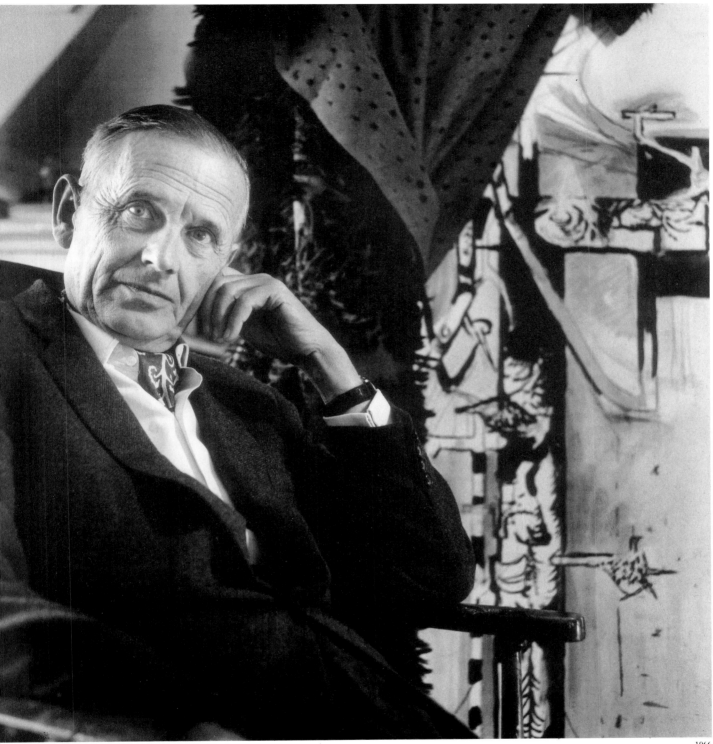

1966

I MANAGED TO PHOTOGRAPH Graham Sutherland only because of my tenacity. In his later years (when I was photographing artists) Sutherland was reluctant to pose for photographers: being uncommonly handsome (and vain), he resented the wrinkles on his sixty-year-old face. The second obstacle was Sutherland's wife Kathleen, who was very protective. In the summer of 1966 however, I finally managed to get the all-clear for a session.

Each year since 1944 the Sutherlands had spent part of the summer at the White House in Tottiscliffe in Kent (for the remainder of the year they usually stayed in Mentone on the French Riviera). It was in their summer house that I set up my camera for the portrait. Personally I have always most admired Sutherland's portraits: his Maugham, Beaver-brook and Adenauer are all masterpieces. Consequently, I chose to portray Sutherland against a background drapery, partly obscuring his painting; a sort of 'official' portrait setting.

I found Graham Sutherland friendly and co-operative (perhaps his amiability was the reason for Mrs Sutherland's protectiveness) and we talked, among other things, about other photographers who had managed to get a sitting with him. One of them was Bill Brandt, the finest of British photographers. Sutherland judged Brandt's portrait of him 'awful – far too detailed'!

Graham Sutherland

1970

1975

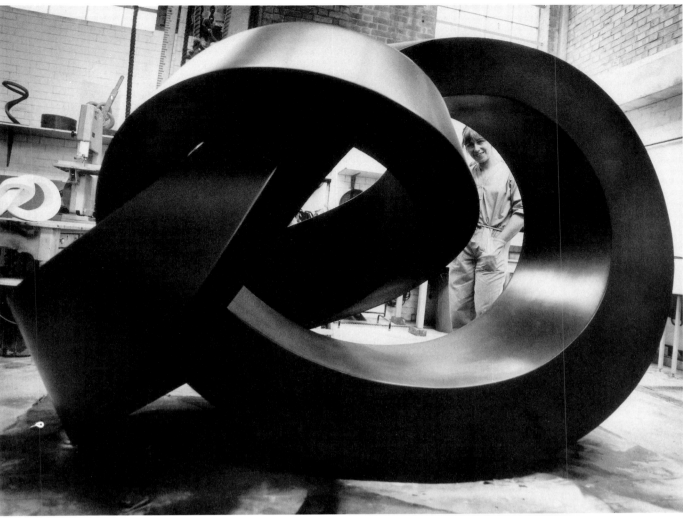

1978

I FIRST CAME ACROSS Wendy Taylor's work through the window of a small gallery in Duke Street in London, in the spring of 1970. It was a strange sight – huge square metal slabs seemingly suspended in the air, held up merely by three short chains, not hanging on the chains, but defying logic, and being propped up in the air. A minute later a beautiful young girl in a mini-skirt appeared in the window adjusting the sculpture. The combination was irresistible.

Wendy's preparations and arrangements for her first individual show proved futile. The next day the Axiom Gallery was found to be bankrupt and had to be closed. Wendy had to transport her heavy sculptures back to her studio. BBC Television could not resist the appeal of the sculptress and her work however, and a film *Wendy Taylor-made* was the result.

Even though she exhibited a few more times with commercial galleries, she eventually became disillusioned with the gallery system, and now concentrates on commissions and personal contacts. In a short period she has been given a number of important commissions, among them her huge *Sundial*, which overlooks the Thames next to Tower Bridge.

Wendy Taylor's work is imaginative, beautiful to look at, amusing even when baffling. Her main preoccupations are balance, stress and apparent movement. She often employs seemingly heavy and cumbersome materials (like bricks) and creates from them dainty sculptures, like a huge, delicate bow made of bricks. She, like her work, is a contradiction in terms: exceptionally pretty and svelte, yet effortlessly handling back-breaking weights.

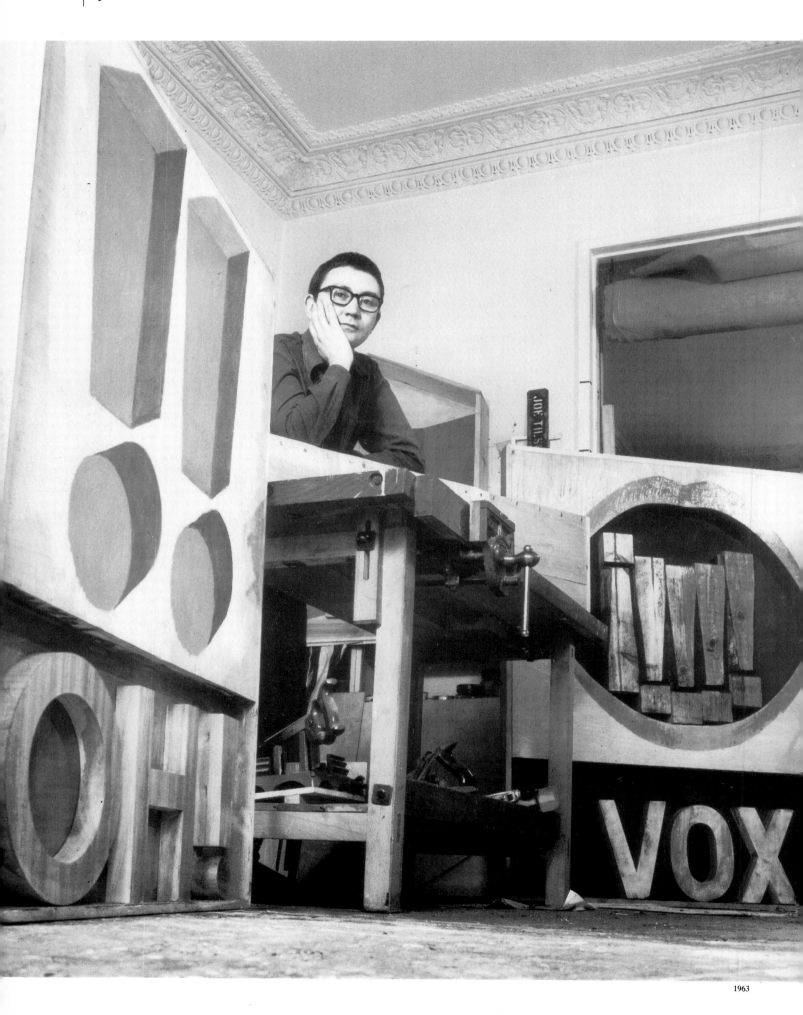

1963

JOE TILSON'S father was a blacksmith and Joe started work at fourteen as a joiner near Elephant and Castle in South London. He is proud of his working-class origins, but they seem remote now Joe is a sophisticated, erudite and penetrating artist. His youthful training is not forgotten and he has retained his love for the medium of wood. Most of his best pieces are in this material.

My first two sessions with him, starting in 1963, took place in his spacious flat just off High Street, Kensington. Evidence of his skill as a carpenter was everywhere, including the kitchen, and his studio was dominated by work-benches and wood-working tools. Tilson's work, painted wood reliefs, occupied a space between painting and sculpture, and were in the idiom of the 'op' movement. The majority of his pieces consisted of large wooden frames containing a jig-saw of pieces of wood, painted and raw, skilfully assembled and often incorporating words and letters.

In the early 1970s the Tilson family – five in all – moved to a rustic environment near Chippenham in Wiltshire. They now occupy a large rambling house surrounded by flowering trees and shrubs. Joe's workshop, separated from the house, resembles a carpenter's yard even more than before. His work is usually in wood (although he is also an important and skilful print-maker), but has grown in proportion and begins to be more in tune with the countryside around it. Tilson was for some time interested in Lunar and Solar Circles and in the four major elements of fire, water, earth and air, and began to incorporate them in large wooden ladders and other constructions. In walking among the trees, you suddenly encounter one of the pieces placed in a natural setting.

Tilson's move to the country was part of the general exodus of pop artists in the 1970s, but while most of the others returned to the city (Blake, Richard Smith and Hodgkin for example), Joe thrives on the country air. As he says, it is important for him to detach himself from the heavy London atmosphere, full of politics and strife.

Tilson

1976

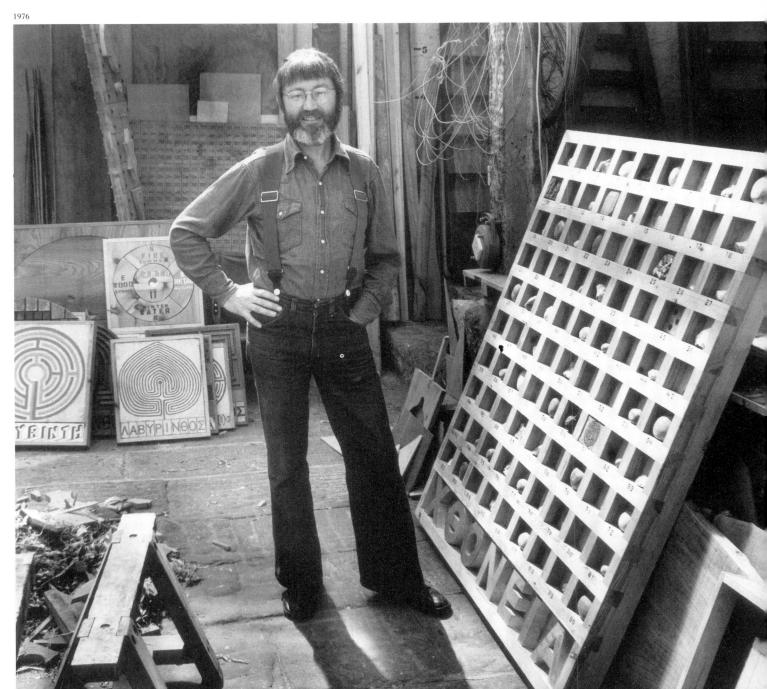

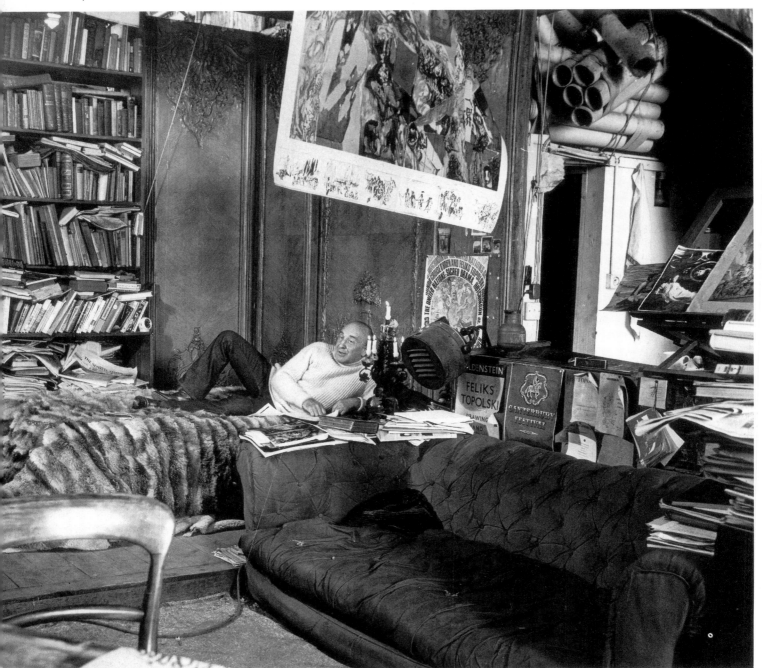

1971 (*opposite:*1977)

FELIX TOPOLSKI, now nearing the end of his eighth decade, remains active and gregarious, full of new projects, always approachable, and invariably the focus of a constant flow of visitors to his studio.

Born and educated in Poland, Topolski settled in England in 1935, soon became a success and an institution as a superb recorder of the life and history of England (and the rest of the world). The finest instinctive, impressionistic draughtsman of this century, with his darting pen Topolski recorded every important event and immortalized most of the outstanding personalities. He has published a score of books, painted murals, (including the 95-foot-long *Coronation of Elizabeth II* for Buckingham Palace), but possibly his most important achievement has been the publication from 1953 to 1970 – twenty-four issues a year – of *Topolski's Chronicle*, the visual record of his travels on five continents, of events and people he has met.

Topolski occupies the most unusual of studios, a huge arch underneath the railway bridge adjoining the Festival

Hall. It is packed with outsize drawings and paintings, mostly of the *demi-monde* of the 1960s, with piles of drawings and prints on tables and benches, and a huge untidy bed surrounded by books and posters.

For the last fifteen years, Topolski has been working intermittently on his *Memoirs of the Century*, a jig-saw of huge twenty-foot-high panels, zigzagging through the remaining two arches of the same bridge – a commission from the former Greater London Council for the South Bank Art Centre.

His home too, is out of the ordinary, situated in one of the riverside Gothic towers opposite the Festival Hall. Its slippery balcony on the ninth floor commands one of the finest views in London, from Tower Bridge to Battersea Gardens.

Feliks Topolski

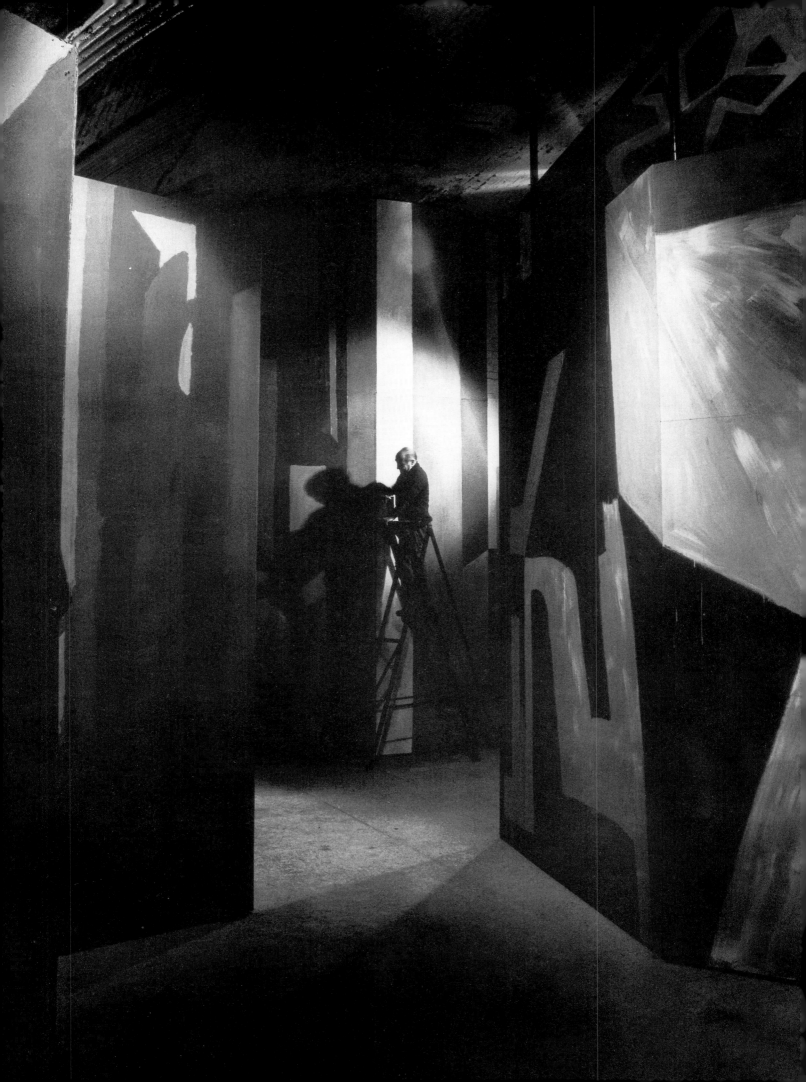

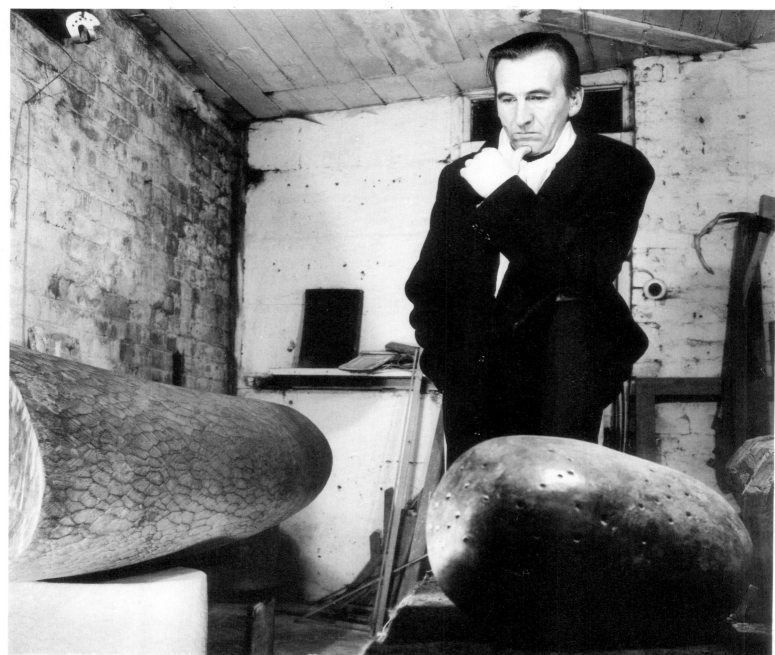

1964

PART OF THE FASCINATION of photographing artists over a long period of time lies in the fact that the second and third sessions often occur a considerable time after the first. Sometimes there is little discernible change: Bacon arrived at a mature style and a specific way of seeing and retains it through his career; other artists – for example Pasmore and Paolozzi – periodically evolve a new mode of expression and representation. William Turnbull belongs to the second group.

When I photographed Bill for the first time in 1964, he was at the end of his 'totemic phase'; his bronze and wooden sculptures were showing associations with Far Eastern or Indian idols, and still managed to retain certain allusions to the human form. At the time he worked in a small studio in Hampstead which had originally been a garage. I photographed Bill on a particularly cold and murky winter day. The dimness of the studio interior augmented the mysterious character of his sculptures.

On my second visit some years later, to his present house in Camden Square, I found a total change. His sculptures

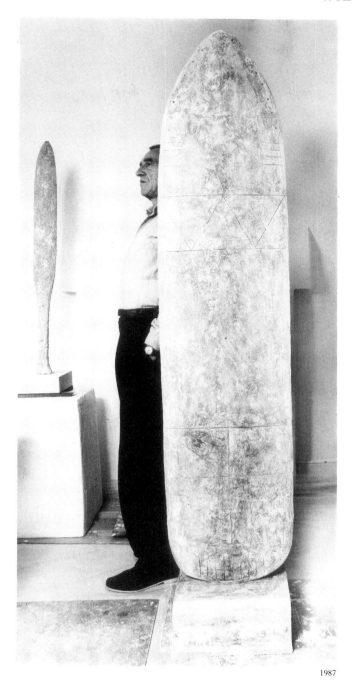

1987

and paintings (since he is also an abstract painter) had become more simplified and any vestige of figuration was completely absent. Rectangular and curved slabs of plastic materials were then in evidence, and Turnbull painted these in single flat colours. His paintings, large square rectangles of canvas, were also of one overall field of colour broken only by a single stripe or line.

For one reason or another I did not visit Bill for nearly twenty years. On my recent visit I found him returning to his old preoccupations. Beautiful totemic figures, slender and tall, once more occupied his studio. Gone were the steel and plaster shapes and plain painted surfaces. Plaster was again the main material, sensitively worked with rough tactile surfaces and subsequently cast in bronze.

Bill is married to Chinese-born sculptress Kim Lim and their works beautifully co-exist, side by side, in the sculpture garden at the back of their house.

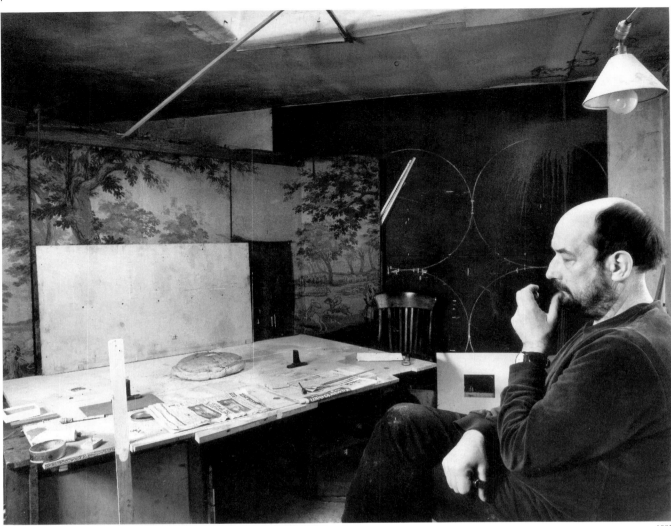

1983

EUAN UGLOW works in an unassuming mews house in Battersea. Through an untidy yard you enter a dark, sparsely furnished living-room, which gives the impression of being scarcely lived-in. The heart of the house is in the studios on the first floor, two large rooms meticulously arranged as separate painting sets. Each set is provided with an easel, but there are no paintings on the easels. In fact there is not a painting to be seen. All of them are modestly turned towards the walls (just as in Bacon's studio). But each set is as if 'furnished', admittedly very frugally: a shelf or two in the background, perhaps a drawing or a plant, and in front a chair or a *chaise-longue*, which must not be moved. I am reluctantly informed that each of these sets is permanently arranged for a specific model and comes to life once a week when the model, undressed or otherwise, takes her customary pose and is painted – with enormous care and concentration – over indefinite periods of time, weeks, perhaps months, one or two hours each session.

The second studio is reserved for still-life painting. A life-size model of human anatomy, all veins and muscles, stands in the corner, face to the wall. The main set is given over to a loaf of bread, slightly mouldering. Some mysterious lines are drawn around it and a few strings hang in front of it. 'Is Uglow waiting for the mould to develop?' – but I dare not ask.

Throughout the session the artist is polite and co-operative, but detached, a little like his work. He is obviously dedicated to his main purpose in life: painting. Nothing else matters – his environment, his dress – all these are mere incidentals beside the truth and integrity of his work.

KEITH VAUGHAN died in 1977. He was a great artist and like many of them was modest, shy and unassuming. I photographed him on a number of occasions in his spacious flat in Belsize Park and I always felt that in spite of his talent and success he was not a happy man. He kept a personal diary from 1943 to 1961 and phrases like 'Demoralizing bouts of self-doubt and helplessness', or 'Increasing difficulty in maintaining the upright position' recur on its pages. He often seemed lonely and dejected. Perhaps his inner unhappiness made his images so poignant and moving.

The first time I visited Keith, in 1963, he showed me his album of photographs. Most had been taken during holidays in sunny places and almost all were of young boys in the nude. He seemed proud of them, but I showed little enthusiasm since they were merely competent snap-shots. Later I realized how important these images were for him. The dominant subject of Vaughan's paintings was the nude male body. Indeed during this first session I photographed Keith with a mural which he was in the process of painting. It consisted of a series of male athletes in action: graceful bodies with noble gestures, their muscles tensed ready to spring into movement. Although modern in spirit and semi-abstract in treatment, they reminded me of classical Greek pediments seen in Athens.

1963 (overleaf: 1974)

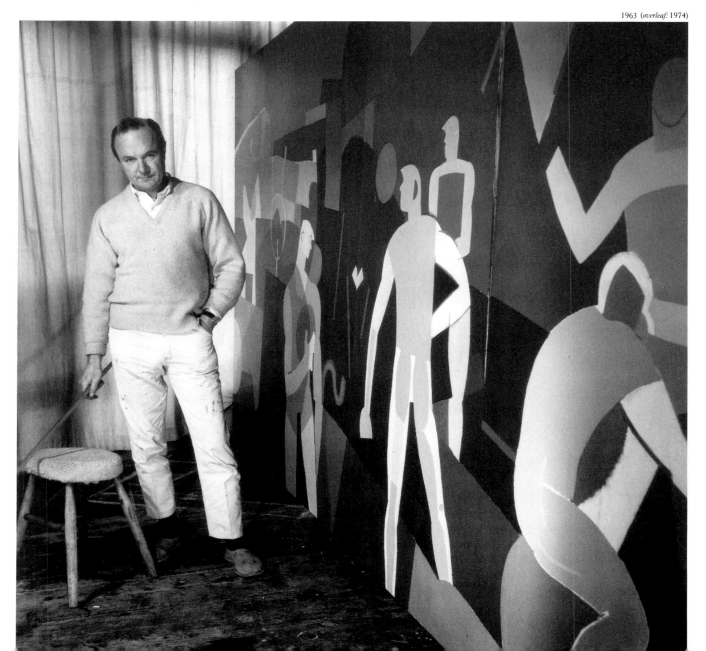

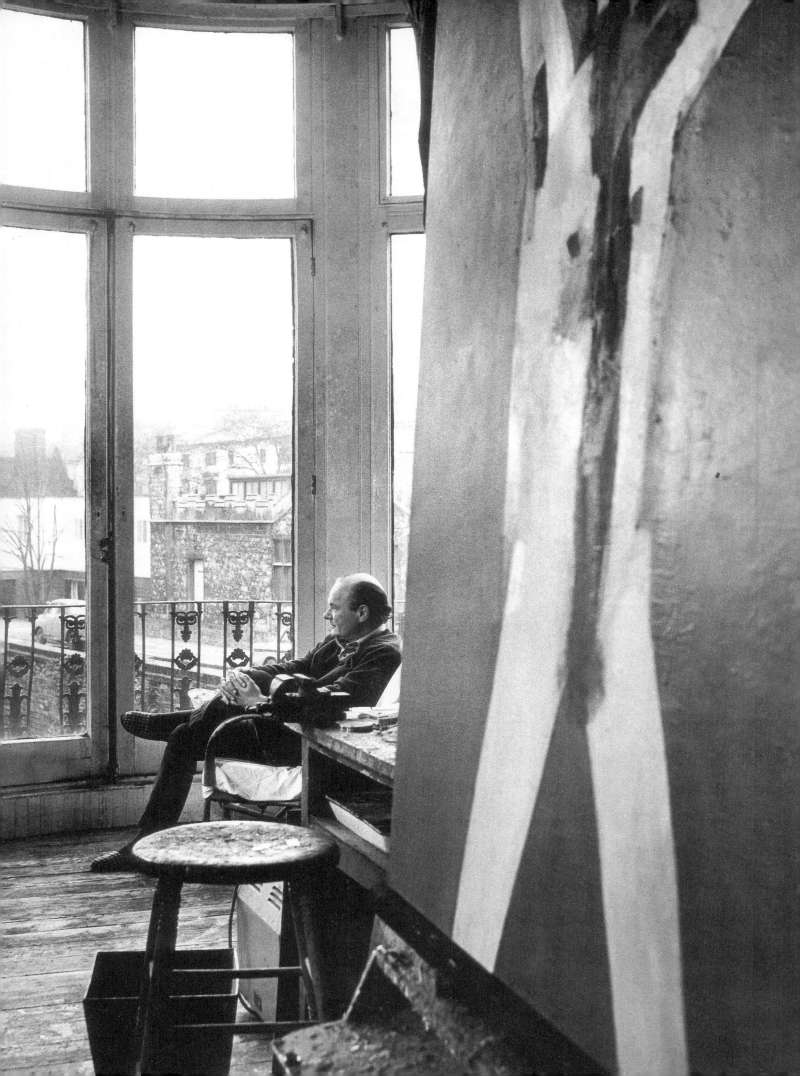

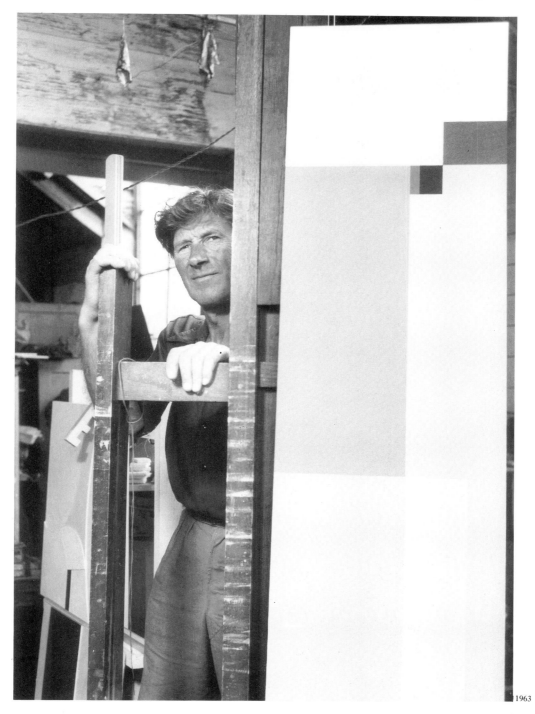

1963

FEW ARTISTS are less interested in fame, recognition or selling paintings than John Wells. As his friends say: when John opens the door to his studio he will treat you as an intruder or enemy. He is a shy and private person, and he hates to part with any of his drawings or paintings.

When I first wrote in 1963 to arrange a photographic session, his reply was a curt, reluctant affirmative. When I arrived I found him in front of his house cutting roses and genuinely surprised that I had come. 'Why me?' he asked, 'Who told you about me? I am an amateur really, why should you want to photograph me?'

We had tea and cakes in a small kitchen and finally I was allowed up to his studio on the first floor. From the window could be seen the magnificent curve of the bay of Penzance, with St Michael's Mount in the far distance.

At first John's studio seemed entirely bare, but with some prompting paintings and constructions began to appear from behind pieces of hardboard (John's favourite painting surface) or from underneath piles of papers. They were mostly abstract, almost geometrical designs and constructions, but all exquisitely harmonious, rhythmical and delicate, with subtle tones of greys, whites and pastel hues predominating.

On the table in front of the window I noticed two objects: a small sign inscribed 'Dr Wells' and a navy-blue sailor's cap, souvenirs of John's previous existence as a doctor in the Scilly Isles. Some of his patients lived in the lighthouses; journeys of a few hours in a small boat on rough seas were commonplace for Dr Wells. He abandoned his practice in order to paint full-time in 1945, but somehow never lost his rugged complexion or managed to adjust to life in a community.

FROM CENTRAL LONDON it takes an hour to get to Matt's Gallery, in the northern corner of London, among derelict warehouses and small commercial establishments. Above the crooked, peeling front door is a line of door-bells, each with a scribbled name. These are the artists in residence: the whole complex is part of an artists' co-operative. 'Matt's' name is only slightly larger than the rest. When you press the button you may have a wait – it is a long walk along twisting corridors to the back of the building and an outside iron staircase to Matt's Gallery. 'It's good to be away from the hustle and bustle of the West End,' they say. 'Only real *aficionados* and art lovers ever venture so far north'.

Richard Wilson's display at Matt's Gallery is worth a pilgrimage. A smooth, hypnotic black surface all around you, silently reflecting the walls, pipes and windows. A soft black mirror, and Wilson aptly quotes *Through the Looking Glass* in the press notice: 'Let's pretend the glass has got soft like gauze, so we can get through.' It takes a few seconds to adjust, in order to appreciate this amazing 'piece'. It required 320 gallons of sump oil to fill the surface. At first sight it seems bottomless, though it is only an inch or two deep. Richard had a problem in constructing it. Apart from having fallen into the oily surface once or twice, he found it far from easy to collect the oil from local merchants. From time to time he bought a barrel that was mostly filled with water.

20 : 50 (the name of the piece is the commercial grade of the oil used) is one of a number of sculptural environments Richard has constructed and exhibited, most of which are ephemeral and unsellable.

This is an intriguing feature of the activity of a number of young artists working in the 1980s – happy to construct environments or create happenings which are in effect one-off events. It is partly art activity, partly a protest against the commercialization of the art world. It all started with the great art-magician, Marcel Duchamp, some seventy years ago.

Richard Wilson

1987

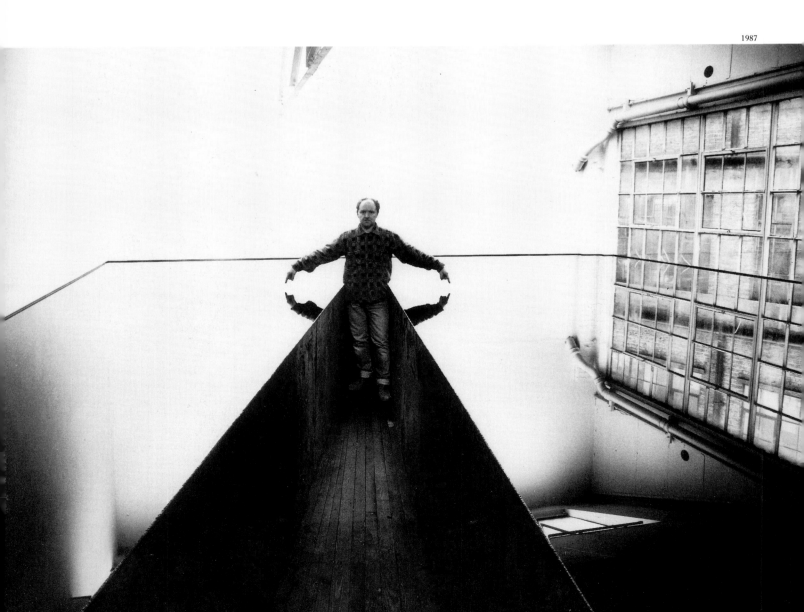

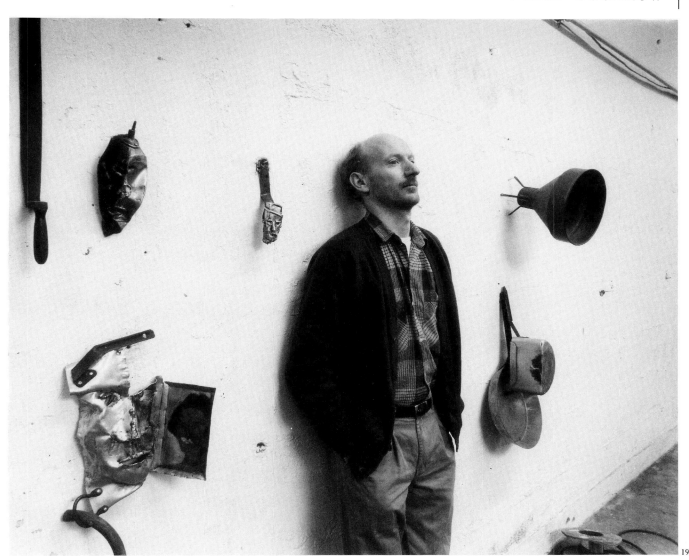

1987

BILL WOODROW is possibly the most exciting and inventive of the younger generation of British sculptors. He has the rare ability (like Picasso) to transform ordinary, everyday objects or pieces of odd materials into telling sculptural entities: a broken black umbrella into *Crow and Carrion*, a car bonnet into a *Ship of Fools* or a frying-pan into a waddling *Water Bird*. With a few blows of a hammer, a cut or two with metal shears and a few twists of pliers (remarkable as it may seem, the only implements – plus a power-drill – he requires for his sculptures) he transforms a metal pot into a human face or a chicken.

Although some of his sculptures are didactic, moralizing or satirical he is not in person a fiery reformer or a rabid radical. Tall, slim, with short red hair and short straggling beard, he could be taken for a great-grandson of Van Gogh, but with Van Gogh's temperament firmly under control.

Woodrow's studio in South London is a model of order and unruffled tranquillity. It is the paradigm of Bill's way of working: not in spurts of frantic, impulsive activity but quietly and precisely building his creations to their startling effect.

1983

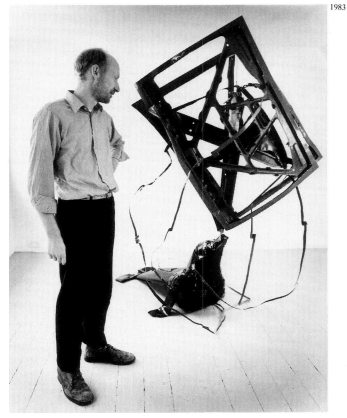

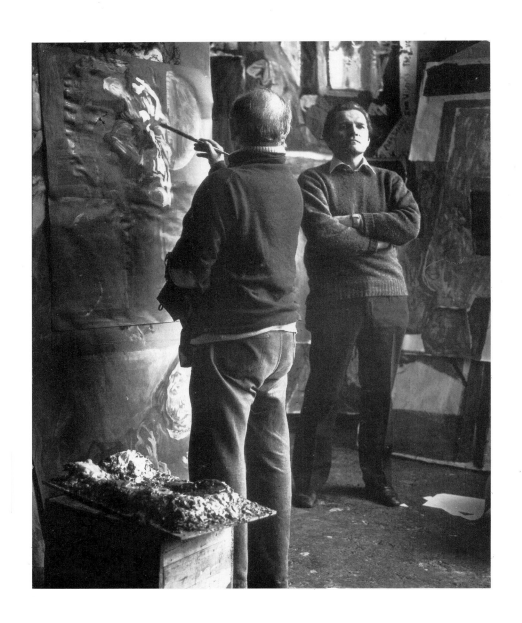

Jorge Lewinski.